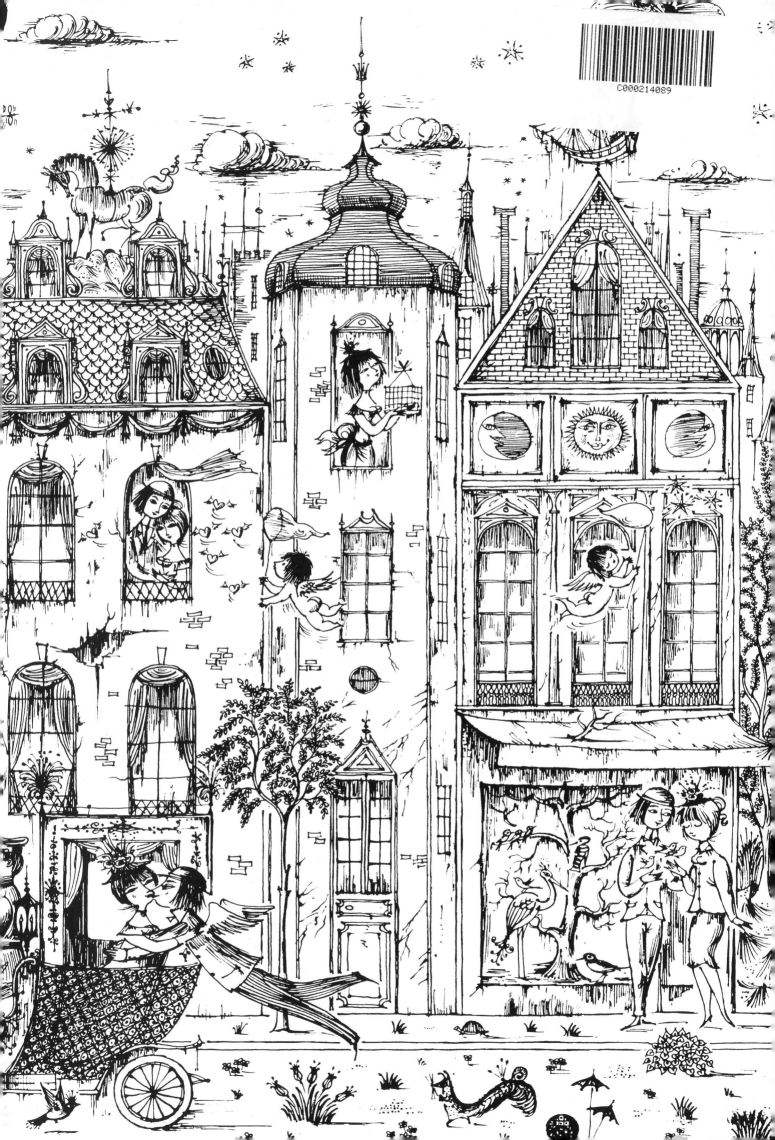

COLLECTIONS

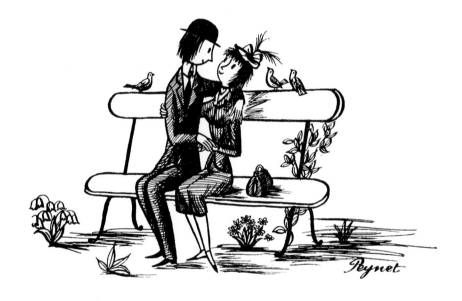

To Monica and Tessa

Peynet drawing the little poet, Paris, 1955.
Peynet dessinant le petit poète, Paris, 1955.

COLLECTIONS

André Renaudo

RICHARD DENNIS
1998

ACKNOWLEDGEMENTS

This book would not have come to fruition without the support and encouragement of Richard Dennis and the generous assistance of Annie Druet-Peynet who allowed me access to her invaluable archives. I thank them both very much.

I would also like to thank the following: Magnus Dennis for the photography, Sue Evans for editing the English text, and Laurence Pollard for editing the French text.

My gratitude to Annette Bordeau of the Musée National of Monaco, Christian Fouquet the founder of *Les Amis de Peynet* in Reims, Monsieur Goujon, curator of the Musée Peynet in Antibes, Georg Okrusch of Rosenthal, Herr Siemen of the Deutsches Porzellanmuseum.

The assistance of the collectors, Kate and Chris Barber, Stéphane Steeman in Bruxelles, and the dealers, John Clark, John Jesse and Dave Simmons, has been invaluable.

My thanks also to Monica Renaudo, Sally Tuffin, Gill Hunt, Wendy Wort and the team at Flaydemouse

A.R.

REMERCIEMENTS

Ce livre n'aurait jamais vu le jour sans l'idée et l'encouragement de Richard Dennis, ni l'aide d'Annie Druet-Peynet qui me permit l'accès à ses précieuses archives, et je les en remercie tous deux infiniment.

Je voudrais également remercier les personnes suivantes: Magnus Dennis pour la photographie, Sue Evans et Laurence Pollard pour la mise au point des textes anglais et français.

J'aimerais exprimer ma gratitude à Annette Bordeau du Musée National de Monaco, Christian Fouquet, fondateur des *Amis de Peynet* à Reims, Monsieur Goujon, conservateur du Musée Peynet à Antibes, Georg Okrusch de Rosenthal et Herr Siemen du Musée de Deutsches Porzellan.

Mes remerciements pour leur aide précieuse aux collectionneurs Kate et Chris Barber, et Stéphane Steeman à Bruxelles ainsi qu'aux antiquaires John Clark, John Jesse et Dave Simmons.

Merci enfin à Monica Renaudo, Sally Tuffin, Gill Hunt, Wendy Wort et à l'équipe de Flaydemouse.

A.R.

Raymond Peynet, 1926.

Photography by Magnus Dennis

Print, design and reproduction by Flaydemouse, Yeovil, Somerset

Published by Richard Dennis, The Old Chapel, Shepton Beauchamp, Somerset TA19 OLE, England

© 1998 Richard Dennis & André Renaudo

ISBN 0 903685 60 4

British Library Cataloguing-in-Publication Data. A catalogue record for this book is available from the British Library

CONTENTS
TABLE DES MATIERES

PREFACE

J'ai passé une partie de ma vie avec un dessinateur célèbre, sans bien m'en rendre compte, car Peynet était avant tout mon père. Dans mon enfance, il était très présent, car il travaillait à la maison. Je pouvais le voir travailler, dessiner, redessiner, n'étant jamais satisfait: pour un détail il recommençait le dessin qui devait paraître le lendemain dans le journal – la corbeille à papier peut en témoigner!

Plus tard j'ai compris qui était mon père, le célèbre dessinateur des *Amoureux*. J'en étais fière. J'ai vu le poète, non seulement dans le dessin mais aussi dans la vie. Ma mère était sa secrétaire, sa muse comme il aime le rappeler; ce sont eux en fait les véritables *Amoureux de Peynet*.

Il y a quelques mois j'ai rencontré André Renaudo et Richard Dennis qui avaient un projet de livre sur mon père très séduisant mais complètement fou. Réunir tout ce que Peynet avait fait dans sa vie de dessinateur, avec un crayon, une plume, des tubes de couleurs etc., enfin réunir 65 ans d'une vie. Beaucoup de dessins m'étaient inconnus, ainsi que les dates ou les sujets pour lesquels ils avaient été créés...

Il a fallu chercher, chiner et bien sûr trouver; grâce à la tenacité d'André et de Richard ce livre a pu voir le jour et je les en remercie.

Annie Druet-Peynet
Biot, 1997

FOREWORD

A part of my life was spent with a famous illustrator without being fully aware of it because, above all, Peynet was my father. During my childhood, he was always there because he worked at home. I was able to watch him work, drawing and re-drawing, as he was never satisfied; over the merest detail, he would begin again an illustration which was due to appear in a newspaper the following day – the wastepaper basket was witness to this!

Later, I understood who my father was – the famous creator of *The Lovers*. I was proud of it. I saw the poet, not only in the drawings, but also in reality. My mother was his secretary and, as he likes to recall, his inspiration. They were in fact the true *Peynet Lovers*.

A few months ago, I met André Renaudo and Richard Dennis who had the idea to publish a book about my father's work. This project was very seductive but seemed completely crazy; to gather everything that Peynet had designed in his life as an artist, with a pencil, a pen, tubes of colours, etc. In short, to put together sixty-five years of a life's work. Information about many drawings, dates, subjects and commissions, were unknown to me.

We had to work hard, search and eventually find the material, and due to the tenacity of André and Richard, this book has seen the light of day and I thank them.

Annie Druet-Peynet
Biot, 1997

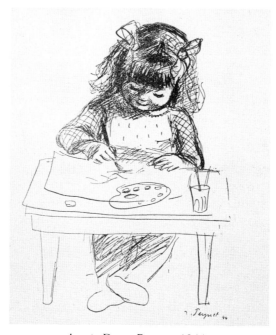

Annie Druet-Peynet, 1944.

RAYMOND PEYNET

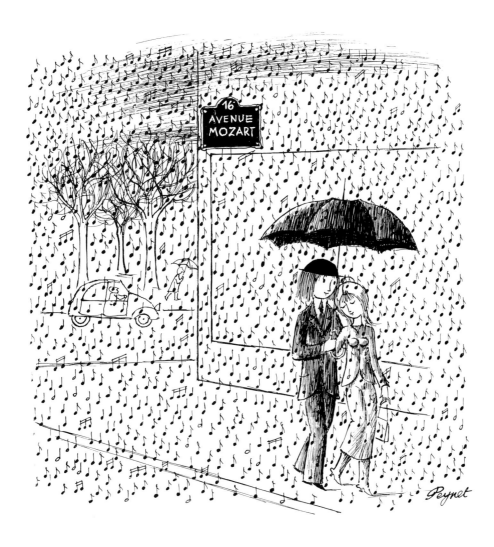

Peynet's Lovers *Les Amoureux de Peynet* were household names in France in the 1950s and 1960s. They had a universal appeal – a charming, carefree, simple way of communicating and amusing people. Peynet's drawings appeared in the most popular newspapers and magazines in the country. Postcards and dolls of the *Lovers* were on sale everywhere. Porcelain plates, vases and figurines, as well as silk scarves and handkerchiefs, were produced and had great commercial success. His anthologies of humorous drawings were very popular and were translated all over the world. These drawings were an unmistakable depiction of France in that period, often showing the town square with its bandstand, and kissing couples on the public benches. The background architecture was often from Paris, the Côte d'Azur and, particularly, Antibes where he spent much time and to where he eventually retired. Peynet's drawings conveyed love and peace – a sweet, kind-hearted and poetic, if slightly bourgeois, romantic couple, at times slightly titillating but always amicable and peaceful and, above all, very French.

Raymond Peynet was born on the 16th November, 1908, in a house on the Quai de Passy in Paris. His parents moved to Paris from the Puy de Dôme area in the

Les Amoureux de Peynet étaient extrèment populaires en France au cours des années 50 et 60. Ils avaient un charme séduisant universel et une façon simple et poétique de communiquer avec tout le monde. Les dessins de Peynet apparaissaient régulièrement dans les journaux et magazines les plus populaires du pays. Les cartes postales et les poupées étaient vendues partout et des assiettes, vases et figurines en porcelaine ainsi que des mouchoirs et des foulards de soie avaient également un gros succès commercial. Ses livres, sortes d'anthologies humoristiques dessinées, étaient très populaires, ils furent traduits en plusieurs langues et se vendirent dans le monde entier. Ses dessins représentaient, sans erreur possible, la France de cette époque – le décor était souvent un parc avec un kiosque à musique, des bancs publics occupés par des amoureux et l'atmosphère faisait souvent penser à Paris ou à la Côte d'Azur et particulièrement à Antibes où Peynet passait beaucoup de temps et éventuellement prit sa retraite. Les dessins, parfois d'une légère touche surréaliste, représentaient aussi l'amour et la paix. *Les Amoureux*, étaient un couple charmant, gentil et poétique, sinon parfois un peu bourgeois, même

Auvergne, the central region of France. They were part of a great wave of immigrants from the rural parts of Auvergne looking for a more prosperous future in Paris. Peynet was ten years old when his parents took over the Café de la Grille near the Place de la République – to increase the income from the bar, they also sold timber and coal. The café was often filled with other Auvergnat emigrants and throughout his childhood Peynet maintained a strong connection with his roots – the pleasures of country cooking and good wine would stay with him all his life. His parents dreamed that one day he would be the owner of a great brasserie, but the closest he came to this was later in life, when he became a Grand Officier du Tastevin, a Chambellan du Champagne and a Compagnon du Beaujolais.

Peynet had an ordinary childhood. He attended the local school where he practised his humorous drawings in the margins of exercise books and drew imaginary posters. His enthusiasm for drawing was sufficient to persuade his parents to send him to the Ecole des Arts Appliqués where he learned the technique of drawing and where he received his diploma from one of the famous Lumière brothers. His first job was with Tolmer, an advertising agency for whom, amongst other work, he designed labels for a parfumerie. At eighteen, Peynet met the girl with whom he was to fall in love. Five years older than him, the very appropriately named Denise Damour, was a jewellery maker. They married in 1930 and she became his

Raymond Peynet, 1928.

romantique et émoustillant mais toujours aimable, paisible et surtout très français.

Raymond Peynet est né à Paris dans une maison sur le Quai de Passy le 16 novembre 1908. Ses parents étaient arrivés à Paris du Puy de Dôme en Auvergne. Ils faisaient partie d'une grande vague d'immigrants vers la capitale venue des régions pauvres du centre de la France et cherchant un avenir plus prospère à Paris. Peynet avait dix ans quand ses parents ouvrirent le Café de la Grille près de la Place de la République. Afin d'augmenter la rentabilité du bar, ils vendaient aussi du bois et du charbon. Le café était souvent plein d'autres émigrants auvergnats et à travers toute son enfance, Peynet put maintenir un contact fort avec ses racines – la cuisine du Terroir et les plaisirs de la bonne table et du bon vin resteront toujours chez lui. Ses parents avaient rêvé qu'un jour Raymond serait le patron d'une grande brasserie: le plus proche qu'il y parviendrait serait que plus tard dans sa vie, il allait devenir un Grand Officier du Tastevin, un Chambellan du Champagne et un Compagnon du Beaujolais.

Peynet eut une enfance ordinaire. Il allait à l'école du quartier, peut-être en remplissant la marge de ses cahiers avec des dessins humoristiques ou en créant quelques affiches imaginaires et magiques. Toujours est-il que ses parents voyant peut-être naître un talent chez Raymond, décidèrent de l'inscrire à l'Ecole des Arts Appliqués où il put apprendre la technique du dessin. Quelques années plus tard il reçut son diplôme qui lui fut présenté par l'un des frères Lumière.

Peynet commença à travailler pour l'agence de publicité Tolmer où, entre autres, il dessinait des étiquettes de parfum. A l'âge de 18 ans, Peynet rencontra la fille dont il allait tomber amoureux. Elle fabriquait des bijoux et elle habitait dans un appartement de l'immeuble au dessus du café de ses parents. Elle avait cinq ans de plus que lui et avait le nom prédestiné de Denise Damour. Ils se marièrent en 1930 et elle devint son inspiration, son confort, son soutien, sa secrétaire, sa femme et sa compagne pour le reste de sa vie. Denise était forte de caractère et elle avait confiance dans les talents de Raymond et eut une grosse influence sur son oeuvre.

La vie était très agréable à cette époque dans leur petit appartement de la Rue Compans dans le 19ᵉ à Paris. Les Peynet recevaient souvent des amis à dîner et Raymond, qui aimait les représentations théâtrales se déguisait souvent ainsi que ses amis pour jouer des petits sketchs impromptus.

Pendant qu'il travaillait dans la publicité, Peynet produisait aussi des dessins humoristiques et il réussit un jour à faire publier un de ses dessins dans une revue pour les anglais qui vivaient à Paris: *The Boulevardier*. Plus tard d'autres dessins apparurent dans certaines revues telles que *A Nos Amours* et *Le Rire*. Avec Denise et un autre dessinateur, ils décidèrent d'ouvrir leur propre agence et se mirent à produire des encarts

inspiration and comfort, his support and secretary, his housewife and companion. A strong personality, Denise had total confidence in Raymond's talent as a graphic artist and greatly influenced his work. Life was fun in their little flat in the Rue Compans, Paris, and the Peynets enthusiastically observed anniversaries and special occasions by entertaining friends for whom Denise would cook celebratory meals. Raymond enjoyed theatrical performances and, together with friends, would often produce small, impromptu sketches.

While working in the publicity business he also produced humorous drawings and was published in *The Boulevardier*, a magazine for English people living in Paris, and in other reviews including *A Nos Amours* and *Le Rire*. Peynet and Denise, together with another designer, opened their own agency producing display advertisements and Peynet began designing sets for the Theatre de la Huchette, one of the smallest theatres in Paris. He also illustrated various books by, amongst others, Musset, Labiche and Anouilh.

In 1938 their only child, Annie, was born. The following year World War II broke out and the Peynets closed their agency and moved out of Paris. They went back to Raymond's roots in the Auvergne, in Vichy's unoccupied free France. There he became a war correspondent and worked in Clermont Ferrand for Max Favalelli, then chief editor of a review called *Ric et Rac*. In the late spring of 1942 Peynet went to Valence in the Rhône Valley for a meeting with a fellow correspondent and had to wait until the next day for transport back to Clermont Ferrand. He decided to spend the night sleeping on a park bench facing the bandstand and, in the quietness of the early morning, began to draw the scene. He recalled later:

"I was seated on a bench in Valence and drew the bandstand in front of me, with a little violinist playing all alone on the stage and a petite lady listening to him and waiting for him. You could also see the other musicians who, having put their instruments back in their cases, were leaving the park. The caption read: 'Feel free to go. I'll finish on my own.'"

Peynet titled his drawing *La Symphonie Inachevée*, The Unfinished Symphony, and sent it to Max Favalelli who, later, with the addition of the 'petite lady', published it under the title, *Les Amoureux de Peynet* – Peynet's Lovers. In the 1970s the city of Valence preserved the bandstand in his honour and it became listed as an Historical Monument and was named The Peynet Bandstand.

Raymond, Denise and their daughter, Annie, returned to Paris at the end of the war in October 1945. He resumed his work, publishing his drawings in newspapers and reviews, as well as illustrating books and designing theatre sets. The Peynets lived in a small apartment and Annie recalls that her father used one of the only two main rooms in the flat as his studio – he needed to concentrate, so often she had to be quiet when she came home from school. Peynet worked very hard taking on

Raymond Peynet (left) entertaining friends at home, Paris, 1931.
Raymond Peynet (à gauche) avec un copain chez lui, Paris, 1931.

publicitaires. Peynet commença à dessiner des décors pour le Théâtre de la Huchette, l'un des plus petits théâtres parisiens ainsi qu'à illustrer plusieurs livres de Musset, Labiche et Anouilh parmi d'autres.

En 1938, leur seule fille Annie est née. L'année suivante quand la guerre éclata, les Peynet fermèrent leur agence et quittèrent Paris. Ils allèrent vivre en Auvergne, une sorte de retour aux racines, dans la France non-occupée de Vichy. Peynet devint alors un correspondant de guerre et il travailla avec Max Favalelli qui était alors rédacteur en chef d'une revue intitulée *Ric et Rac* à Clermont Ferrand.

Vers la fin du printemps de 1942 quelque chose d'exceptionnel allait se produire: Peynet devait aller à Valence dans la Vallée du Rhône pour rencontrer un autre correspondant. Après avoir fini son travail, il devait attendre le lendemain pour prendre le prochain car et décida de passer la nuit sur un banc dans un jardin public en face d'un magnifique kiosque à musique. A son réveil, dans la tranquillité et la douceur du petit matin, Peynet commença à dessiner le kiosque et laissa courir son imagination. Plus tard il dira:

"Assis sur un banc, j'ai dessiné le kiosque qui se trouvait devant moi, avec un petit violoniste qui jouait tout seul sur l'estrade et une petite femme qui l'écoutait et l'attendait. On voyait aussi tous les musiciens qui, ayant rangé leurs instruments dans leurs étuis, s'en allaient dans le parc de Valence. Dans la légende, le petit musicien disait: "Vous pouvez partir tranquille, je terminerai tout seul".

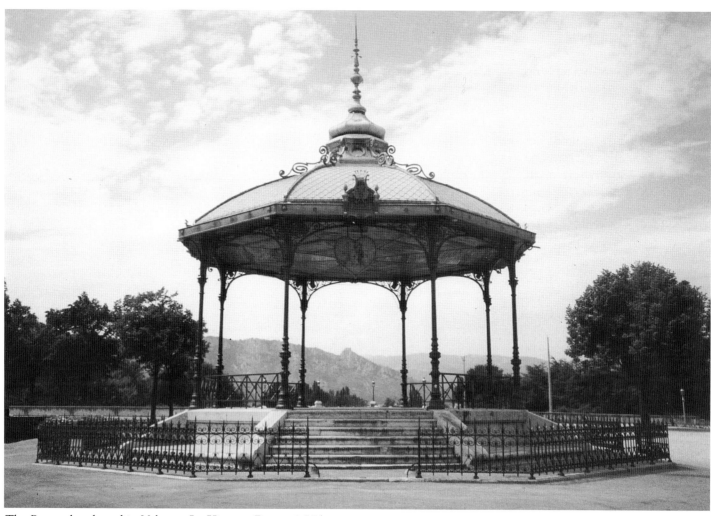

The Peynet bandstand in Valence. **Le Kiosque Peynet à Valence.**

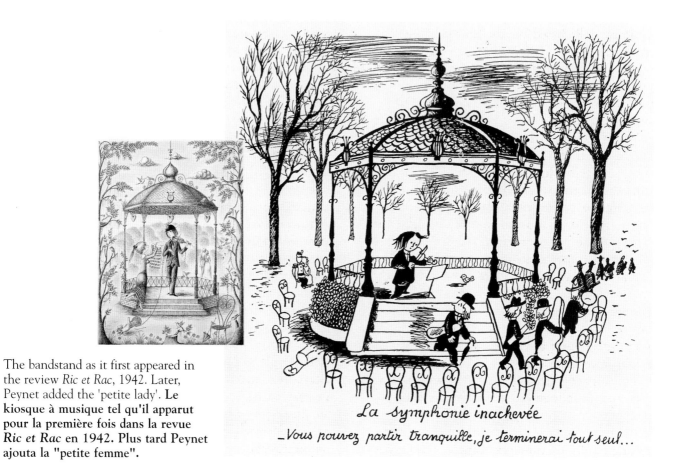

The bandstand as it first appeared in the review *Ric et Rac*, 1942. Later, Peynet added the 'petite lady'. **Le kiosque à musique tel qu'il apparut pour la première fois dans la revue *Ric et Rac* en 1942. Plus tard Peynet ajouta la "petite femme".**

La symphonie inachevée

—Vous pouvez partir tranquille, je terminerai tout seul...

practically all the work that came his way and Denise gave him her constant support by surrounding him with all the comfort and encouragement she could provide.

The Peynets were on a summer holiday in Provence in 1947 and, when visiting Antibes and the surrounding area, fell in love with an old Saracen tower with its own ramparts in nearby Biot. They bought and gradually restored it, returning during school holidays throughout the year, especially at Easter and in the summer.

Peynet decided to develop the characters of *The Lovers* and this marked the beginning of a career of great inventiveness. The thin man with long, straight hair, immaculately dressed in his tight suit and bowler hat, was a gentle, friendly, poetic figure, aspiring to very sensitive feelings of love as well as lust and humour. Usually ponytailed and thin-waisted, the woman, while perfectly demure and modest, was always responsive to the needs of her lover. At times the pair were almost surreal but they remained attractive in a coy, reserved and simple way. There is a clear parallel between the little poet and his petite lady and the image Peynet had of the relationship between himself and Denise. He saw himself as the poet but using drawings, rather than words, as his means of expression and, to him, Denise was the exact representation of the poet's lady-love.

From the early fifties, Peynet succeeded in promoting his two lovers throughout the world. They regularly appeared in numerous series of drawings in the press and magazines such as *Elle, Ici Paris, Paris Match, Marie France,* etc. He produced publicity posters for, amongst many, Air France, the Galeries Lafayette, the Loterie Nationale, and film studios. In the early 1950s, Peynet created a series of three-dimensional dolls based on the characters of *The Lovers,* paying the utmost attention to every aspect of their design, from their hair to their costumes. Eventually there were over 200 different designs of the couple and the dolls went on to sell in their millions. Simultaneously, a series of over 140 postcards of colour photographs of these dolls was produced. Peynet had a real passion for costumes and even selected most of Denise's clothes. He was fastidious over design, colour, fabric and fit, and this attention to detail motivated him to have a close involvement in the design and production of the dolls and their costumes. His love of costumes and his abiding interest in the theatre led to frequent work in costume design and scenery. Peynet continued to design publicity material such as chocolate boxes, tea packets, wine labels and so forth.

Since his return to Paris at the end of the war, Peynet signed all his work ∿ Peynet. This squiggle in front of his name was a small R for Raymond. However, in 1952, Hélène Lazareff, the editress of *Elle* said to him, "When you are Peynet, you don't need a bit of spaghetti in front of your name" and, from then on, all his work was simply signed, Peynet.

Les Amoureux were a great success all over France and gradually, during the 1950s, throughout the world. Peynet

Peynet intitula son dessin *La symphonie Inachevée* et l'envoya à Max Favalelli qui l'aima beaucoup. Plus tard, Peynet ayant ajouté "la petite femme", il le publia avec le titre *Les Amoureux.* Dans les années 1970, la ville de Valence décida de préserver le kiosque à musique, d'en faire un monument historique et de le nommer *Le Kiosque Peynet.*

Raymond Peynet, Denise et leur fille Annie retournèrent à Paris en Octobre 1945, après la fin de la guerre. Peynet reprit son travail et publia ses dessins dans des journaux et des revues. Il illustra aussi plusieurs livres et créa des décors de théatre. Les Peynet vivaient dans un petit appartement et Annie se souvient que pendant son enfance, quand elle rentrait de l'école, elle ne devait pas faire de bruit car son père travaillait dans l'une des deux pièces principales. Peynet acceptait tous les travaux qui se présentaient à lui et il pouvait dessiner constamment, grâce au confort et à l'encouragement dont Denise l'entourait.

Pendant l'été de 1947, alors que les Peynet étaient en vacances en Provence et qu'ils visitaient Antibes et la région, ils tombèrent amoureux d'une ancienne tour Sarrazine avec ses propres ramparts dans le petit village de Biot. Ils l'achetèrent et peu à peu la restaurèrent d'année en année, au cours de leurs séjours réguliers, au rythme des vacances scolaires, surtout à Pâques et pendant les grandes vacances.

Peynet décida de développer *Les Amoureux* et cette décision allait marquer le départ d'une grande carrière pleine d'invention et de succès. L'amoureux, mince, toujours très élégant, les cheveux raides, longs et noirs, coiffé d'un chapeau melon, était un gentil petit poète, aimable, très sensible aux sentiments de l'amour, du désir et bien sûr toujours plein d'humour. L'amoureuse, portant habituellement une queue de cheval et à la taille fine, était parfaitement posée mais toujours sensible aux besoins de son amant. Parfois ces amoureux semblaient devenir irréels mais ils gardaient toujours un côté assez timide et réservé, ce qui les rendaient pratiquement irrésistibles au public. Il est assez facile de sentir ici un parallèle entre les personnages du petit poète et de sa muse avec la vision qu'avait Peynet de lui-même, de Denise et de leur amour mutuel. Lui, était le poète dont les dessins étaient le moyen d'expression et Denise était la représentation exacte de la petite femme qui l'accompagnait.

A partir du début des années 50, Peynet réussit à faire connaître ses deux amoureux au monde entier. Ils apparaissaient régulièrement en séries de dessins dans des journaux et des revues telles que *Elle, Ici Paris, Paris Match, Marie France* et sur des affiches de publicité pour Air France, les Galeries Lafayette, la Loterie Nationale ainsi que sur des affiches de cinéma. A cette époque également, Peynet commença à produire une série de poupées, dessinant chaque costume individuellement. Ceci bien sûr entrait dans le cadre de son intérêt pour la production de décors et de costumes

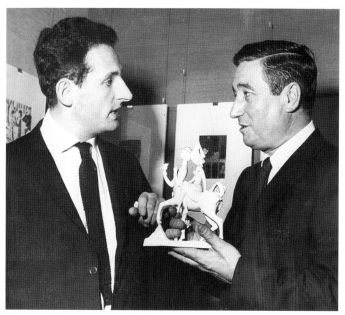

From right: Peynet and the Marquis of Queensberry at the Rosenthal Exhibition, Old Brompton Road, London, 1962.
De droite à gauche: Peynet et le Marquis de Queensberry à l'Exposition de Porcelaines de Rosenthal, Londres, 1962.

was approached by Murat, the jewellers, for permission to use his characters on golden hearts, brooches, pendants and rings. The silk company, Baccara of Lyon, offered to produce high-quality scarves and handkerchiefs and the Bavarian porcelain manufacturers, Rosenthal, invited Peynet to their factory in Selb to produce a series of designs for three-dimensional figurines, plates, vases, bowls, candlesticks, and cigarette holders etc. From 1953 and for the following ten years, Peynet paid regular visits to the Rosenthal empire where he worked with, and decorated shapes created by, the modernist designers of the times, Bjorn Wiinblad, Tapio Wirkkala, and Raymond Loewy who had become famous in the United States for designing the Lucky Strike cigarette packet and Studdebaker motor cars.

Peynet continued designing wine and champagne labels, all types of posters, restaurant menus and even a pack of playing cards – he rarely refused a new project and his output was prolific. His books were published in England by Perpetua and during that time he struck up a friendship with Kaye Webb, who ran the publishing company, and her husband, the artist and humourist, Ronald Searle.

During one of the many wine-tasting banquets they attended, Raymond and Denise became friendly with Roland Bouchacourt a wine producer in the Juliénas Beaujolais region. As a Compagnon du Beaujolais, Peynet became a frequent visitor to the vineyards where, among the merry gathering of Beaujolais afficionados, he met the actor, Lino Ventura. Raymond agreed to design a label for the St. Amour wine and this label is still used, once a year, to celebrate St. Valentine's Day. Monsieur Bouchacourt recalls what a united couple Raymond and Denise were,

de théâtre, qu'il menait toujours à bien par ailleurs. Peynet était extrêmement attentif aux détails. Dans son style particulier il était très exigeant sur la couleur, le tissu et la coupe. Il en arrivait même très souvent à choisir les vêtements que portait Denise. C'est pourquoi il avait un contrôle total sur la production des poupées et de leurs costumes. Eventuellement plus de 200 poupées furent créées et des millions en furent vendues. Une série de carte postales représentant ces poupées se vendait aussi très bien.

Peynet était maintenant très demandé et il dessinait toujours du matériel de publicité tel que des boîtes de chocolat, des paquets de thé, des étiquettes de bouteilles de vin et des affiches. Peynet avait toujours signé ses oeuvres " ∿ Peynet" avec le petit R devant son nom. Un jour en 1952, Hélène Lazareff, rédactrice de *Elle* lui dit: "Quand on est Peynet, on n'a pas besoin de mettre un morceau de spaghetti devant son nom". A partir de ce moment-là toute son oeuvre fut signée Peynet.

Les Amoureux avaient maintenant un grand succès dans toute la France et pendant les années 50 ce succès sortit des frontières. Murat, le bijoutier, demanda à Peynet de dessiner des bijoux avec *Les Amoureux*. La compagnie Baccara, soyeux à Lyon, proposa de faire des mouchoirs et des foulards; les Porcelaines Rosenthal en Allemagne invitèrent Peynet à travailler à Selb en Bavière, en compagnie des grands stylistes de l'époque, afin de reproduire *Les Amoureux* sur assiettes, vases, bols et même d'en faire des figurines en porcelaine de haute qualité. L'un de ces stylistes, Raymond Loewy, comme Peynet, était sorti de l'Ecole des Arts Appliqués

Peynet at Rosenthal, 1955.
Peynet chez Rosenthal, 1955.

and he treasures his collection of menus and greetings cards dedicated to him by Peynet with his humorous, and sometimes personal, innuendos.

In 1957 Queen Elizabeth II made her first official visit to Paris and, to commemorate the occasion, she was presented with a box containing a 3-D map of Paris with Peynet dolls representing the different areas of the city. Peynet was commissioned to paint frescoes and murals in France and Italy. He designed television sets, a games room on a French steamer ship, the bar in an Air France Boeing and shop window displays for Galeries Lafayette in Paris. In 1958 he designed the Urbanism stand at the Brussels World Fair and, during this period, also designed more than twenty record covers. During the 1960s, he was asked to design the menu for the wedding feast of Margrette, the Queen of Denmark. In an attempt to develop his artistic talent beyond the confines of *The Lovers* theme, Peynet started to produce lithographs, illustrated more books and also painted pictures of great quality. In 1967 his daughter, Annie, now married, moved into the house in Biot, and Raymond and Denise continued to visit for holidays. Peynet gave this house to his daughter in 1977, choosing to stay in a more comfortable flat in nearby Antibes.

By the late 1970s, in keeping with changing times and fashions, attention was focused on his book illustrations and lithographs. However, *The Lovers* remained popular and, in 1975, an animated feature film entitled *Around the World with Peynet's Lovers* was produced in Italy, with music by Enio Morricone. In 1985 a special 2F10 stamp featuring *The Lovers* was issued by the French Post Office

Peynet with the stand he designed for the 1958 Brussels World Fair.
Peynet au stand de l'Urbanisme qu'il créa pour la Foire Internationale de Bruxelles, 1958.

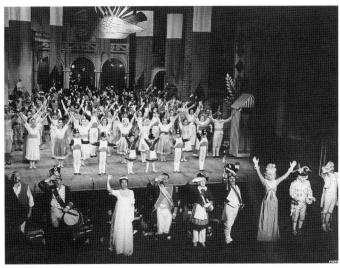

The Daughter of the Drum Major. A theatre production in Avignon with sets and costumes by Peynet, c.1960.
La Fille du Tambour Major. **Pièce de théâtre à Avignon. Décors et costumes de Peynet, c.1960.**

à Paris. Loewy avait émigré aux Etats-Unis où il avait acquis une certaine renomée, particulièrement comme créateur du paquet de cigarettes Lucky Strike et dessinateur de l'automobile Studdebaker, tout en travaillant longtemps pour Coca-Cola.

Ses livres commençaient à être publiés en plusieurs langues et se vendaient beaucoup en Allemagne, en Belgique, en Italie, en Angleterre et au Japon.

Peynet travaillait beaucoup et refusait rarement un nouveau projet. Il continuait à faire des affiches, des menus et des cartes de voeux ainsi que des encarts publicitaires de toute sorte. Il illustra même un jeu de cartes.

En 1957, on offrit en cadeau à la Reine d'Angleterre, en visite officielle en France, une boîte représentant les différents quartiers de Paris et garnie de poupées de Peynet.

Producteur de vins en Beaujolais, Monsieur Roland Bouchacourt rencontra Raymond et Denise à l'occasion de cérémonies du Tastevin et devint leur ami. Peynet qui était un Compagnon du Beaujolais, accepta de dessiner une étiquette pour le vignoble de St. Amour. Cette étiquette est toujours utilisée une fois par an, pour célébrer la Saint Valentin. Lino Ventura faisait également partie de ce groupe de joyeux passionnés du Beaujolais. Monsieur Bouchacourt se souvient à quel point Raymond et Denise formaient un couple uni; il garde soigneusement sa collection de menus et de cartes que Peynet lui dédia de façon très amusante et très personnelle.

On demanda à Peynet de peindre des fresques en France et en Italie, de créer une salle de jeux sur un paquebot, un bar sur un Boeing d'Air France et de décorer les vitrines des Galeries Lafayette à Paris. En 1958, Peynet dessina le stand de l'Urbanisme à la Foire Internationale de Bruxelles. Pendant cette période

for St. Valentine's day and twelve million stamps were sold in the first month.

In 1980 Raymond and Denise Peynet decided to leave Paris and retire to Antibes. He continued working mostly on lithographs which were produced in editions of 250. He enjoyed the challenge of working on a larger format with the use of colour. In 1989 he donated a collection of almost three hundred works to his adoptive home town of Antibes and today these are housed in what is now the Musée Peynet near the plane trees on the Place Nationale. Also displayed in its open-plan spacious rooms, are some examples of lesser-known aspects of the artist's career: stage sets, costumes, scupltures born from the sea, and a short film about his life.

In 1995, to celebrate the fiftieth anniversary of the end of the war in the East, a life-size bronze statue representing *The Lovers* was inaugurated in Hiroshima as a symbol of love and peace, and their daughter, Annie, represented the Peynets at the ceremony. Japan prides itself on having the only other Peynet Museum in the world at Karuizawa where another bronze statue of *The Lovers* stands at the entrance. A third statue made of marble is situated in a park in Sakuto-Sho.

Peynet ceased working in 1994 and on the 3rd November, 1996, Denise Peynet died, aged ninety-two. Raymond was grief stricken over the death of his wife and he moved to nearby Mougins on the Côte d'Azur. Since the beginning of the nineties Annie Druet-Peynet has managed her father's estate from her home near Antibes.

Peynet's 'Golden Years' spanned the period from around 1952 to 1975 and during that time he established

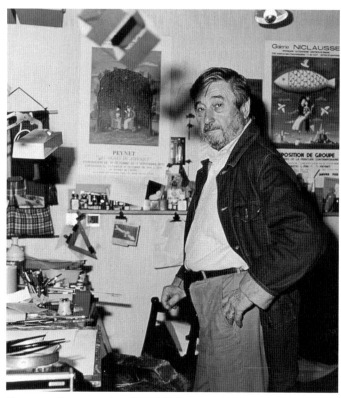

Peynet at home in Antibes, 1985.
Peynet chez lui à Antibes, 1985.

également, Peynet dessina plus de 20 pochettes de disques et Marcel Amont enregistra même une chanson intitulée "Les Poupées de Peynet". Plus tard Georges Brassens admettra qu'il avait écrit sa chanson *Bancs Publics* inspiré par *Les Amoureux*. On demanda même à Peynet de dessiner le menu pour le banquet du mariage de Margrette, la reine du Danemark.

Peynet commença aussi à produire des lithographies qu'il tirait en moyenne à 250 exemplaires. Elles lui permirent d'utiliser ses talents d'artiste, car il peignait très bien, aussi bien à la gouache qu'à l'huile.

En 1967, sa fille Annie, maintenant mariée, vint vivre à Biot dans la maison familiale des Peynet et Raymond et Denise continuèrent à y venir souvent. Dix ans plus tard, Peynet donna cette maison à sa fille, choisissant d'acheter un appartement plus confortable à Antibes. Vers la fin des années 70, avec le changement de mode, Peynet accentua ses efforts dans la production de nouvelles lithographies et d'illustrations de livres.

Cependant *Les Amoureux* attiraient toujours la demande du public. En 1975, un film de long-métrage fut produit en Italie: *Le Tour du Monde des Amoureux de Peynet* avec une musique de Enio Morricone. Un timbre-poste de 2F10 figurant les *Amoureux de Peynet* fut issu par La Poste pour la Saint Valentin et se vendit à près de 12 millions d'exemplaires dans le premier mois.

En 1980 Raymond et Denise Peynet décidèrent de quitter Paris et d'aller vivre à Antibes.

En 1989 Peynet donna à sa ville adoptive une collection de près de 300 oeuvres qui se trouvent maintenant au Musée Peynet, sur la Place Nationale à Antibes. Dans ce spacieux musée, il est très agréable de découvrir aussi quelques objects personnels et moins connus de la carrière de l'artiste, parmi lesquels des décors de théâtre, des costumes, des sculptures et un court métrage sur sa vie.

En 1995, pour célébrer le 50ème anniversaire de la fin de la guerre en Extrême-Orient, une statue de bronze grandeur nature, représentant *Les Amoureux de Peynet*, fut inaugurée à Hiroshima pour symboliser l'Amour et la Paix. Raymond et Denise ne purent s'y rendre et c'est leur fille Annie qui les représenta.

Le Japon est le seul autre pays au monde à posséder un Musée Peynet, à Karuizawa où une seconde statue de bronze des *Amoureux de Peynet* est située à l'entrée.

Il existe au Japon une troisième statue des *Amoureux de Peynet*; celle-ci en marbre, est située dans un jardin public à Sakuto-Sho.

La mort de Denise, survenue le 3 novembre 1996, causa énormément de chagrin à Peynet. Depuis le début des années 90, Annie Druet-Peynet, du haut de la tour Sarrazine de Biot, s'occupe de maintenir la flamme et de diriger les affaires de Peynet. Il habite maintenant près de Mougins sur la Côte d'Azur et ne travaille plus.

Il semble qu'on pourrait dire que l'Age d'Or de la carrière de Peynet s'étend de 1952 à 1975. Pendant cette période il a réussi à établir ses *Amoureux* comme

his *Lovers* as one of the twentieth-century icons of modern France. He received international recognition through this charming creation, but his work in other mediums and themes – his interest in architectural detail, the quality of his easel painting and the versatility of his design – is a testament to his wide-ranging artistic ability. He expressed his humour by playing on the ever-increasing sexual freedom in France and elsewhere during the 1950s and 1960s; and by poking innocent fun, rather than directly attacking the worrying development of urban concretisation. His was a gentle, tender and romantic vision of a world which was rapidly changing.

des icônes de la France du XXe siècle.

Peynet était universellement connu à travers *Les Amoureux* dont il était le créateur, mais son oeuvre globale est le testament de ses nombreux talents.

La qualité du dessin et de la composition démontrent combien il était capable de manipuler les sujets architecturaux et la peinture tout en sachant conserver un sens de l'humour avec ses personnages, car il a été sensible aux changements qu'allait entraîner la libération sexuelle et il a très bien su refléter l'esprit d'une société en pleine évolution.

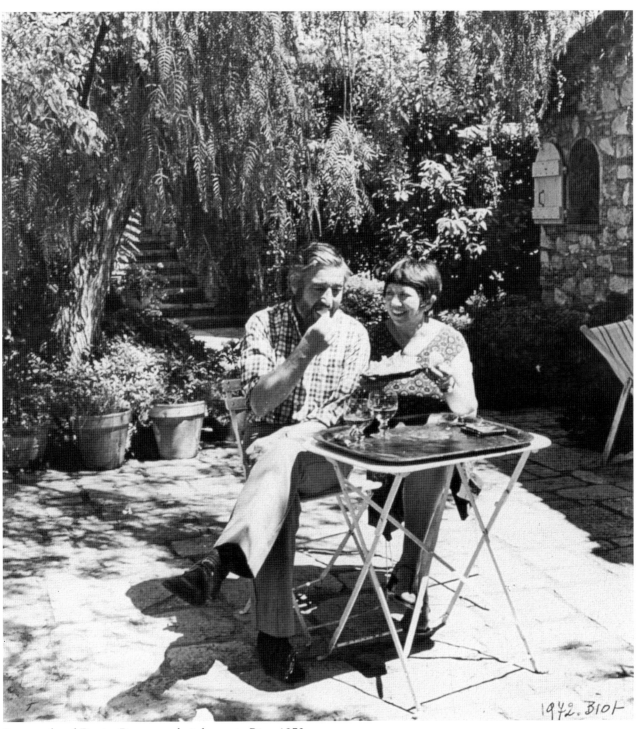

Raymond and Denise Peynet at their home in Biot, 1972.
Raymond et Denise Peynet chez eux à Biot, 1972.

POSTERS

AFFICHES

Apart from the many humorous drawings that Peynet produced for the press and magazines, his largest output was posters. He began drawing them in the 1930s and continued to do so throughout his career – in fact, posters using Peynet's drawings are still produced today. Before the war, commissioning an artist to design a poster was less costly than expensive colour-photographic reproduction and it was for this reason that Peynet began designing posters. However, the escalating popularity of *The Lovers* was the reason for him continuing to do so.

Peynet's posters advertised a wide array of subjects including films, dance nights, St. Valentine's Day, the Galeries Lafayette, the French Railways, the National Lottery, perfumes, cigarettes and tyres.

Peynet was an excellent designer of posters. Trained as a graphic artist, poster design was almost second nature to him. He was extremely conscientious and, as with his limited edition prints, oversaw production and maintained control of many aspects of the printing process. An expert in the techniques of colouring, Peynet was able to advise and guide the printers.

The list of Peynet's posters (see p99) comprises nearly 200 titles and, while it is not wholly complete, it nevertheless conveys the artist's formidable output.

En dehors bien sûr de la multitude de dessins créés par Peynet, les affiches représentent une autre facette de son activité artistique. Les premières affiches furent créées chez Tolmer en 1930, une agence de publicité qui l'employait depuis sa sortie de l'Ecole des Arts Appliqués. Peynet fit des affiches pendant toute sa carrière et ses dessins sont encore utilisés pour en faire de nos jours.

Au début, la photographie coûtait cher, les annonceurs préféraient faire appel à un artiste et c'est ainsi que Peynet débuta. Ses affiches couvrent une vaste série de sujets, de l'affiche de cinéma aux Bals des Grandes Ecoles en passant par les parfums, les Galeries Lafayette, La S.N.C.F., la Loterie Nationale, les cigarettes et les expositions diverses.

Ayant suivi une formation artistique, Peynet composait l'affiche entièrement, titres compris, et il allait souvent chez l'imprimeur pour en surveiller l'impression, ce qu'il fit aussi plus tard avec ses lithographies. La liste qui se trouve à la page 99 nous fait découvrir environ 200 affiches et elle essaie de transmettre une idée de la production de Peynet dans ce domaine. Bien qu'elle risque de ne pas être complète, cette liste a le mérite d'être réaliste, car chacune des affiches cataloguées a été vue par l'auteur.

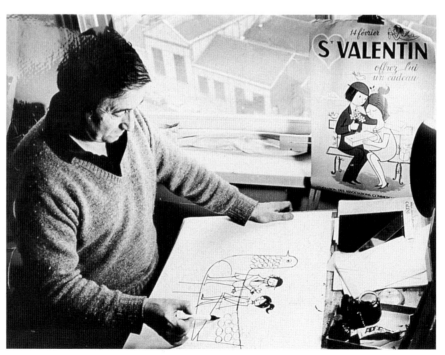

Peynet working in his studio in Paris, 1970.
Peynet au travail dans son atelier à Paris, 1970.

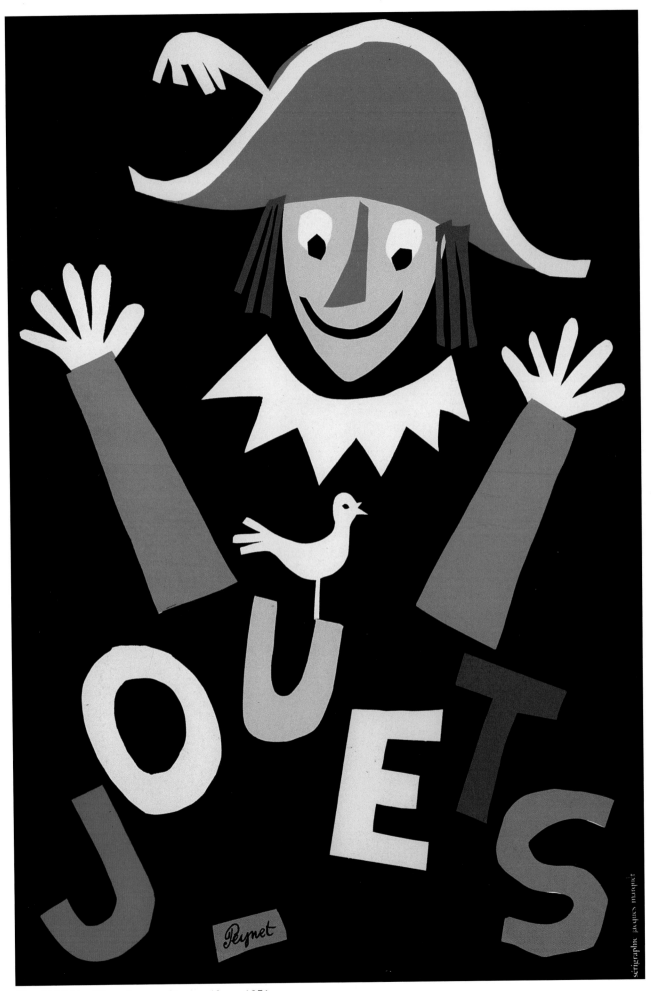

*Toys Exhibition/**Expo Jouets**,* 61cm x 40cm, 1971.

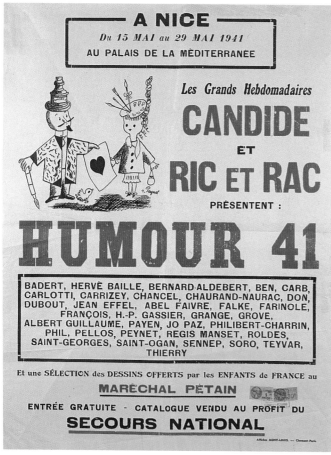

Humour 41, 65cm x 50cm, 1941.

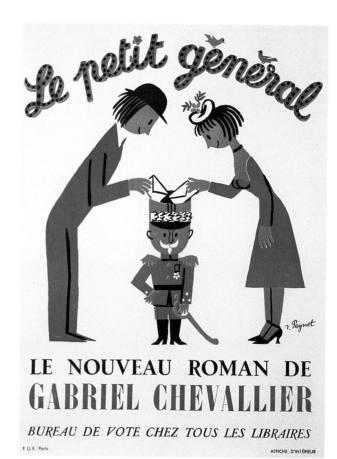

*The Little General/**Le Petit Général**, 70cm x 41cm, c.1950.

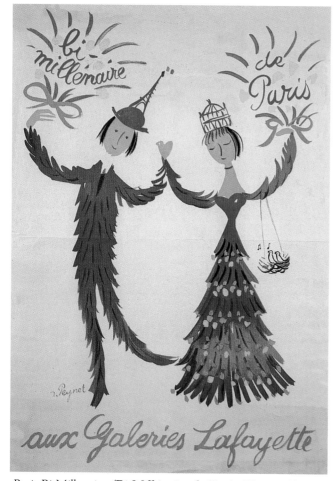

*Paris Bi-Millennium/**Bi-Millénaire de Paris**, 70cm x 48cm, 1953.

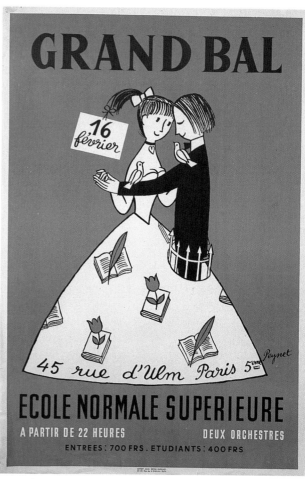

*Grand Ball of the Norm. Sup. School/**Grand Bal de Normale Supérieure**, 60cm x 40cm, c.1950.

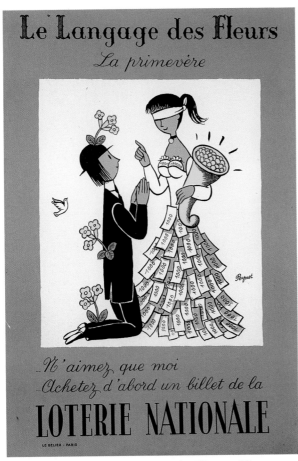

National Lottery/**Loterie Nationale**, 58cm x 37cm, 1954.

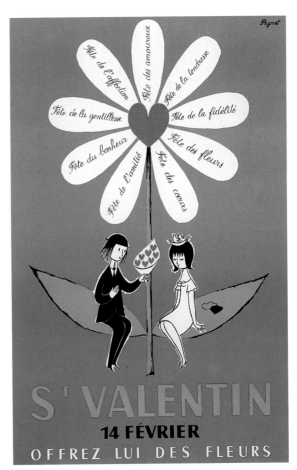

St. Valentine's Day/**St. Valentin**, 60cm x 40cm, c.1950.

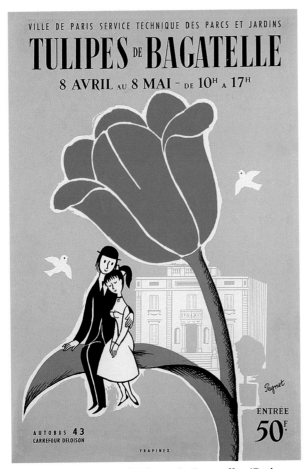

Tulips for a Mere Song/**Tulipes de Bagatelle**, (Parks and Gardens of Paris), 60cm x 40cm, 1955.

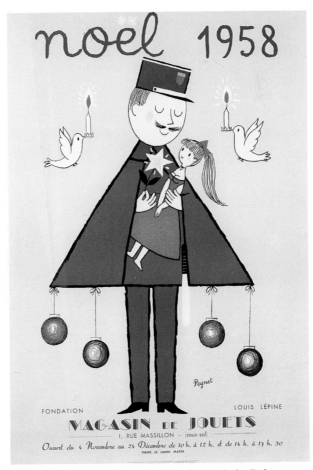

Christmas Greetings from the Police/**Noël de la Police**, 56cm x 39cm, 1958.

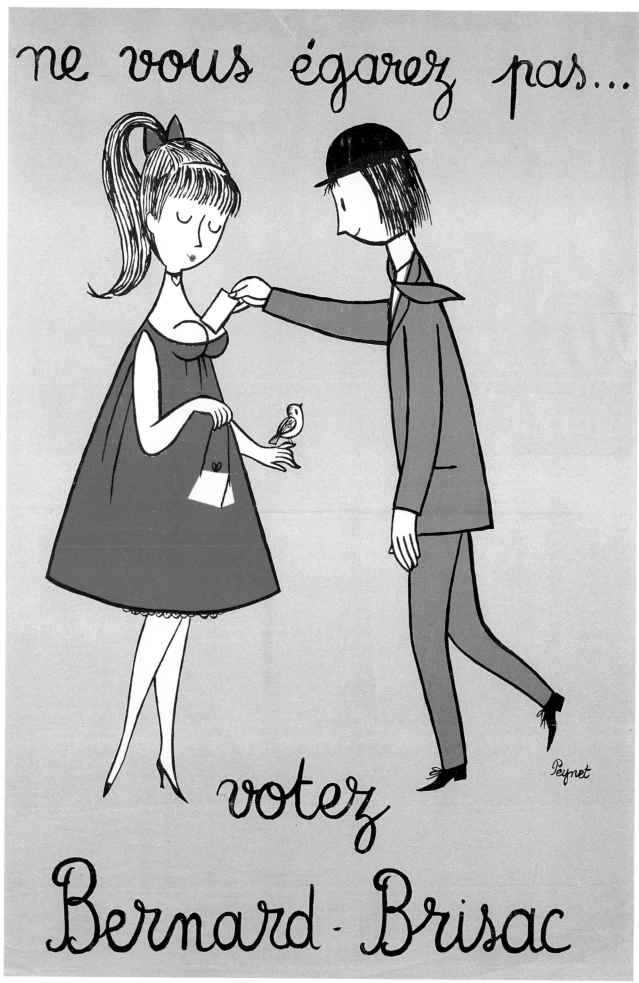

*Vote Bernard Brisac/**Votez Bernard Brisac**, 64cm x 48cm, 1958.

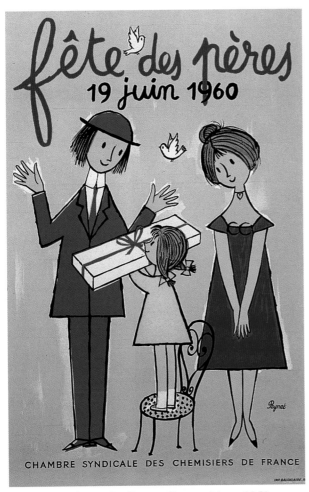

*Father's Day/***Fête des Pères**, 60cm x 44cm, 1960.

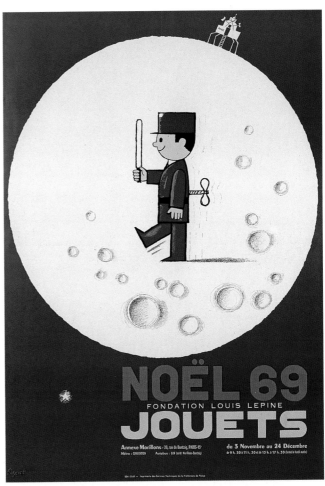

*Christmas 69 Toys – Lépine Foundation/***Noël 69 Jouets –
Fondation Lépine**, 64cm x 46cm, 1969.

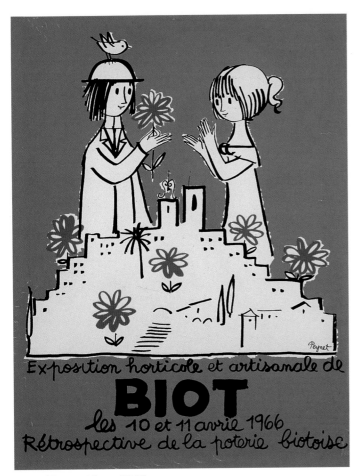

Biot, 65cm x 46cm, 1966.

*Night of the Electronic/***Nuit de L'Electronique**,
(Debutantes Ball), 40cm x 30cm, 1969.

*Kim Cigarettes/**Cigarettes Kim**, 74cm x 50cm, 1970.

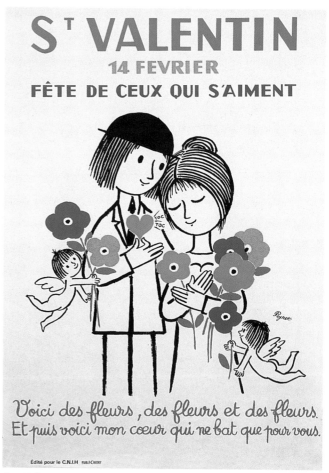

*St. Valentine's Day/**St. Valentin**, 60cm x 40cm, 1971.

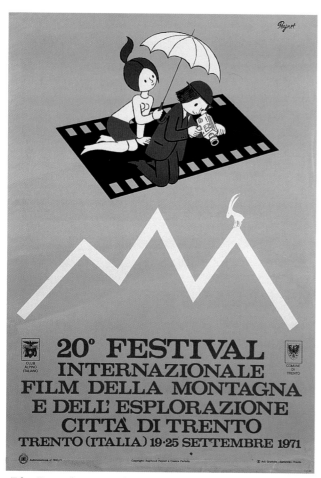

*Film Festival in Trento/**Festival du Film à Trento**, 70cm x 48cm, 1971.

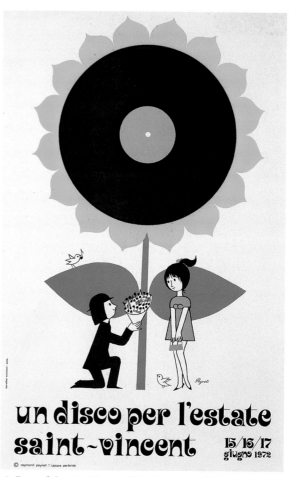

*A Record for St. Vincent/**Un Disco per l'Estate St. Vincent**, (Italian Charity), 70cm x 47cm, 1972.

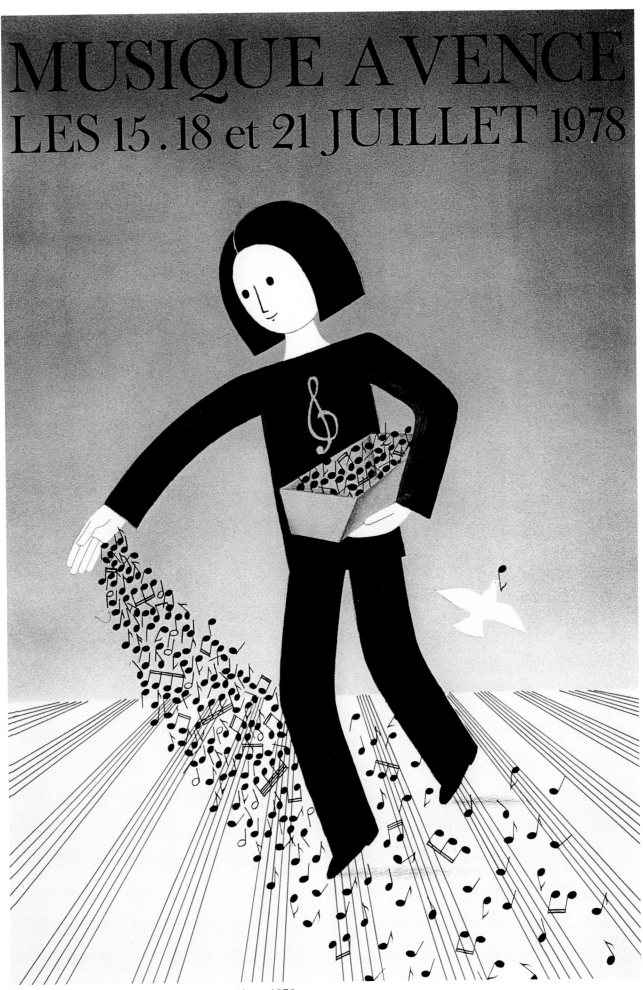

Music in Vence/**Musique à Vence**, 60cm x 40cm, 1978.

Animated film (Italian version): *Around the World with Peynet's Lovers*/**Dessin Animé (version Italie): Il Giro del Mondo Degli Innamorati de Peynet**, 50cm x 29cm, 1975.

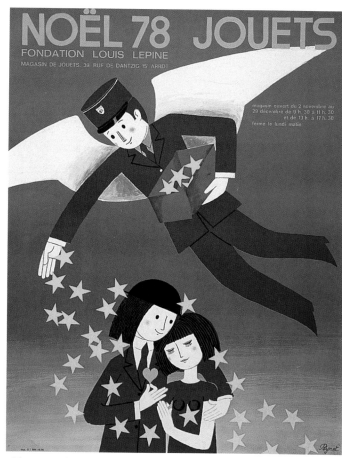

Christmas Greetings from the Police – Foundation Lépine/**Noël de la Police – Fondation Lépine**, 56cm x 43cm, 1978.

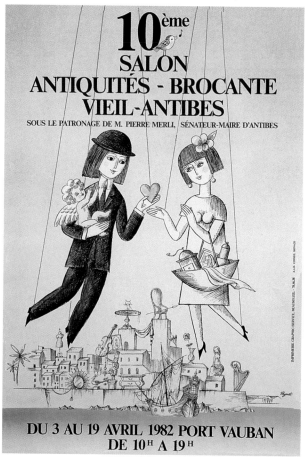

Antique Fair – Antibes/**Salon des Antiquaires – Antibes**, 50cm x 35cm, 1982.

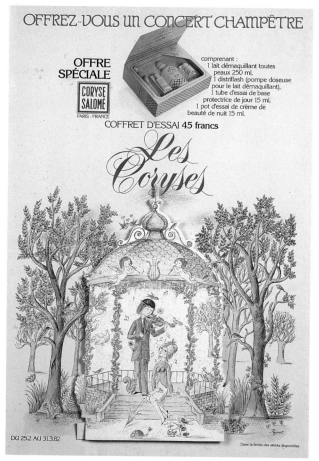

Beauty Products/**Les Coryses – Produits de Beauté**, 48cm x 36cm, 1982.

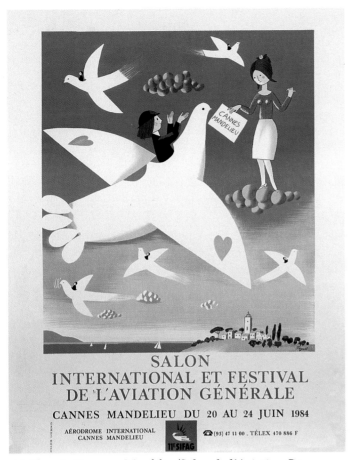

*Air Show in Cannes – Mandelieu/***Salon de l'Aviation Cannes – Mandelieu,** 64cm x 49cm, 1984.

*Stamp Exhibition/***Exposition Philatélique,** 64cm x 36cm, 1985.

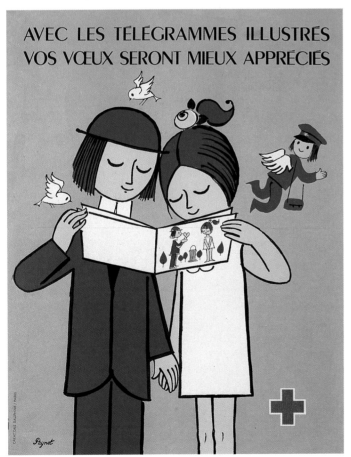

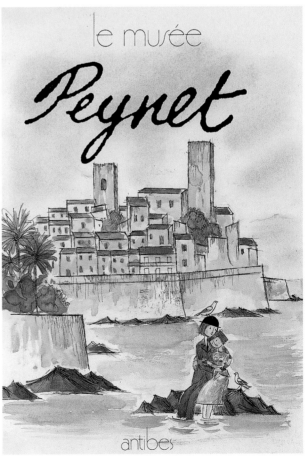

*Illustrated Telegrams – Red Cross/***Télégrammes Illustrés – Croix Rouge,** 60cm x 40cm, 1989.

*Peynet Museum – Antibes/***Le Musée Peynet – Antibes,** 58cm x 40cm, 1989.

BOOKS

LIVRES

In Paris during the 1930s, Peynet was becoming known for his graphic design, publicity material, posters and also for his drawings which were appearing regularly in the press and magazines such as *The Boulevardier, Le Rire, A Nos Amours, La Bataille, Paysage, Candide, Paris Match* etc. Authors and editors became increasingly familiar with the quality of his work.

Peynet's serious involvement with book illustration and cover design began during World War II. Having left Paris with his wife and young daughter to live in the Auvergne in unoccupied free France, Peynet worked for Max Favalelli, the editor of the review *Ric et Rac*. Although this kept him fairly busy, publicity work had diminished since leaving the capital which gave him the opportunity to concentrate on book covers and illustrations. He continued working in this field on his return to Paris after the war and, in the 1950s and 1960s, the great success he had with *The Lovers* led to an increased demand for his books. He began to compile his own books, mostly anthologies of his drawings which, once they had appeared in the press, were used along with additional original drawings, to form a series.

Towards the end of the 1940s the German publishers, Rowohlt, made an agreement with Peynet to publish his books in Germany. His work became so popular he was approached by Philip Rosenthal to produce a series of Peynet designs for his well-known ceramics factory in Bavaria.

There was an international demand for Peynet illustrations and his books were translated into ten languages and published in thirteen countries. This demand appears to be perpetual – a Peynet book was published in Slovenia in 1995. The list of Peynet's books appears on p101.

Dès 1928, Peynet travaillait comme publiciste dans une agence. Parallèlement à cela il faisait des illustrations pour les revues de l'époque: *The Boulevardier, A Nos Amours, Le Rire, Cinémonde*, etc., jusqu'en 1939. S'étant établi avec sa femme Denise et sa fille Annie en Auvergne, Peynet participait à des expositions itinérantes avec d'autres dessinateurs, ce qui lui permit de se faire connaître; de plus il travaillait pour la revue *Ric et Rac* dont le rédacteur en chef était Max Favalelli. Il fit de nombreuses illustrations d'auteurs classiques à cette époque et de retour à Paris en 1945, la demande en augmenta considérablement car *Les Amoureux* venaient de naître. L'éditeur allemand Rowohlt lui proposa de faire un recueil de ses dessins parus dans la presse. Ceci permit à Philip Rosenthal de le rencontrer et de suggérer à Peynet de décorer plusieurs pièces de porcelaine.

Ses livres furent traduits en dix langues différentes et publiés dans treize pays – l'un des derniers est sorti en Slovenie en 1995! La liste des ouvrages de Peynet apparaît page 101.

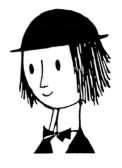

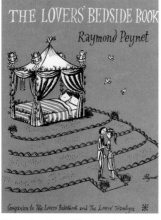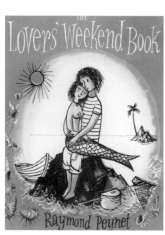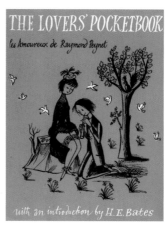

Four books of Peynet's drawings published in the United Kingdom by Perpetua, c.1955.
Quatre livres de recueils de dessins de Peynet, Perpetua, Londres, c.1955.

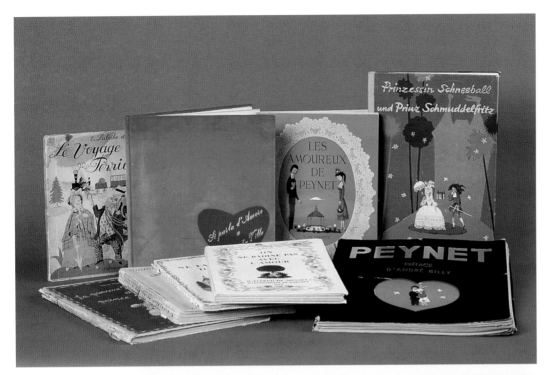

Selection of early books by Peynet, or illustrated by Peynet, in French, German and Italian.
Sélection de livres des années 40 et 50 par Peynet, ou illustrés par Peynet, en Français, Allemand et Italien.

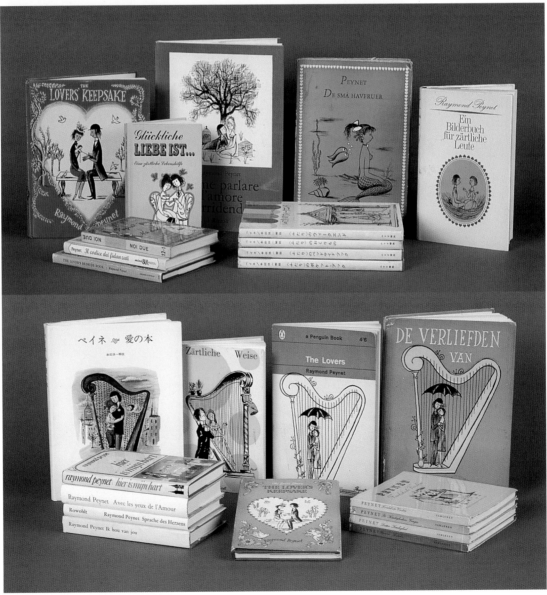

Selection of books by Peynet, or illustrated by Peynet, in different languages.
Sélection de livres de Peynet, ou illustrés par Peynet, traduits en plusieurs langues.

CERAMIC AND GLASS
PORCELAINES ET VERRES

Peynet's first designs on porcelain were made by Couleuvre, a French company, who marketed a cake dish, a coffee set, a chocolate set and cache-pot between 1947 and 1952. The firm was taken over in the late 1950s and continued to produce Peynet designs without authorisation. These are recognisable because they were marked Couleuvre but without the snake backstamp.

In 1952 Philip Rosenthal, of the famous German company of that name, invited Peynet to produce drawings for a new porcelain series, including shapes by the Swedish designer, Bjorn Wiinblad, the Polish designer Tapio Wirkkala and Raymond Loewy who, like Peynet, attended the Ecole des Arts Appliqués in Paris.

From 1953 to 1963 Peynet worked regularly for two or three weeks at a time in Rosenthal's factory in Bavaria drawing directly onto a wide range of objects including dishes, bowls, vases and cigarette boxes. It was a close and successful collaboration. Philip believed that taking his designers on a working holiday inspired and developed their creative spirit – on one occasion the team went on a two week Nile cruise away from the greyness of the Selb factory.

Peynet originated three dimensional figures of *The Lovers* and spent much time working on the models and painting the decorative details. The vase and dish designs were produced by coloured lithographs or with black and gold prints usually adapted to different shapes, sometimes in a series of up to seven pieces. Some of the designs were commissioned specially for ceramics and others adapted from existing illustrations. Shape numbers are impressed and pieces may have painted pattern numbers but always with a printed factory backstamp, often with the new Rosenthal *Studio-Line* mark introduced in 1961.

Volkwagen commissioned a series of three designs by Peynet for engraved brandy glasses to promote the Beetle. Rosenthal produced a further six designs made at their Bad Soden glassworks from 1958 (see p44).

In the mid-1950s Peynet produced about eight designs for the Danish company, RAFA, which were made on Nymolle art faience at the request of his new friend Bjorn Wiinblad who worked extensively for Nymolle (see p45).

Entre 1947 et 1952, Peynet commença à dessiner sur porcelaine pour la compagnie française Couleuvre où il produisit un plat à gâteau, un service à café, un service à chocolat ainsi qu'un cache-pot. Quand Couleuvre fut rachetée, d'autres objets furent produits vers la fin des années 50, sans l'autorisation de Peynet. Bien que portant la marque Couleuvre, ces porcelaines n'avaient pas l'emblème du serpent, ce qui les différencie des plus anciennes.

En 1952, Philip Rosenthal invita Peynet ainsi que plusieurs dessinateurs mondialement réputés à venir en Bavière dans le but de créer de nouvelles gammes de porcelaines. Les dessins de Peynet étaient transférés sur des formes, généralement créées par les grands modernistes de l'époque, tels que le styliste suédois Bjorn Wiinblad et le polonais Tapio Wirkkala ainsi que Raymond Loewy.

Durant les dix années suivantes, Peynet se rendit régulièrement en Bavière où il travaillait pendant deux ou trois semaines d'affilée, dans l'usine de Rosenthal à Selb.

Ses dessins, en couleurs ou noir et or, étaient imprimés sur des formes différentes. Certains étaient des dessins originaux, d'autres, des adaptations de dessins qui avaient déjà été publiés. Les numéros des formes étaient incrustés et les numéros des dessins étaient généralement peints sous les objets, et tous avaient la marque Rosenthal *Studio-Line* de l'usine introduite en 1961. Peynet travaillait aussi en étroite collaboration avec les modeleurs et il peignait les figurines originales des *Amoureux*.

Philip Rosenthal avait beaucoup de respect pour les dessinateurs qui travaillaient pour lui. Il les invitait tous à des séminaires grandioses, comme par exemple une croisière sur le Nil, en Egypte, afin d'inspirer leur créativité, loin de l'atmosphère lugubre de l'usine de Selb. En 1958, Rosenthal demanda à Peynet de créer une série de gravures pour verres promotionnels pour la compagnie Volkswagen. Ils étaient fabriqués à la verrerie de Bad Soden appartenant à Rosenthal, qui plus tard les commercialisa en séries de verres à whisky, cognac et champagne.

Vers 1955, Bjorn Wiinblad qui travaillait beaucoup pour la compagnie Danoise R.A.F.A. à Copenhague, proposa à son ami Peynet de soumettre quelques dessins pour des faïences d'art Nymolle.

Left: Couleuvre backstamp. **A gauche: marque Couleuvre.**
Others: examples of Rosenthal printed backstamps found with Peynet designs. Note the impressed shape no. and the painted design no. **Les autres: exemples de marques Rosenthal pour les dessins de Peynet. Remarquez l'empreinte du numéro de forme et le numéro du dessin imprimé.**

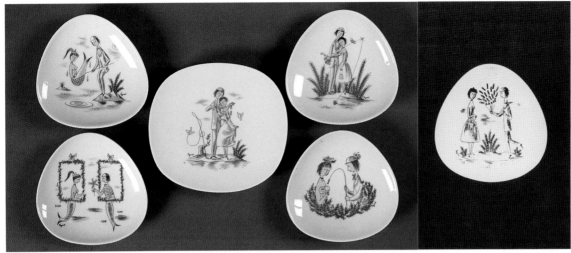

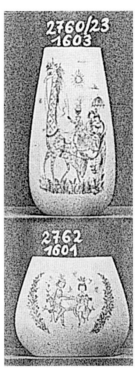

Fishing set, six scenes, design no.1500 (refers to several Peynet designs), shape no.2131, 11cm, and larger dish, shape no.2179. Also found on a vase see p38. **Série *Pêche*, six images, dessin no.1500 (se réfère à plusieurs dessins Peynet), forme no.2131, 11cm, et plat plus grand, forme no.2179, aussi sur vase p38.**

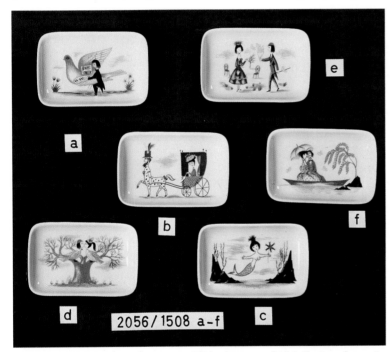

2056 / 1508 a-f

Small trays, six scenes, design no.1508, shape no.2056. **Petits plats, six images, dessin no.1508, forme no.2056.**

Small tray, design no.1519, shape no.425. **Petit plat, dessin no.1519, forme no.425.**

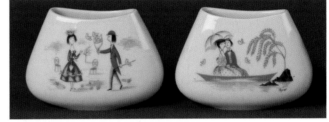

Vases, design no.1508, shape no 2697. Also found on covered box, shape no.2203, and dish, shape no.2110. **Vases, dessin no.1508, forme no.2697. Dessin que l'on trouve aussi sur boîte couverte, forme no.2203, et plat, forme no.2110.**

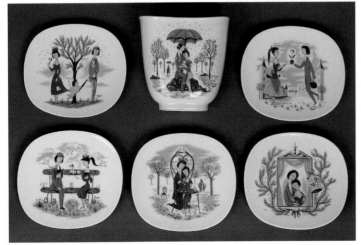

Park set, six shapes, design no.1509; dish, shape no. 2179. **Série *Parc*, six formes, dessin no.1509; plat, forme no.2179.**

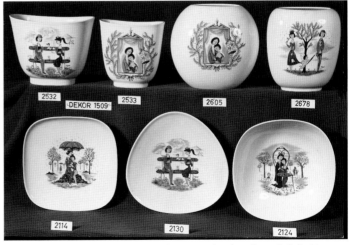

Design no.1509 found on these shapes and a fan-shaped dish. **Dessin no.1509, que l'on trouve sur ces formes et sur un plat en forme éventail.**

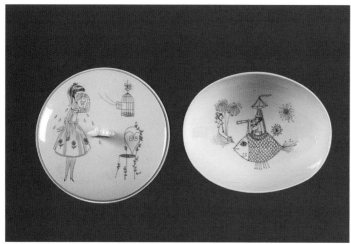

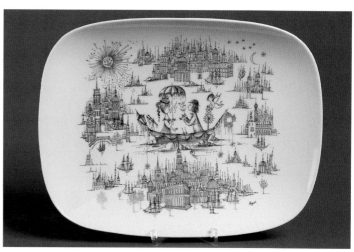

Left to right: covered bowl (interior of bowl painted with a bird); dish, shape no.2266. **De gauche à droite: bol et couvercle (intérieur du bol peint avec oiseau); coupe, forme no.2266.**

Large dish, architectural details, 3lcm. The design is found on different shapes. **Grand plat, details architecturaux, 31cm. Le dessin se trouve aussi sur d'autres formes.**

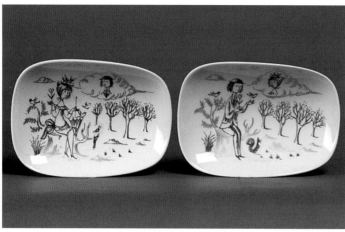

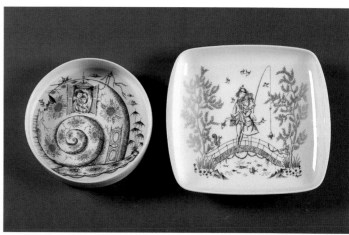

The Dream, two dishes, shape no.2175, 12¹/₂cm. **Le Rêve, deux petits plats, forme no.2175, 12,5cm.**

Two dishes, *L'Escargot*, 19cm, and *Fishing From the Bridge*, shape no.2395, 25cm. Also found on different shapes. **Deux plats, L'Escargot, 19cm, et Pêcheurs sur Le Pont, shape no.2395, 25cm, que l'on trouve aussi sur d'autres formes.**

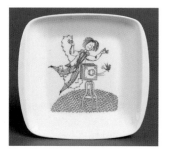

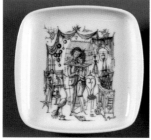

Left: square dish, shape no.2394 by Baumann, 16cm. **A gauche: plat carré, forme no.2394 par Baumann, 16cm.** Right: square dish, 9cm, 1962. **A droite: plat carré, 9cm, 1962.**

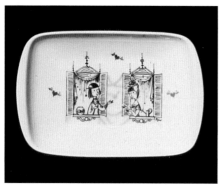

Tray, shape no.2396. **Petit plat, forme no.2396.**

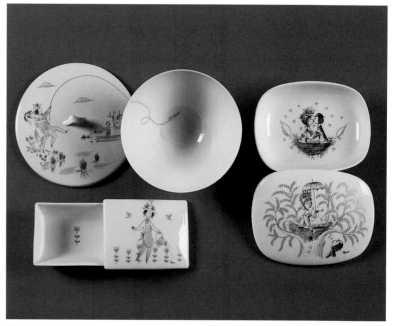

Top left: bowl and cover, design no.1682; right: bowl and cover, shape no.2203; bottom left: box and cover, design no.1578. **En haut à gauche: bol et couvercle, dessin no.1682; à droite: bol et couvercle, forme no.2203; en bas à gauche: boîte et couvercle, dessin no.1578.**

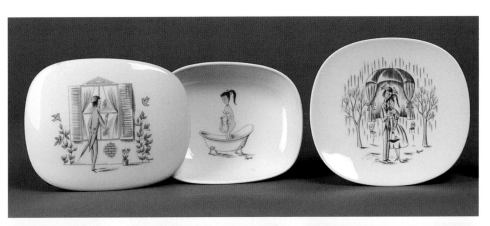

Left to right: dish and cover, design no.1500, shape no.2203; dish, rain scene, design no.1500, shape no.2179. **De gauche à droite: Coupe et couvercle, dessin no.1500, forme no.2203; plat, scène de pluie, dessin no.1500, forme no.2179.**

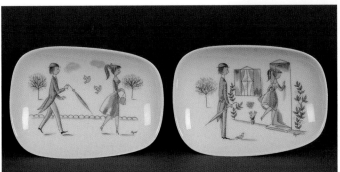

Two dishes, design no.1500/2, shape no.2175. **Deux coupes, dessin no.1500/2, forme no.2175.**

Pair of dishes, design no. 1533, shape no.2130. **Paire de plats, dessin no.1533, forme no.2130.**

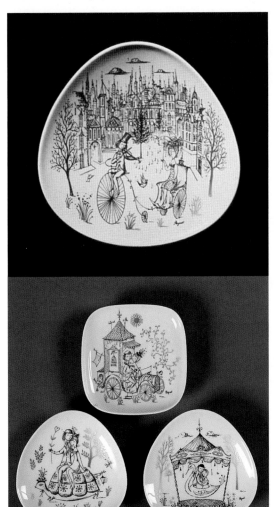

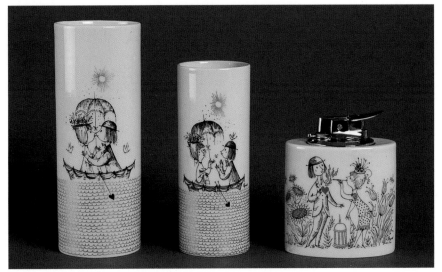

Central vase design no.1648, shape no.2642 by Prof. Bonjes van Beek, ht.16cm; cigarette lighter, shape no.2281, sold as a set with ashtray and cigarette box. **Vase au centre, dessin no.1648, forme no.2642 par Prof. Bonjes van Beek, hauteur 16cm; briquet, forme no.2281, vendu dans un ensemble avec cendrier et boîte à cigarettes.**

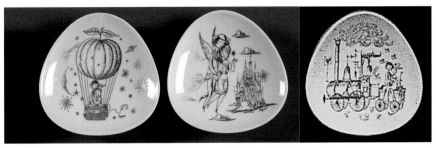

Above and left: fantasy transport set of dishes, design no.1648/6, shape nos. 2130 & 2131.
Ci-dessus et à gauche: ensemble de plats avec transports fantaisie, dessin no.1648/6, formes no.2130 & 2131.

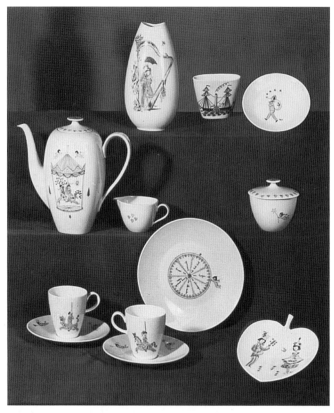

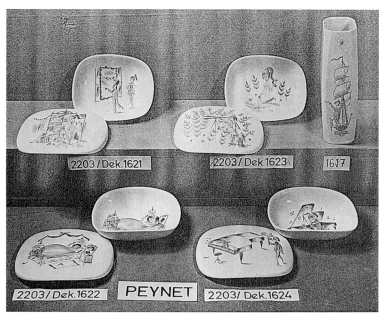

PROMOTIONAL LEAFLET showing design and shape numbers. The vase, shape no.2782 by Erich John. **BROCHURE PUBLICITAIRE montrant les numéros des dessins et formes. Le vase, forme no.2782 par Erich John.**

Left: PROMOTIONAL PHOTOGRAPH: *Harp* vase, shape no.95/2 and *Carousel* coffee set, design no.1575. **A gauche: PHOTOGRAPHIE PUBLICITAIRE: vase à la *Harpe*, forme no.95/2 et service à café *Carousel*, dessin no.1575.**

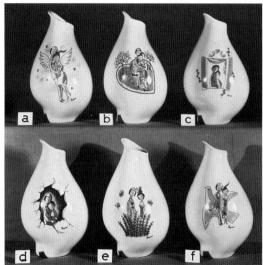

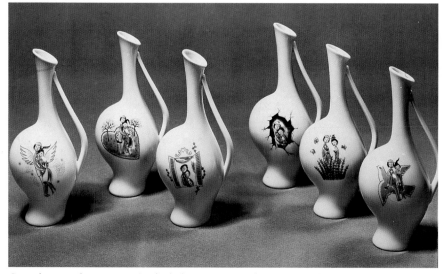

Set of vases, design no.1502/a-f, shape no.2594 by Fritz Heidenreich. **Série de vases, dessin no.1502/a-f par Fritz Heidenreich.**

Set of vases, design no.1502/a-f, shape no.2592 by Fritz Heidenreich. **Série de vases, dessin no.1502/a-f, forme no.2592 par Fritz Heidenreich.**

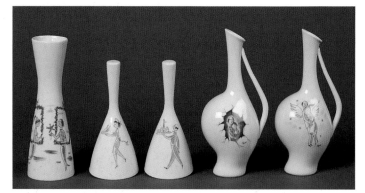

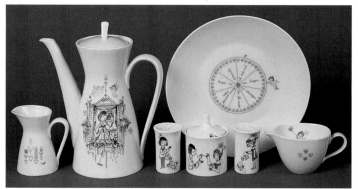

Left to right: vase with design from *Fishing* set (see p29); pair of bells, design no.1577; Solefleur vases, design no.1502 (see above). **De gauche à droite: vase avec dessin de la série *Pêche* (voir p29); paire de clochettes, dessin no.1577; vases fleur seule, dessin no.1502 (voir ci-dessus).**

Left to right: jug, coffee pot, condiment set, plate and jug from the *Carousel* set, design no.1575. **De gauche à droite: petite cruche, cafetière, ensemble d'assaisonnement, plat et petite cruche *Carousel*, dessin no.1575.**

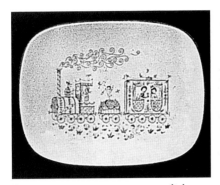

PROMOTIONAL PHOTOGRAPH: dish, design no.1604, shape no.2259 by Scharrer.
PHOTOGRAPHIE PUBLICITAIRE: plat, dessin no.1604, forme no.2259 par Scharrer.

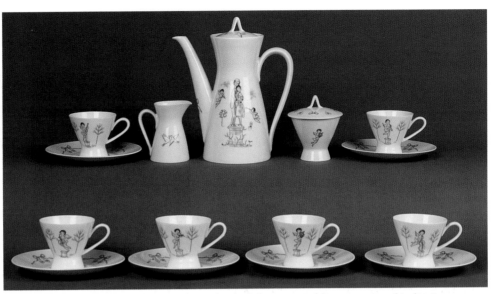

Coffee service, coffee cups, design no.1529/a-f. **Service à café, tasses à café, dessin no.1529/a-f.**

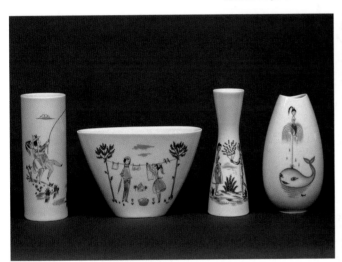

Left to right: vase, design no.1582, shape no.2642; vase with washing line, design no.1578; vase, design no.1500, shape no.2000, ht.16cm; vase, design no.1506, shape no.95/2. **De gauche à droite: vase, dessin no.1582, forme no.2642; vases avec étendoir, dessin no.1578; vase, dessin no.1500, forme no.200, hauteur 16cm; vase, dessin no.1506.**

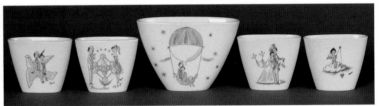

Left to right: cigarette holders, shape no.2240 and Brussels World Fair 1958; vase, design no.1581, shape no.2757; cigarette holders, *Wedding*, design no.1525; *Cherubs*, design no.1526. **De gauche à droite: portes-cigarettes, forme no.2240 and Foire Internationale de Bruxelles 1958; vase, dessin no.1581, forme no.2757; porte- cigarettes, *Mariage*, dessin no.1525; *Chérubins*, dessin no.1526.**

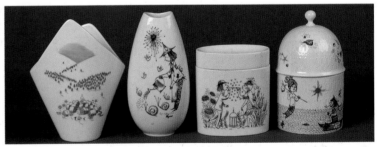

Left to right: vase, shape no.2653; vase shape no.95; cigarette box, shape no.2282 and a covered box. **De gauche à droite: vase, forme no.2653; vase forme no.95, boîte à cigarettes, forme no. 2282 et boîte avec couvercle arrondi.**

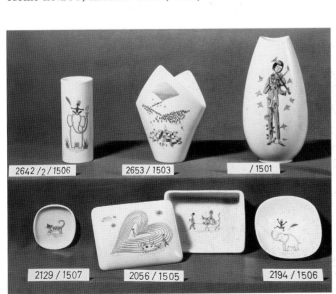

PROMOTIONAL LEAFLET with shape and design numbers.
BROCHURE PUBLICITAIRE avec numéros de formes et dessins.

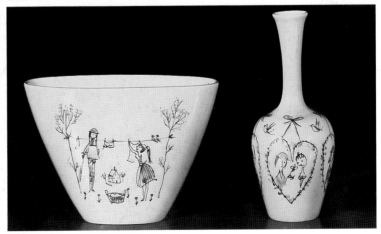

Peynet's original prototype drawings on biscuit vases. **Dessins originaux de Peynet, prototype sur vase en porcelaine biscuit.**

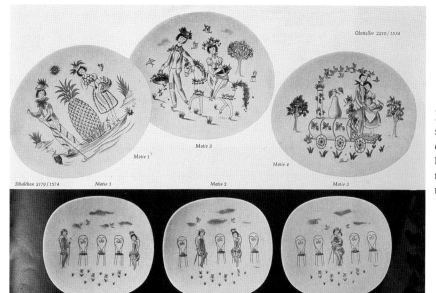

PROMOTIONAL LEAFLET: fruit set, design no.1534, shape no.2210; and *Wrought Iron Chair* series, design no.1574, shape no.2179. **BROCHURE PUBLICITAIRE: série fruits, dessin no.1534, forme no.2210; et série *Chaises de Jardin*, dessin no.1574, forme no.2179.**

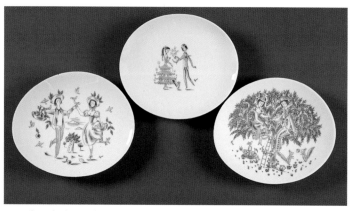

Two bowls from the fruit set, design no.1534, and a Christmas dish. **Deux coupes à fruits, dessin no.1534, et coupe de Noël.**

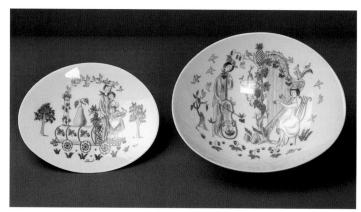

Dish and serving dish from the fruit set, design no.1534. **Coupe et grande coupe à fruits, dessin no.1534.**

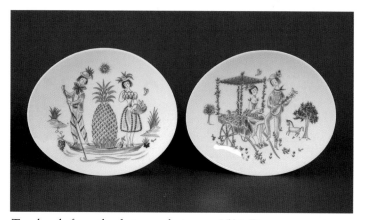

Two bowls from the fruit set, design no.1534. **Deux coupes à fruits, dessin no.1534.**

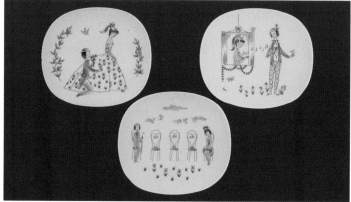

Two dishes from the *Flower* series, design no.1578; and a dish from the *Wrought Iron Chair* series, see above, design no.1574. **Deux petits plats de la série *Fleurs*, dessin no.1578, et plat de la série *Chaises de Jardin*, dessin no.1574.**

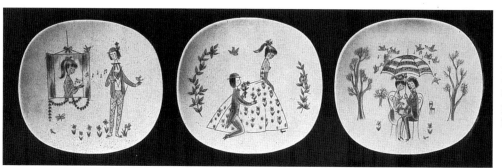

PROMOTIONAL LEAFLET showing the *Flower* series, design no.1578, shape no.2179. **BROCHURE PUBLICITAIRE pour la série *Fleurs*, dessin no.1578, forme no.2179.**

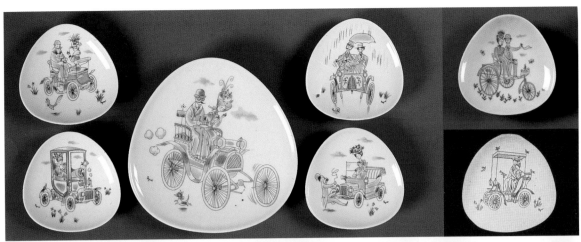

Vintage Car Series, seven designs no.1600, shape nos.2130 & 2131 by Wohlrab. **Série *Vieux Tacots*, sept dessins no.1600, formes no.2130 & 2131 par Wohlrab.**

PROMOTIONAL PHOTOGRAPH: box and cover, design no.1508, shape by Loewy. **PHOTOGRAPHIE PUBLICITAIRE: boîte et covercle, dessin no.1508, forme par Loewy.**

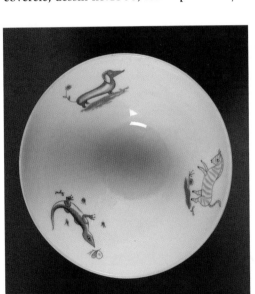

Serving dish for design no.1507, shapes by Loewy. **Coupe pour dessin no.1507, formes par Loewy.**

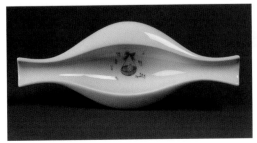

Cigar ashtray for Lufthansa Airline, 21cm. **Cendrier à cigares pour la compagnie Lufthansa, 21cm.**

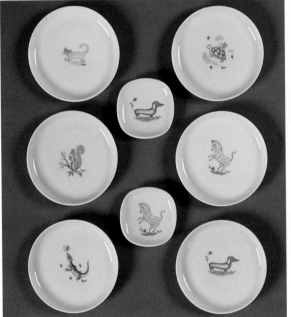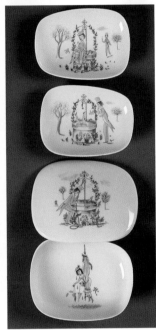

Animal Series, design no.1507/6, shape no.2000, 10cm; small dishes, shape no.2129. Also found on vases, shape no.2000. **Série *Animaux*, dessin no.1507/6, forme no.2000, 10cm; petits plats, forme no.2129, que l'on trouve aussi sur vases, forme no.2000.**
The Well Series, design no.1524, shapes nos.2203 & 2175. **Série *Le Puits*, dessin no.1524, formes no.2203 & 2175.**

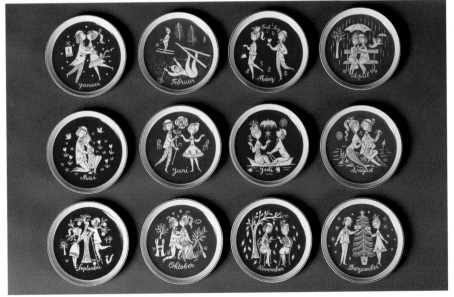

Zodiac Series, design no.1625, shape no.337, 10cm. **Série *Zodiaque*, dessin no.1625, forme no.337, 10cm.**

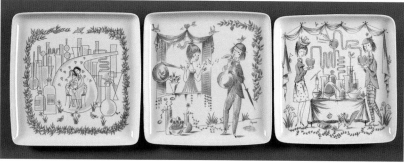

Three square dishes for a pharmaceutical company, 18cm. **Trois plats carrés pour entreprise pharmaceutique, 18cm.**

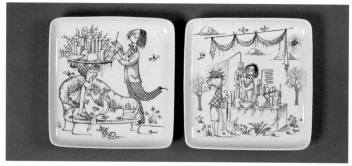

Two square dishes for a pharmaceutical company, 18cm. **Deux plats carrés pour entreprise pharmaceutique, 18cm.**

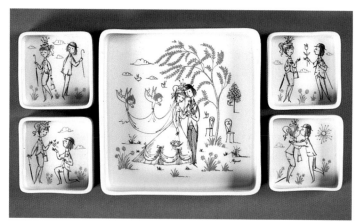

An hors d'oeuvre set with a courting story, design no.1648, shape nos.2397 & 2398 by Peynet. Largest dish, 14½cm. **Ensemble hors d'oeuvre avec histoire d'amour, dessin no.1648, formes no.2397 & 2398 par Peynet. Grand plat, 14,5cm.**

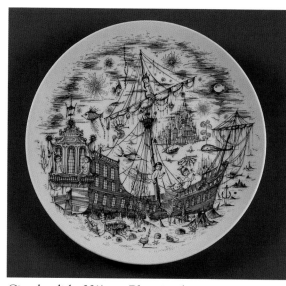

Circular dish, 32½cm. **Plat circulaire, 32,5cm.**

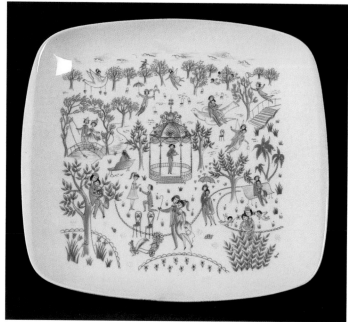

The Bandstand in the Park. Large hand-coloured dish, 36cm. *Le Kiosque à Musique dans le Parc.* **Grand plat, colorié à la main, 36cm.**

PROMOTIONAL PHOTOGRAPHS: set of ten tile patterns, design nos.1558/4 & 1559/6, shape no.2256. **PHOTOGRAPHIES PUBLICITAIRES: série de dix carreaux, dessins no.1558/4 & 1559/6, forme no.2256.**

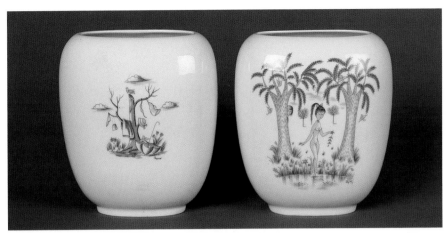

Vase, design no.1500, shape no.2678, 15cm. Front and reverse views. **Vase, dessin no.1500, forme no.2678, 15cm. Vues recto verso.**

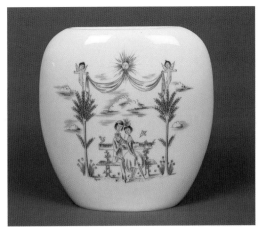

Vase, design no.1500, shape no.2666. **Vase, dessin no.1500, forme no.2666.**

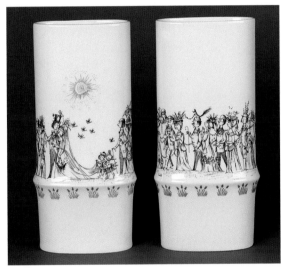

Wedding vase, shape no.2883, 29cm. Front and reverse views. **Vase de** *Mariage*, **forme no.2883, 29cm. Vues recto verso.**

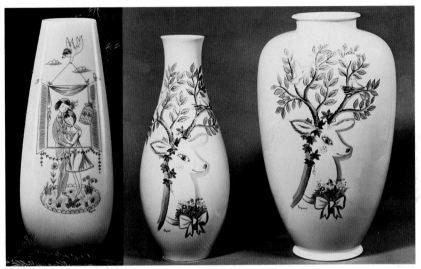

PROMOTIONAL LEAFLET: left to right: vase, design no.1601, shape no.2761; vase, design no.1504, shape no.2606; vase design no.1504, shape no.2636. **BROCHURE PUBLICITAIRE: de gauche à droite: vase, dessin no.1601, forme no.2761; vase, dessin no.1504, forme no.2606; vase dessin no.1504, forme no. 2636.**

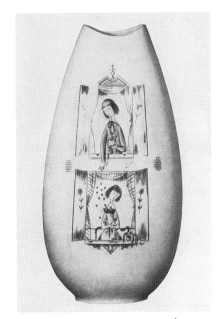

PROMOTIONAL LEAFLET: vase, design no.1578, shape no.95 by Loewy, ht.28cm. **BROCHURE PUBLICITAIRE: vase, dessin no.1578, forme no.95 par Loewy, hauteur 28cm.**

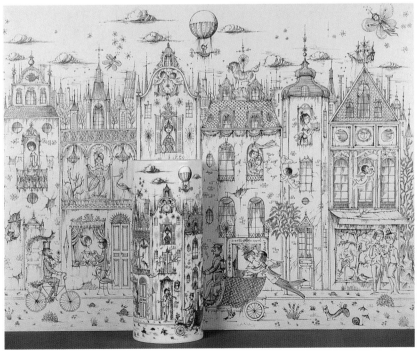

Vase with street scene and original design, ht.42$^{1}/_{2}$cm. **Vase avec scène de rue et dessin original, hauteur 42,5cm.**

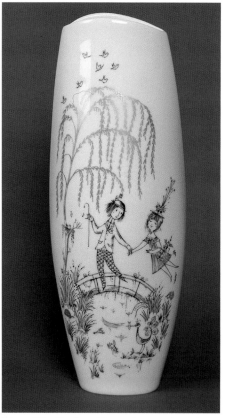

Vase, *The Bridge*, 32cm. Design found on other shapes. **Vase, *Le Pont*, 32cm, que l'on trouve aussi sur d'autres formes.**

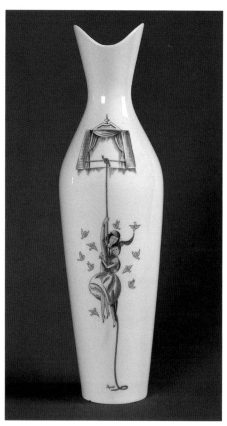

Vase, *The Elopement*, design no.1500, shape no.2687, 33cm. **Vase, *La Fuite*, dessin no.2687, 33cm.**

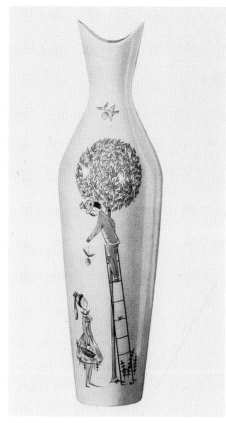

Vase, design no.1578, shape no.2687 by Jünger, ht.33cm. **Vase, dessin no.1578, forme no.2687 par Jünger, hauteur 33cm.**

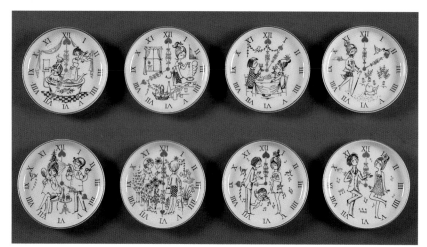

Eight small dishes with the timetable of a young lady's day, 10cm. **Huit petits plats avec l'emploi du temps de la journée d'une jeune fille, 10cm.**

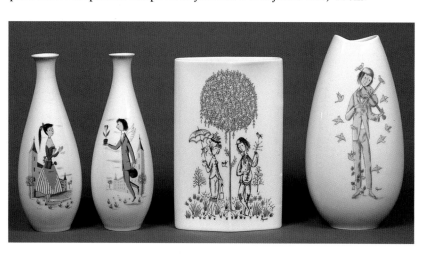

Vase 2000 / 13 cm / 1525

Vase 2000 / 16 cm / 1500

Vase 2000 / 25 cm / 1579

PROMOTIONAL LEAFLET: *Umbrella, Wedding* and *Fishing* designs on different sizes of shape no.2000 by Loewy. **BROCHURE PUBLICITAIRE: dessins *Parapluie, Mariage* et *Pêche* sur forme no.2000 par Loewy, de tailles différentes.**
Left to right: pair of vases from the series 1509, the maker K.P.M., a Rosenthal subsidiary in Silesia; vase of diamond section, shape no.2786 by Wirkkala, 17cm; vase, *The Violinist*, design no.1501, shape no.95, 20cm. **De gauche à droite: paire de vases de la série 1509, fabricant K.P.M, filiale de Rosenthal en Silésie; vase à section en lozange, forme no.2786 par Wirkkala, 17cm; vase *Le Violoniste*, dessin no.1501, forme no.95, 20cm.**

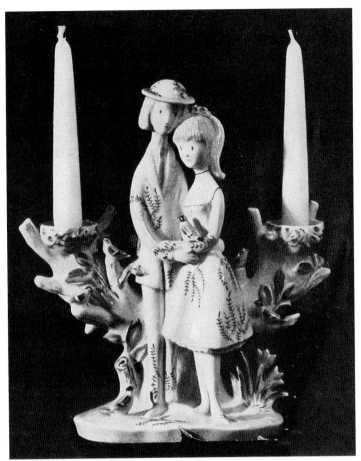

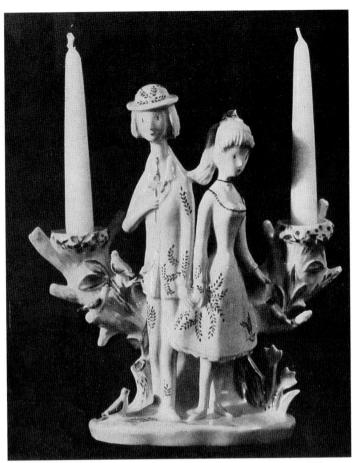

Candelabra, *The Happiness of Love*, no.3131/7010, shape no.5152, introduced 1959. **Chandelier, *Le Bonheur de l'Amour*, no.3131/7010, forme no.5152, sorti en 1959.**

Candelabra, *The Pain of Love*, no.3132/7010, introduced 1959. **Chandelier, *La Douleur de l'Amour*, no.3132/7010, sorti en 1959.**

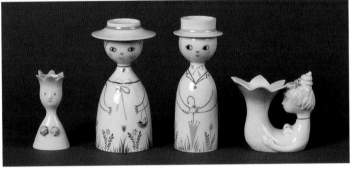

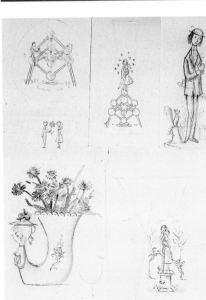

Above: four candlesticks, shape no.3130 by Peynet. Height of tallest 14cm. **Ci-dessus: quatre bougeoirs, forme no.3130 par Peynet. Hauteur du plus grand, 14cm.**

Original drawings by Peynet for ceramics. **Dessins originaux de Peynet pour la porcelaine.**

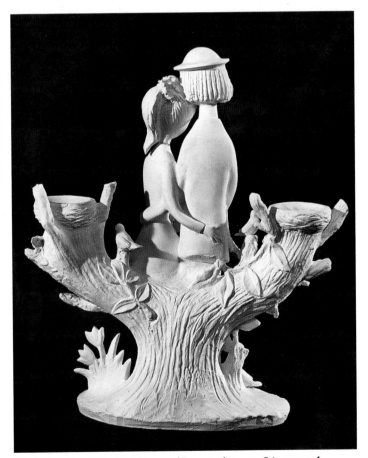

The reverse of *The Happiness of Love* in biscuit. **L'envers du *Bonheur de l'Amour* en porcelaine biscuit.**

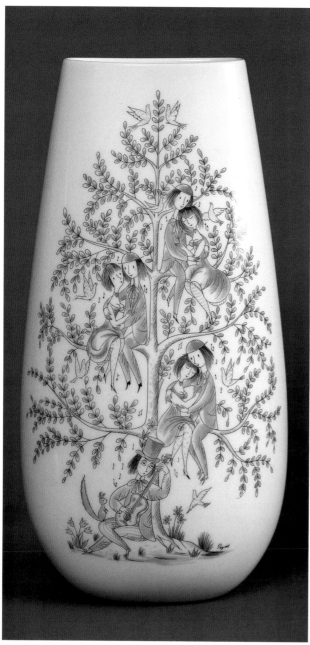

Above: bowl and cover, design no.1624, shape no.2203 by Wohlrab. **Ci-dessus: bol et couvercle, dessin no.1624, forme no.2203 par Wohlrab.**

Right: box and cover, an invitation to a Peynet Exhibition. **A droite: boîte et couvercle, invitation à une exposition Peynet.**

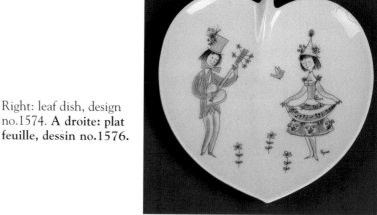

Vase, design no.1601, shape no.2760 by Scharrer, 32cm.
Vase, dessin no.1601, forme no.2760 par Scharrer, 32cm.

Right: leaf dish, design no.1574. **A droite: plat feuille, dessin no.1576.**

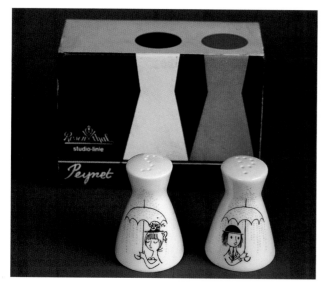

Salt and pepper set, original box. **Ensemble sel et poivre, boîte originale.**

Dekor 1573 auf nebenstehendem Rauchsatz

Designs for smoking room dishes. **Dessins pour service à fumeur.**

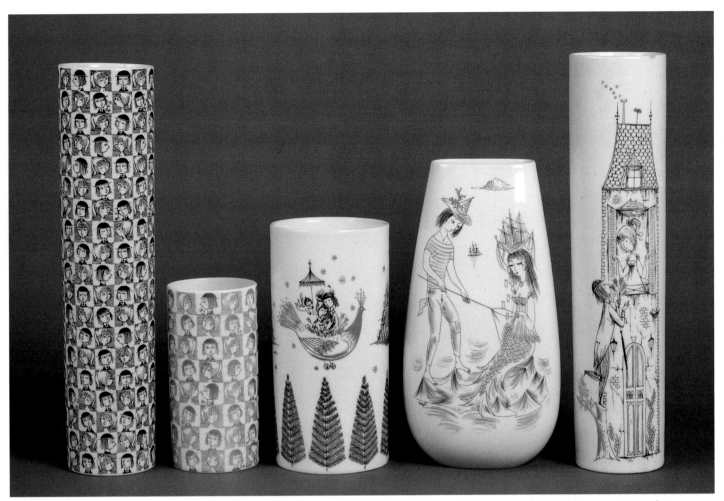

Group of vases. Left to right: design no.1648, shape no.2766 by Wiinblad; design no.1602, shape no.2760; shape no.2824; design no.1789, shape no.2825; design no.1790, shape no.2766. Height of tallest, 31cm. **Groupe de vases. De gauche à droite: dessin no.1648, forme no.2766 par Wiinblad; dessin no.1602, forme no.2760; forme no.2824; dessin no.1789, forme no.2825; dessin no.1790, forme no.2766. Hauteur du plus grand, 31cm.**

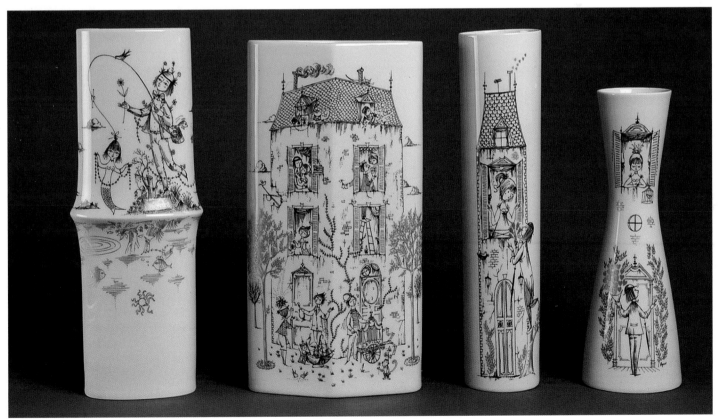

Group of vases. Right: shape no.2000 by Loewy. Height of tallest, 30cm. **Groupe de vases. A droite: forme no.2000 par Loewy. Hauteur du plus grand, 30cm.**

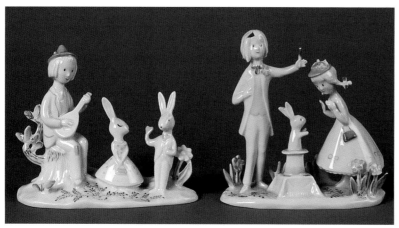

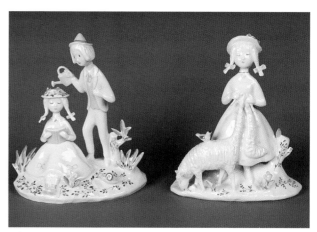

The Mandolin Player, model no.5118 and *The Magician*, model no.5117, ht.15cm, introduced 1958. **Le Joueur de Mandoline, modèle no.5118 et Le Magicien, modèle no.5117, hauteur 15cm, sortis en 1958.**

The Gardener and the Young Lady, model no.5116, and *The Knitter*, model no.5119, 15¹/₂cm, introduced 1958. **Le Jardinier et La Demoiselle, modèle no.5116 et La Tricoteuse, modèle no.5119, 15,5cm, sortis en 1958.**

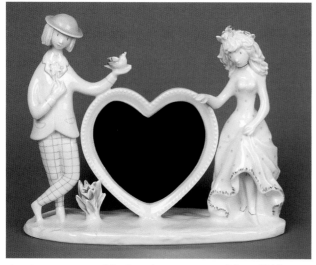

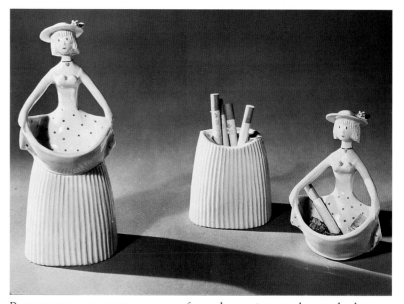

A mirror supported by *Les Amoureux*, model no.5219, ht.19¹/₄cm, introduced 1960. Courtesy of *Deutsches Porzellanmuseum in Hohenberg/Eger*. **Miroir supporté par *Les Amoureux*, modèle no.5219, hauteur 19,25cm, sorti en 1960. Courtoisie du *Musée de Deutsches Porzellan à Hohenberg/Eger*.**

PROMOTIONAL LEAFLET: a woman formed as a cigarette box and ashtray, model no.5097, introduced 1957. **BROCHURE PUBLICITAIRE: femme en forme de présentoir à cigarettes et cendrier, modèle no.5097, sorti en 1957.**

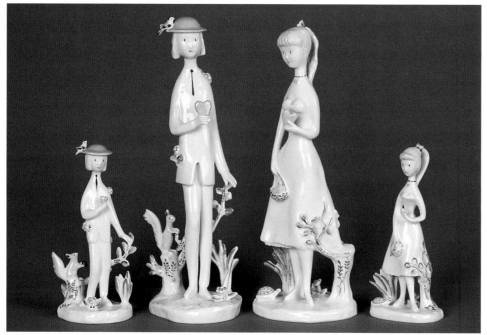

Les Amoureux holding hearts. Large size, model nos.5093 & 5094, ht.26cms; small size, model nos.5120 & 5121, ht.15¹/₂cm, introduced in 1958. **Les Amoureux avec coeurs. Grands modèles no.5093 & 5094, hauteur 26cm; petits modèles no.5120 & 5121, hauteur 15,5cm, sortis en 1958.**

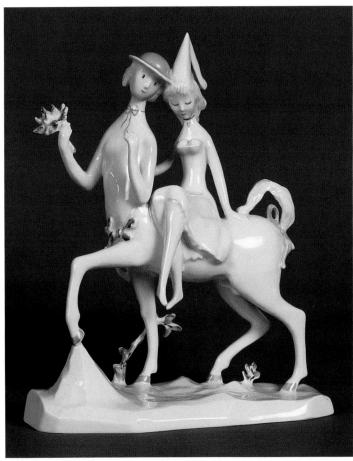

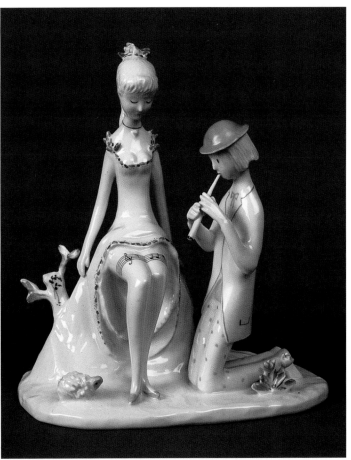

Centaur, model no.5095, ht.25cm, introduced 1957. **Centaure modèle no.5095, hauteur 25cm, sorti en 1957.**

Springtime, model no.5092, ht.20cm, introduced in 1957. **Le Printemps, modèle no.5092, hauteur 20cm, sorti en 1957.**

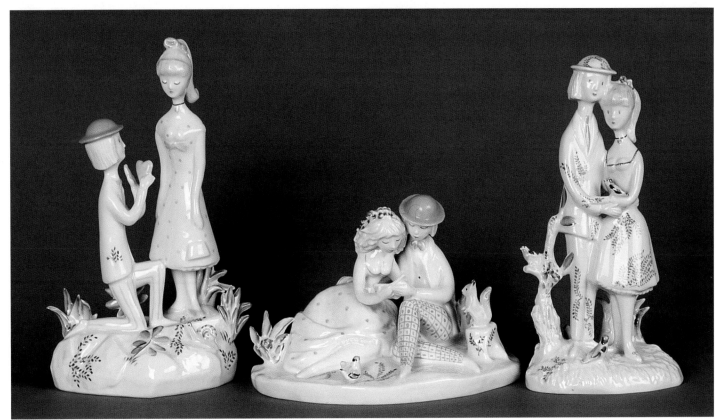

Left to right: *The Suitor*, model no.5151, ht.23½cm, introduced in 1959; *Lovers with Book*, model no.5218, ht.13½cm, introduced in 1960; *The Lovers*, model no.5150, ht.22cm, introduced in 1959. **De gauche à droite: L'Amoureux, modèle no.5151, hauteur 23,5cm, sorti en 1959; Les Amoureux avec Livre, modèle no.5218, hauteur 13,5cm, sorti en 1960; Les Amoureux, modèle no.5150, hauteur 22cm, sorti en 1959.**

Tisch- und Bodenleuchter
Raymond Peynet,
der Zeichner des zärtlichen und
liebevollen Details, schuf
aus Stahl und farbigen Glas-
elementen diese Leuchter der

Rosenthal Studio-Linie. Sie
kommen direkt aus der freundlichen
Welt seiner liebenswürdigen
Gestalten, um in unserer Umge-
bung eine intime Atmosphäre
für freundliche Töne zu schaffen.

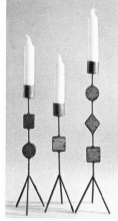
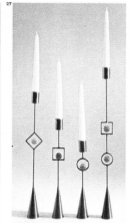
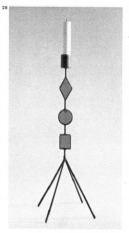

**Tisch- und Bodenleuchter
von Raymond Peynet**
schwarz-brünierter Stahl und farbige
Glaselemente
26 **Feuerzauber:**
Tischleuchter P 002
Glasfarben: cognac, amethyst, aquamarin,
rubin ocer kristall
35 cm hoch
Tschleuchter P001, Glasfarben wie P002
28 cm hoch
Tischleuchter P003, Glasfarben wie P002
43 cm hoch

27 Tischleuchter P 003a
mit farbigen Glaskugeln
in cognac, amethyst, aquamarin, rubin,
oder kristall
40,5 cm hoch
Tischleuchter P 002a
mit farbiger Glaskugeln wie P 003a
32 cm hoch
Tischleuchter P 001a
mit farbiger Glaskugeln wie P 003a
24,5 cm hoch
Tischleuchter P 004a
mit farbiger Glaskugeln wie P 003a
49 cm hoch

28 Bodenleuchter P 004
Glasfarben: cognac, amethyst, aqua-
marin, rubin und kristall, 85 cm hoch

29 **Holzkohlen-Gartengrilltisch
von Bjørn Wiinblad**
mit Feuereinsatz, Grill- und Aschenrost,
Zugregler, 3teiligem Grillaufsatz,
6 Grillgabeln und 6 Grillspiessen, Tisch-
und Abdeckplatte aus «Weisser Erde»,
einem neuen keramischen Material,
wetterfest, handgemalt
Dekor: Kobalt, Unterglasmalerei
73 cm hoch, 123 cm Ø
Gesamtgewicht: 312 kg
grösstes Einzelgewicht: 93 kg

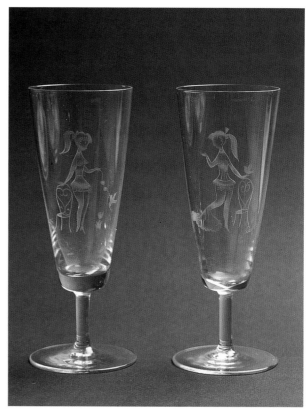

PROMOTIONAL LEAFLET: glass and wrought iron candlesticks in three colours, called *Magic Fire* by Domus for Rosenthal, designed by Peynet, c.1960. **BROCHURE PUBLICITAIRE: bougeoirs en fer forgé et verre, trois couleurs, nommés *Feu Magique* par Domus pour Rosenthal, et dessinés par Peynet c.1960.**

A pair of champagne glasses with engraved figures, scenes of a young lady dressing, shape no.1041. **Paire de verres à champagne avec figurines gravées, scènes d'une jeune fille qui s'habille, forme no.1041.**

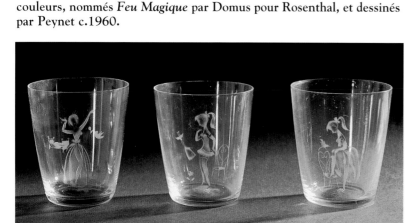

Whisky tumblers, shape no.1039, probably eight designs in the set. **Verres à whisky, forme no.1039, probablement huit dessins dans la série.**

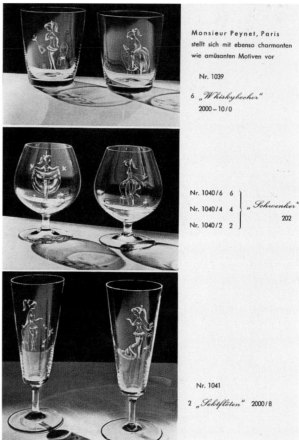

Monsieur Peynet, Paris
stellt sich mit ebenso charmanten
wie amüsanten Motiven vor

Nr. 1039
6 „*Whiskybecher*"
2000 – 10/0

Nr. 1040/6 6
Nr. 1040/4 4 } „*Schwenker*"
Nr. 1040/2 2 202

Nr. 1041
2 „*Sektflöten*" 2000/8

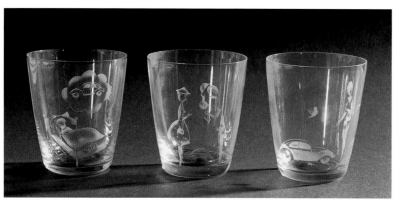

Whisky tumblers from a set made for the Volkswagen Company. **Verres à whisky d'une série qui avait été créée pour la Compagnie Volkswagen.**

PROMOTIONAL LEAFLET: the brandy glasses are shape no.1040. **BROCHURE PUBLICITAIRE: les verres à cognac sont de forme no.1040.**

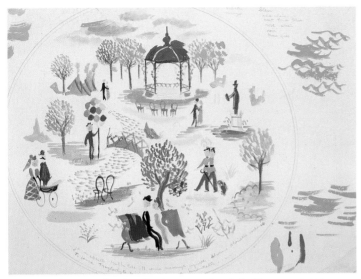

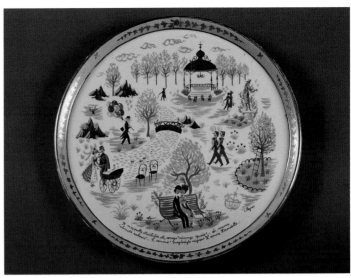

Peynet's drawing for the Couleuvre cake dish illustrated right. **Dessin de Peynet pour le plat à gâteau pour Couleuvre, illustré à droite.**

Cake dish by Couleuvre c.1950. **Plat à gâteau par Couleuvre c.1950.**

Right: French manufacturers. Left to right: two bowls by Couleuvre; the foie gras box and the dish by Limoges; the mug by Gien. **A droite: de gauche à droite: deux bols de Couleuvre, la boîte de foie gras et le petit plat de Limoges et la chope de Gien.**

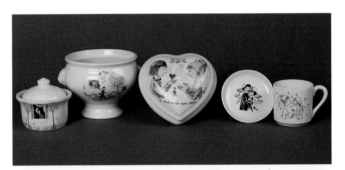

Right: two dishes made in the far east without a license, copied from Series no.1509, c.1965. **A droite: deux plats fabriqués en Extrême-Orient sans license, copiés de la série no.1509, c.1965.**

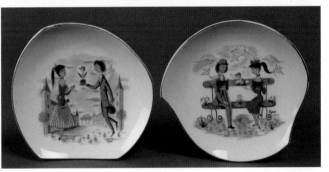

A cache-pot by Couleuvre, c.1950. **Cache-pot par Couleuvre, c.1950.**

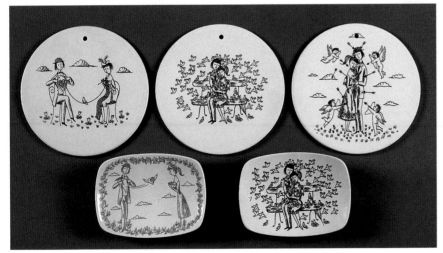

Peynet designs used by the Danish company, Nymolle, c.1955. Two further designs are recorded, a window scene and a mermaid writing waves; the trays, 12½cm. **Dessins de Peynet utilisés par la compagnie Danoise Nymolle, c.1955. Deux dessins supplémentaires existent: une scène à la fenêtre et une sirène qui écrit des vagues; les plats rectangulaires, 12,5cm.**

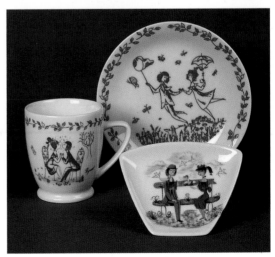

Japanese ceramics. There are five designs in the blue-printed wares by Yamaka, introduced in 1994. **Porcelaines japonaises. Il existe cinq dessins dans la gamme imprimée bleue par Yamaka, sortie en 1994.**

JEWELLERY

BIJOUX

At the beginning of the 1950s Peynet's *Lovers* were extremely popular and a household name in France. Murat, the French jewellers, approached Peynet and asked him to design a set of jewellery which would appeal to lovers everywhere. Peynet produced several designs for pendants and charms for necklaces and bracelets. These were made in eighteen carat gold, gold plate, and silver and were a great commercial success. For nearly forty years Peynet regularly produced new styles and designs.

Almost every jeweller's shop in France displayed Peynet's pendants. The jewellery was sold in heart- or oval-shaped presentation boxes which also contained an extract from a poem by Verlaine. A few pendants were made in Italy by Orafa Aretina, jewellers in Arezzo.

It is very difficult to give an accurate listing of everything produced by Murat. Jewellery was made in different shapes and designs and in many combinations. Below are some guidelines to the various shapes and designs:

1. Pendants and charms for necklaces and bracelets:

Heartshape	x	12 versions
Round	x	13 versions (min)
Rectangular	x	9 versions
Oval	x	4 versions
Double-heart	x	3 versions
Large engraved	x	3 versions
Novelty diamond-shaped	x	2 versions
Window	x	1 version

2. Rings: a variety of 8 shapes
3. Key rings: a variety of 5 shapes and designs
4. Tie clips: 7 designs
5. Fob watches: 3 types
6. Cuff links: 2 types

Peynet's designs of *The Lovers* for Murat included:

Lovers with dove (head and shoulders)
Lovers with violin (head and shoulders)
Lovers with flower/s (head and shoulders)
Lovers with heart (head and shoulders)
Lovers with leaves and dove (head and shoulders)
Lovers alone (head and shoulders)
Lovers standing with doves
Lovers walking
Lovers geometrically engraved
Female alone and Male alone

Au début des années 50, l'oeuvre de Peynet était à son apogée. *Les Amoureux* devenaient très populaires et les Etablissements Murat lui demandèrent de créer une médaille pour les amoureux du monde entier. Différents modèles suivirent en or 18 carats, plaqué or et argent. Ces bijoux connurent un grand succès commercial; toutes les bijouteries avaient une vitrine de médailles de Peynet. Les bijoux étaient vendus dans des boîtes en carton, en forme de coeur ou arrondies et toutes comportaient un extrait d'un poème de Verlaine.

Certaines médailles furent également fabriquées en Italie par la Société Orafa Aretina à Arezzo.

La collaboration Murat-Peynet dura 40 ans.

Un récapitulatif précis de cette production est difficile car le même dessin pouvait avoir comme support différents modèles. Voici un guide des modèles:

1. Médailles et charmes pour colliers et bracelets:

En forme de coeur	x 12 versions
De forme ronde	x 13 versions (au moins)
De forme rectangulaire	x 9 versions
De forme ovale	x 4 versions
En double coeur	x 3 versions
Larges, gravées	x 3 versions
En lozange	x 2 versions
Fenêtre	x 1 version

2. Bagues: une gamme de 8 formes
3. Porte-clés: une gamme de 5 dessins et formes
4. Pinces à cravates: 7 dessins différents
5. Montres Régence: 3 types différents
6. Boutons de manchettes: 2 types différents

Les dessins des *Amoureux de Peynet* pour Murat comprennent:

Les Amoureux avec colombes
Les Amoureux avec violon
Les Amoureux avec fleur/fleurs
Les Amoureux avec coeur
Les Amoureux seuls

Les dessins ci-dessus sont en portrait, puis il y a:
Les Amoureux debout avec colombes
Les Amoureux qui marchent
Les Amoureux en formes géométriques, gravés
L'Amoureuse seule et l'Amoureux seul

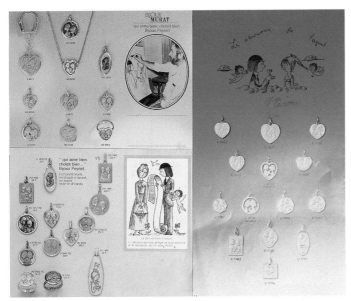

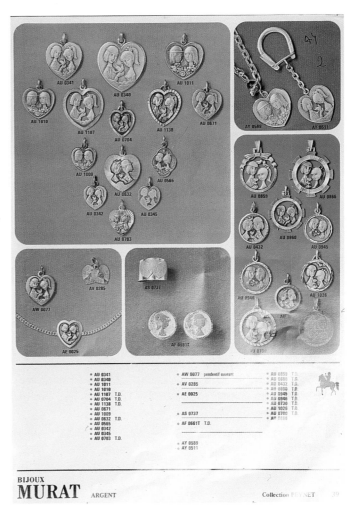

Pages from Murat's catalogue showing a variety of pendants, rings, and key rings in gold or silver.
Section d'un catalogue des bijoux Murat: on peut y voir des médailles, bagues, chaînes et porte-clés, en or et en argent.

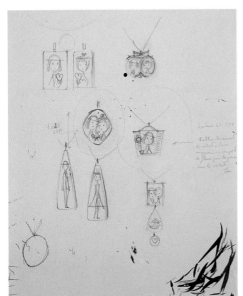

Original pencil drawing by Peynet for Murat.
Dessins originaux de Peynet pour les bijoux Murat.

Pages from Murat's catalogue.
Autre section de catalogue des bijoux Murat.

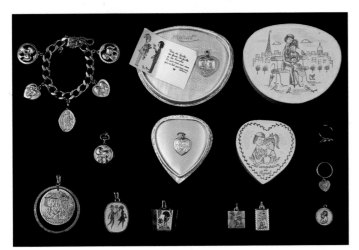

On display, Murat's jewellery designed by Peynet: bracelet with pendants, pendants and rings. The presentation boxes are also by Peynet. **Les bijoux Murat en exposition: bracelet avec médailles (pendantifs), médailles et bagues. Les boîtes présentoirs étaient également dessinées par Peynet.**

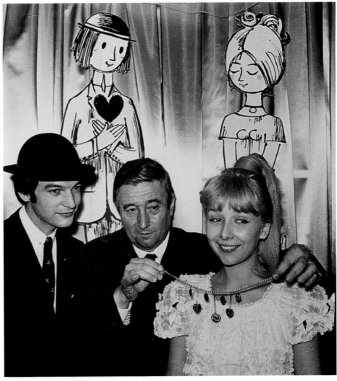

Publicity shot for the launch of a series of jewels by Murat. Peynet in the centre surrounded by 'real' amoureux based on the drawings behind! **Photo publicitaire pour le lancement d'une gamme de bijoux Murat. Peynet au centre entouré de "vrais" amoureux basés sur les dessins qui sont derrière!**

SCARVES, HANDKERCHIEFS, FABRIC
FOULARDS, MOUCHOIRS, TISSUS

The French had great affection for Peynet and it was inevitable that *The Lovers* would, eventually, make their appearance on fabric. Baccara, a firm of silk designers in Lyon, were the first to use *The Lovers* on their luxury scarves and handkerchiefs. Peynet adapted his drawings onto silk so that they fitted successfully, and about thirty different designs were used on scarves and handkerchiefs which were sold in Galeries Lafayette, Printemps and other shops throughout France and other countries during the 1950s, 1960s and 1970s. Cotton handkerchiefs in presentation boxes were also produced to celebrate the New Year, St. Valentine's Day and other anniversaries.

The Italian firm, *Eli*, owned by Elio Lona, produced cotton handkerchiefs and a set of kitchen towels and aprons featuring Peynet's drawings. The kitchen sets included the four seasons, the twelve months, and a series of capital cities of the world.

The photographs below give an impression of the contribution made by *Peynet's Lovers* to fashion and textiles at that time.

L'énorme succès des *Amoureux* devait tôt ou tard entraîner leur apparition sur tissu, ce qui se produisit au cours des années 50.

Bien que Peynet ait déjà conçu quelques foulards, ce fut le soyeux Baccara à Lyon qui en fabriqua une trentaine de modèles d'après des dessins préalablement publiés dans la presse ou d'autres avec un dessin original de Peynet. Ces carrés de soie étaient vendus dans les grands magasins et boutiques spécialisées. Les Galeries Lafayette notamment, chaque Noël, éditaient des mouchoirs dans des pochettes en papier, également décorées par Peynet.

Une entreprise italienne *Eli* de Elio Lona, fabriqua une gamme de torchons et tabliers en coton ayant pour thème les quatres saisons, le mariage, les douze mois de l'année et les capitales du monde. Ils furent vendus aussi bien en Italie qu'en France.

Les photographies ci-dessous ont pour but de donner une idée de la contribution des *Amoureux de Peynet* à la mode des accessoires textiles de cette époque.

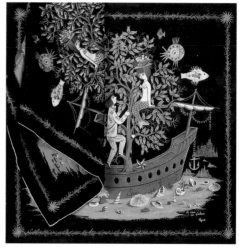

Fisherman's Dream – silk scarf. Baccara, c.1960.
Le Rêve du Pêcheur – foulard en soie. Baccara, c.1960.

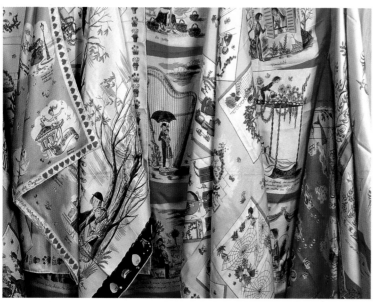

A selection of silk scarves with Peynet's drawings. Baccara, c.1960.
Une sélection de foulards en soie avec dessins de Peynet. Baccara, c.1960.

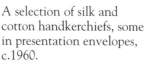

A selection of silk and cotton handkerchiefs, some in presentation envelopes, c.1960.
Une sélection de mouchoirs en soie et en coton, certains avec pochette présentation, c.1960.

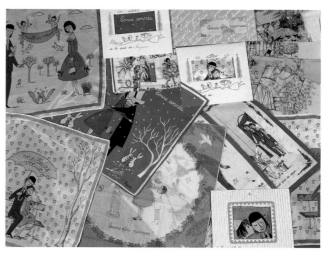

POSTCARDS
CARTES POSTALES

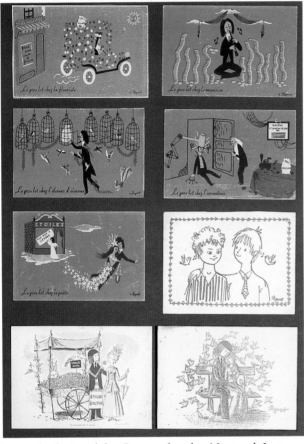

Postcards designed by Peynet for the National Lottery, c.1946 and *The Friends, The Merchant of the Four Seasons,* and *Lovers on a Bench,* c.1960.

Cartes postales dessinées par Peynet pour la Loterie Nationale c.1946 et *Les Amis, Le Marchant des Quatres Saisons,* et *Les Amoureux sur un Banc,* c.1960.

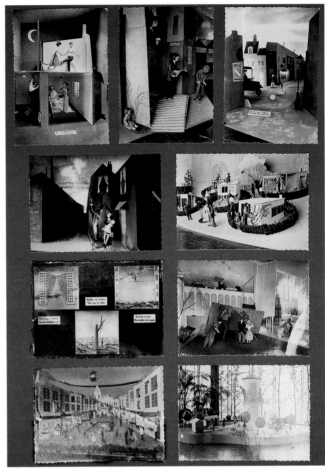

Nine postcards of the Peynet stand representing France at the World Fair in Brussels, 1958.
Neuf cartes postales du stand de Peynet représentant la France à la Foire Internationale de Bruxelles, 1958.

The first Peynet postcards, produced in the 1930s, resulted from his work in advertising. After the war Peynet continued producing publicity postcards. Most of the postcards featuring *The Lovers* were reproductions of drawings that had previously appeared in books or periodicals. The popularity of *The Lovers* increased his output of postcards but, strangely, it was the dolls postcards that were to become the most collectable and had the greatest commercial success.

When Peynet created his dolls with Technigom in 1953, they became instantly popular throughout France. Soon after Editions Yvon in Paris, specialising in postcards, approached Peynet with the plan to create a series of postcards using photographs of his dolls. The series comprised single dolls postcards or couples arranged as a tableau. Each numbered card was titled in script by Peynet, under the overall series title *Les Poupées de Peynet,* which was adorned by a bird.

The cards were 14½cm x 10½cm, with a few

Les premières cartes postales de Peynet datent de 1930. Elles étaient surtout des cartes publicitaires. Après la guerre, il continua d'en faire, mais *Les Amoureux* en devinrent plus souvent le sujet. Sa plus importante production fut sans aucun doute consacrée aux cartes postales des *Poupées Peynet* éditées chez Yvon et imprimées chez Draeger. En effet la société Technigom à Montrouge venait de créer la *Poupée Peynet* et chaque poupée était photographiée en carte postale numérotées, avec au verso *Les Poupées de Peynet* écrit de la main de Peynet. Il y en eut souvent plusieurs tirages, dont un en Italie (quatre cartes) et en 1995 une réédition exceptionnelle de dix cartes par Yvon.

Ces cartes sont devenues le rêve du collectionneur: elles étaient produites en format 14,7cm x 10,5cm puis quelques-unes en 19,5cm x 15cm. D'autres étaient produites en format double plié, pour cartes de voeux. Au total environ 200 cartes différentes furent éditées. Pour illustrer le thème bien précis de ces cartes postales,

reproduced in smaller sizes and about sixteen in larger formats. Yvon edited 137 postcards of Peynet's dolls, which represented around 70% of the total output, and these became a collector's dream during the 1950s and 1960s. They were so popular that some of the dolls were created simply for photographic purposes and were never intended to be sold as dolls.

Peynet created series of publicity postcards for The Red Cross, the National Lottery, the Blood Donor Service, and other charities, some of his posters were produced in postcard format. There was great demand for *The Lovers*, on St Valentine's Day and for special occasions such as weddings, Christmas and New Year. Several series of postcards were produced by different publishers. The twelve lithographs of the signs of the zodiac were printed as postcards by Editions des Maîtres Contemporains, and the Peynet Museum in Antibes issued postcards of Peynet's drawings. In Japan, Peynet postcards, using drawings from past publications, are still being published.

Collections of Peynet postcards are widespread. The lists on p103 cannot guarantee to be fully complete but are a comprehensive guide and, hopefully, a stimulus for further discoveries.

des poupées furent parfois spécialement habillées à cette fin, mais non commercialisées.

De nos jours, quand on pense carte postale Peynet, la série des poupées vient immédiatement à l'idée. Elle représentait à l'époque 70% de la production totale des cartes postales Peynet.

Peynet créa également d'autres cartes postales, souvent publicitaires: Loterie Nationale, Don du Sang, Croix Rouge, Coeur Artificiel... Différentes villes eurent leurs propres cartes Peynet personnalisées.

A l'occasion de la sortie du timbre dessiné par Peynet pour la St Valentin en 1985, de nombreuses cartes furent produites avec l'oblitération premier jour. Il existe une série très rare de cartes postales en noir et blanc, éditée en 1958 pour l'Exposition Universelle de Bruxelles.

Les douze lithographies aux eaux-fortes que Peynet avait créées avec les signes du zodiaque furent reproduites en cartes postales par les Editions des Maîtres Contemporains.

Le Musée Peynet à Antibes en édite toujours un certain nombre en exclusivité. Au Japon également, le Musée Peynet à Karuizawa en crée régulièrement tous les ans.

La collection des cartes postales est très populaire. Les listes à la page 103 de cet ouvrage, bien que méticuleusement établies, ne peuvent être garanties complètes à 100%, car Peynet ne tenait pas une comptabilité scrupuleuse de tous ses dessins, mais elles serviront de guide et, espérons-le, éveilleront un instinct de recherche et un espoir de nouvelles découvertes.

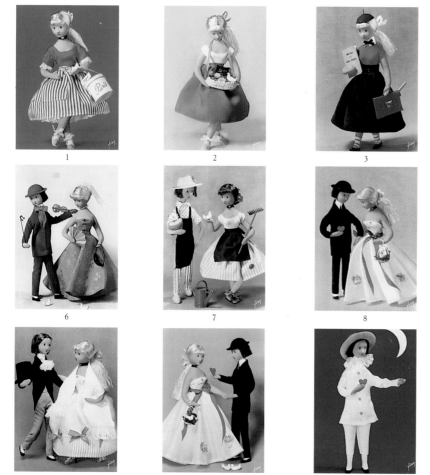

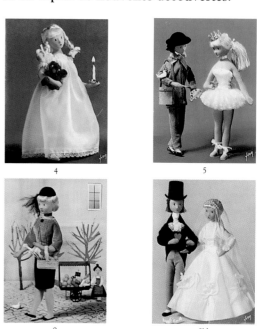

Postcard series of *Peynet Dolls*, 1953-1968. The numbers correspond to the titles listed on page 103.
Série des cartes postales *Les Poupées de Peynet*, 1953-1968. Les numéros correspondent aux titres qui se trouvent à la page 103.

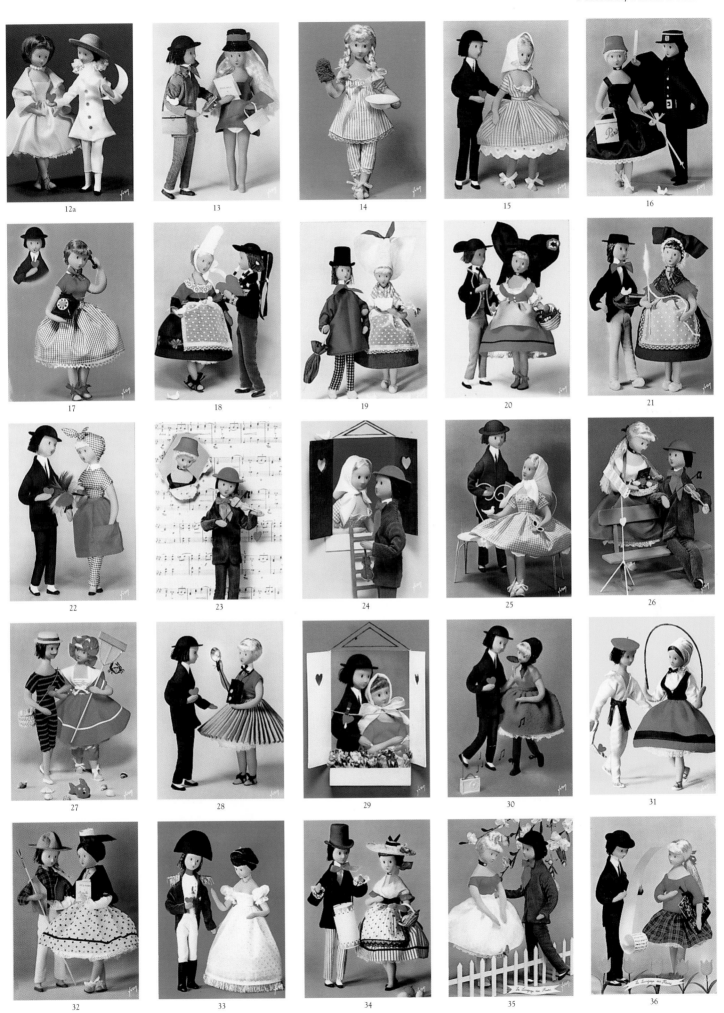

12a

13

14

15

16

17

18

19

20

21

22

23

24

25

26

27

28

29

30

31

32

33

34

35

36

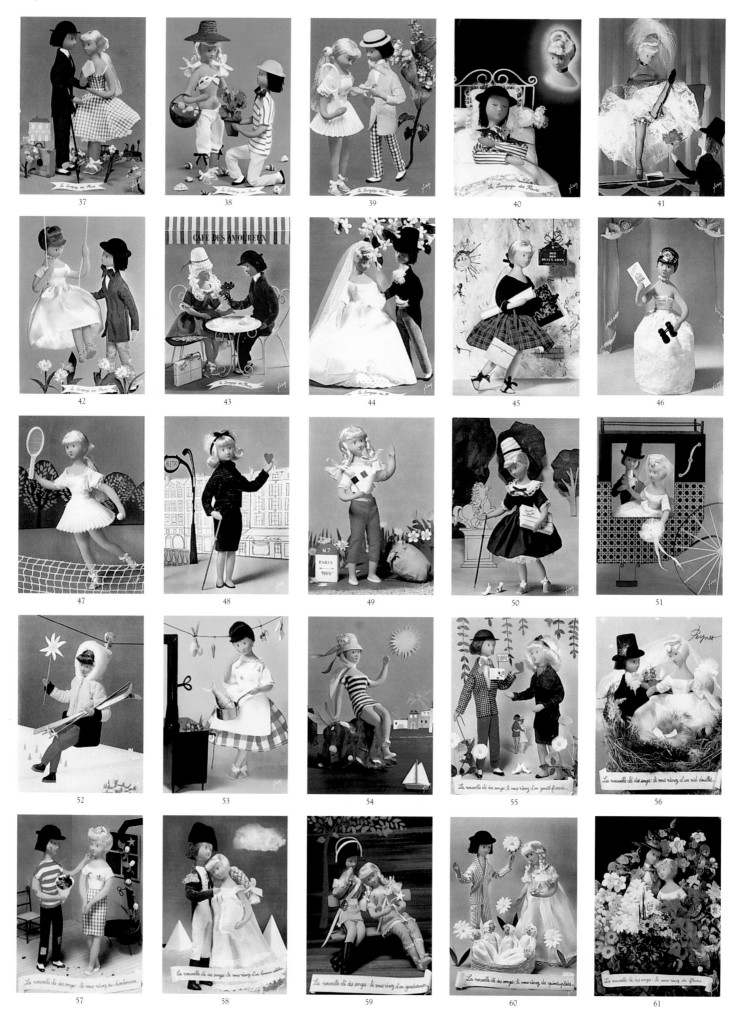

37

38

39

40

41

42

43

44

45

46

47

48

49

50

51

52

53

54

55

56

57

58

59

60

61

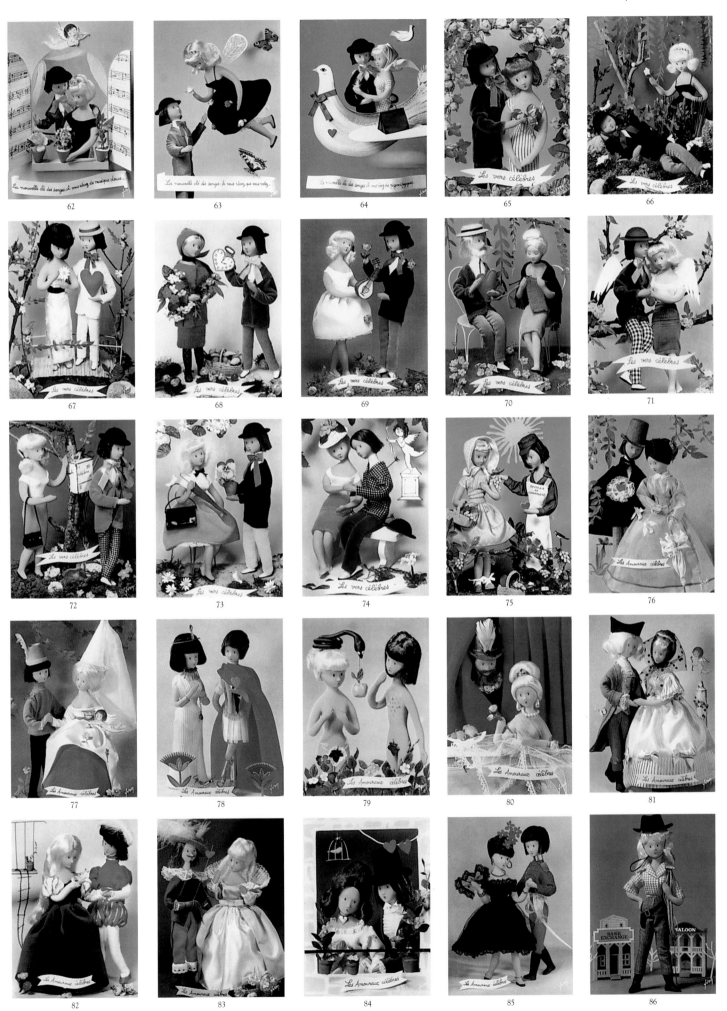

62

63

64

65

66

67

68

69

70

71

72

73

74

75

76

77

78

79

80

81

82

83

84

85

86

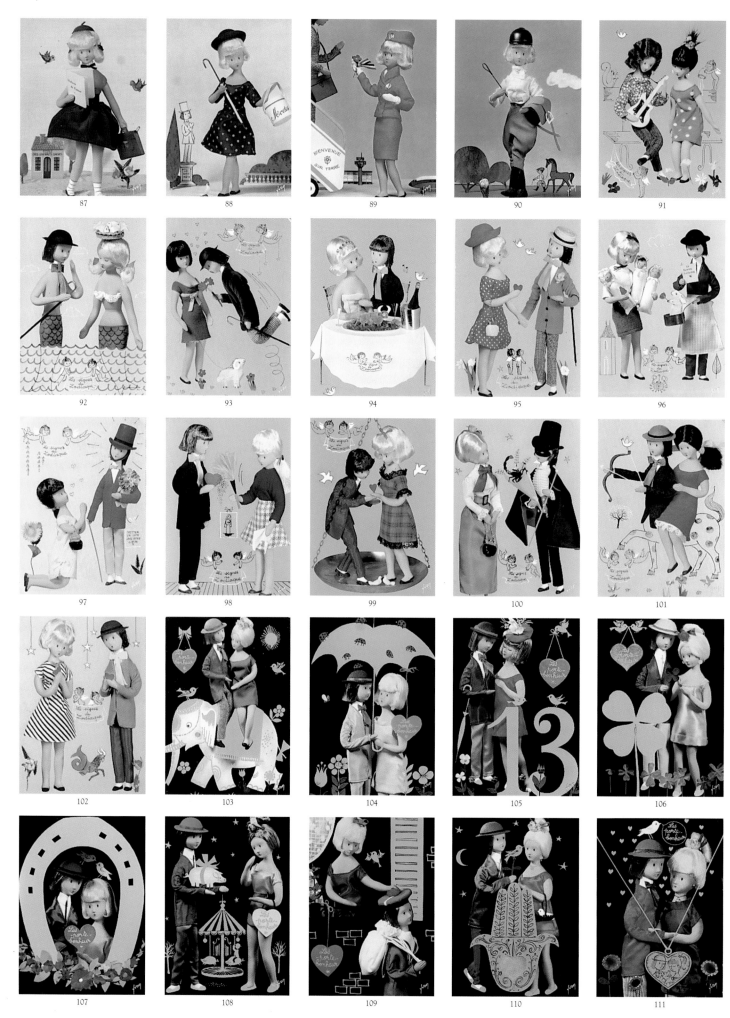

87 88 89 90 91

92 93 94 95 96

97 98 99 100 101

102 103 104 105 106

107 108 109 110 111

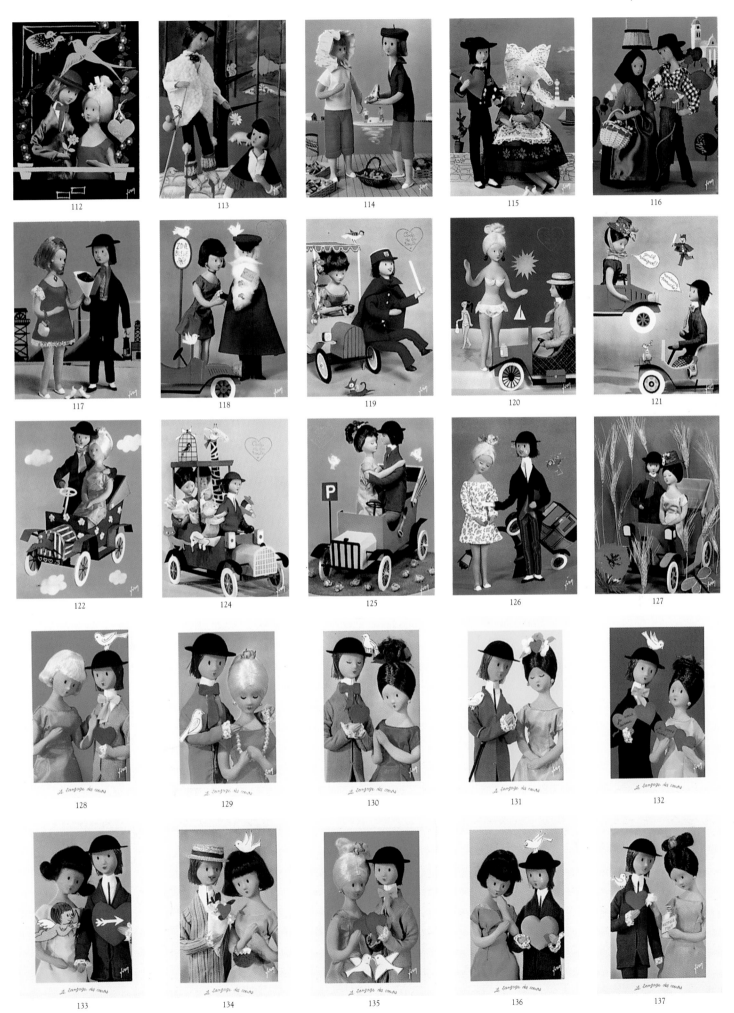

112

113

114

115

116

117

118

119

120

121

122

124

125

126

127

128

129

130

131

132

133

134

135

136

137

TEN LARGE FORMAT POSTCARDS OF *PEYNET'S DOLLS*
DIX CARTES POSTALES GRAND FORMAT: SERIE *LES POUPEES DE PEYNET*

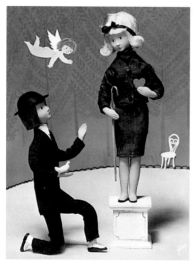

E.K.G. 190. *The Garden of Lovers/**Le Jardin des Amoureux.***

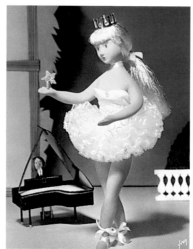

E.K.G. 189. *Once upon a time there was a Ballet Dancer…/**Il était une fois une Danseuse Etoile…***

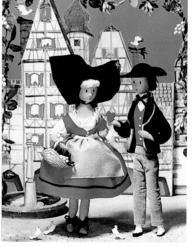

E.K.G. 13. *Memories from Alsace/**Souvenir d'Alsace.***

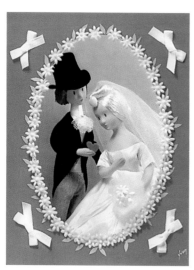

E.K.G. 187. *Happiness for a Lifetime/**Du Bonheur pour toute la Vie.***

E.K.G. 350. *Sleeping Beauty/**La Belle au Bois Dormant.***

E.K.G. 352. *Hi Chicks!/**Salut les Poussins!***

E.K.G. 127N. *The Magician/**La Magicienne.***

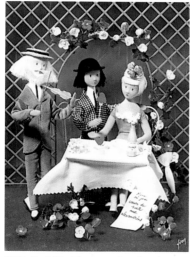

E.K.G. 353. *Pleasure Gardens/**La Guinguette.***

E.K.G. 351. *A Thatched Roof and a Heart/**Une Chaumière et un Coeur.***

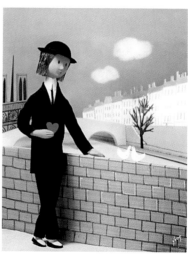

E.K.G. 188. *I shall wait for you all my Life/**Je vous attendrai toute la Vie.***

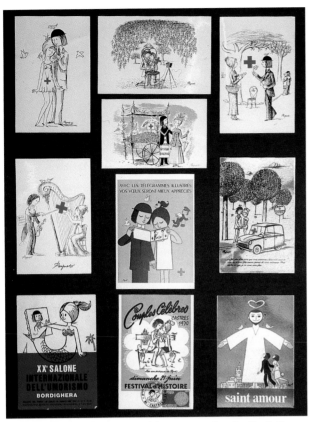

Series of postcards designed by Peynet for the Red Cross, the Humorist Show in Bordighera, the Festival in Castres, etc., c.1970. **Cartes postales dessinées par Peynet pour la Croix Rouge, le Salon des Humoristes à Bordighera, le Festival de Castres etc., c.1970.**

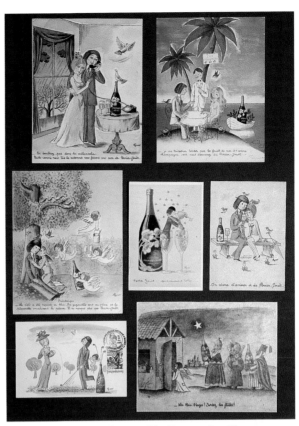

Series of postcards designed by Peynet for Champagne Perrier-Jouët, 1970s-80s. **Cartes postales dessinées par Peynet pour le Champagne Perrier-Jouët, années 70-80.**

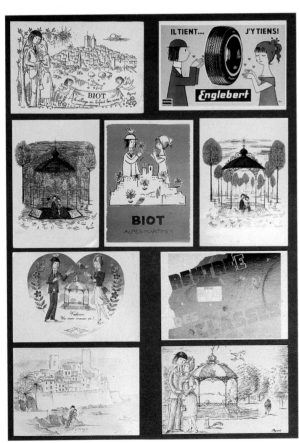

Series of postcards designed by Peynet for publicity purposes, 1950s-80s. **Cartes postales dessinées par Peynet à but publicitaire, années 50-80.**

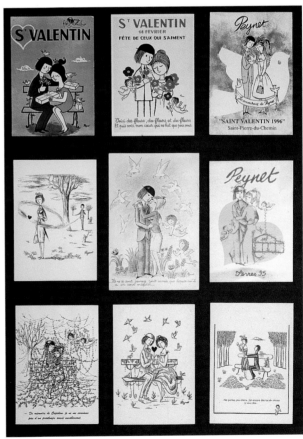

Series of postcards designed by Peynet to celebrate St. Valentine's Day and lovers all over the world, 1960s-90s. **Cartes postales dessinées par Peynet pour célèbrer la St. Valentin et tous les amoureux du monde, années 60-90.**

Postcards designed by Peynet for publicity purposes, 1950s-80s. **Cartes postales dessinées par Peynet à but publicitaire, années 50-80.**

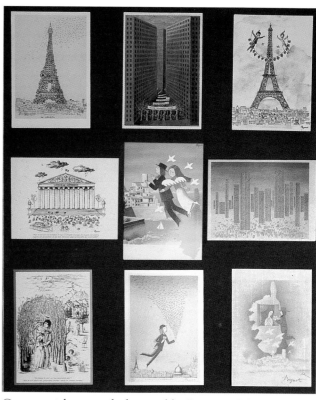

Commercial postcards designed by Peynet, 1960s-80s. **Cartes postales dessinées par Peynet, années 60-80.**

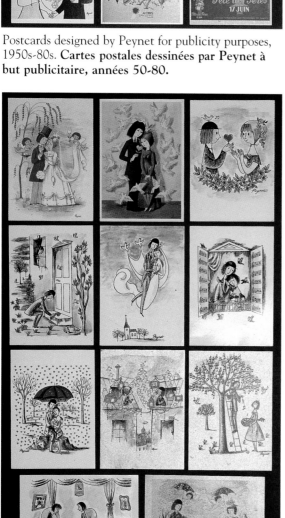

Commercial postcards designed by Peynet, 1960s-80s. **Cartes postales dessinées par Peynet, années 60-80.**

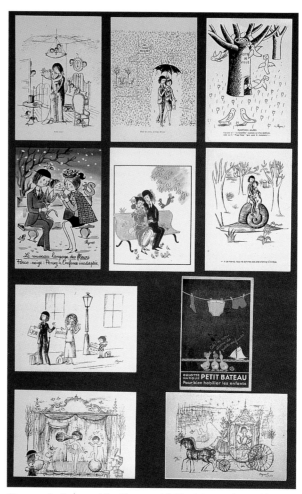

Postcards designed by Peynet 1960s-80s, and a publicity postcard for Petit Bateau underwear for children, c.1930. **Cartes postales dessinées par Peynet, années 60-80, et une carte postale publicitaire pour Petit Bateau, c.1930.**

DOLLS

POUPEES

Peynet had an abiding interest in designing stage sets and costumes for the theatre. When asked by the Galeries Lafayette to decorate one of their Christmas windows, Peynet used large dolls and, later, decided to produce a series of smaller dolls based on his *Lovers*. He did this in collaboration with the firm Technigom which was situated in Montrouge near Paris.

The dolls were made around a wire core frame placed into a mould into which liquid latex was poured. The dolls (with the exception of a few that were produced in mini-sizes of 10cm) were all 21cm high with hand-painted eyes.

Peynet took great trouble and care in selecting the material and cloth used for the dolls' costumes which were all designed by him. The patterns were then made from his drawings by the firm Martine in Paris. Outworker seamstresses meticulously made the clothes and dressed each doll individually in garments to suit its personality.

During his association with Technigom from 1953 to 1968, Peynet created more than 200 different dolls. The dolls reflected the fashions, occupations, customs and leisure time of French society of that period and were an enormous commercial success selling over five million.

When Queen Elizabeth II visited France in 1957, President Coty asked Peynet to design costumes for his dolls to represent the different areas of Paris – these dolls were then presented to the Queen as a gift for the young Princess Anne.

A few dolls were created only to be photographed for the postcard market and, therefore, were never produced for sale.

In 1964, Technigom produced *Sophie*, a Peynet doll that could be dressed and undressed. She had a series of clothes for all occasions as well as a set of amusing accessories but *Sophie*, who was in direct competition with the very popular American doll, *Barbie*, enjoyed only modest success.

In 1997, the firm Masport, using a new rubber material, produced four new dolls based on Peynet's design and more are to follow.

Caroline, Princess of Monaco owns a collection of nearly 200 Peynet dolls. They are on permanent exhibition at the Musée National de Monaco and are, without doubt, one of the most complete collections.

The list on page 106 indicates all the dolls created from 1953 - 1968.

Après la guerre, Peynet créa de nombreux décors et costumes pour le théâtre et l'opéra. Pour chaque Noël, les Galeries Lafayette à Paris lui demandèrent de concevoir des vitrines animées. Des poupées grandeur nature furent créées à l'image des *Amoureux*. Ceci donna l'idée à la Société Technigom à Montrouge de fabriquer une poupée en mousse de latex de 21cm avec armature en fer à l'effigie du poète et de l'amoureuse. L'originalité, car nous étions en 1953, résidait en la forme de la poupée. C'était une femme en miniature, donc les costumes taillés par la société Martine devaient être à l'image de la femme de l'époque. Le poète était une personification du dessin de Peynet qui paraissait dans la presse. Jusqu'à présent les petites filles avaient comme poupée des baigneurs habillés en fille.

250 modèles environ furent produits. Ces poupées reflétaient la société de l'époque avec sa mode, ses métiers, ses loisirs et ses coutumes. Elles eurent un gros succès commercial en Europe et se vendirent à plus de 5 millions d'exemplaires en 15 ans.

A la venue de la Reine d'Angleterre à Paris en 1957, le Président Coty demanda à Peynet de dessiner des costumes qui représenteraient les différents quartiers de Paris, pour les offrir à la jeune Princesse Anne.

Dans les années 60, quand on s'apperçut que la mousse de latex s'abimait, la Société Reyvor fabriqua une douzaine de poupées Peynet en caoutchouc, sans armature, maintenant très rares à trouver.

En 1964, la Société Technigom sortit une poupée mannequin *Sophie* avec de nombreux accessoires. Elle était trop parisienne et entrait en compétition avec *Barbie*, récemment créée. *Sophie* n'eut qu'un succès modeste.

En 1997, la Société Masport a décidé de refabriquer la poupée Peynet dans un matériau synthétique pour que le temps n'ait pas d'emprise sur elle: une dizaine de modèles vont voir le jour.

Le Musée National de Monaco a reçu 200 poupées: la collection de la Princesse Caroline. Ces poupées sont en exposition permanente et sont périodiquement exposées dans diverses villes de France. C'est la collection, à ce jour, la plus complète.

La liste à la page 106 répertorie toutes les poupées créées entre 1953 et 1968.

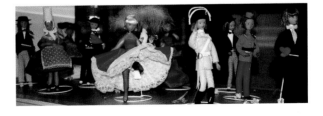

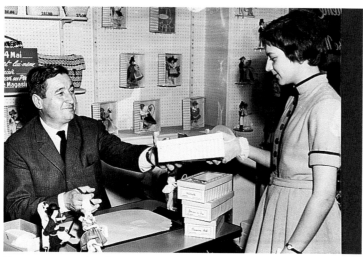

Peynet signing his dolls. Promotion campaign, 1955.
Peynet dédicace ses poupée. Promotion publicitaire, c.1955.

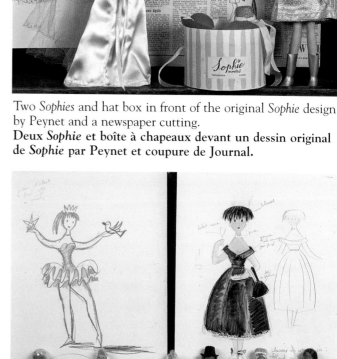

Two *Sophies* and hat box in front of the original *Sophie* design by Peynet and a newspaper cutting.
Deux *Sophie* et boîte à chapeaux devant un dessin original de *Sophie* par Peynet et coupure de Journal.

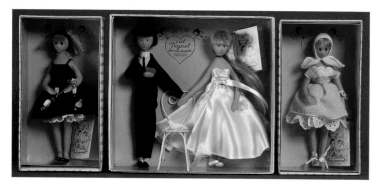

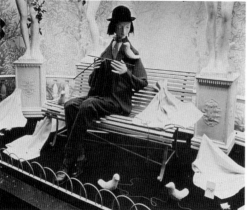

Above: four new dolls.
En haut: quatre nouvelles poupées. Société Masport, Saumur, 1997.

Left: Galeries Lafayette shop window designed by Peynet. **A gauche: Galeries Lafayette Vitrines par Peynet.** Paris c.1950.

A row of mini-size dolls in front of two original designs for dolls by Peynet.
Quelques poupées, taille mini, devant deux dessins originaux de Peynet pour poupées.

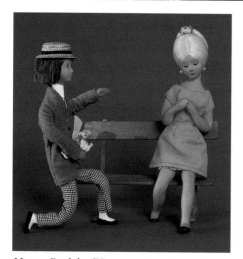

Happy Birthday/**Heureux Anniversaire,** c.1960.

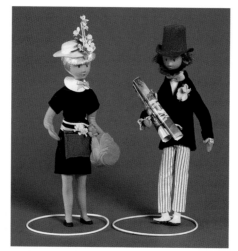

Left: *My Milliner*; right: *Qualified Illusionist*. **A gauche: Ma Modiste; à droite: Illusioniste Diplômé,** c.1960.

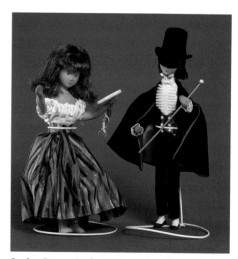

Left: *Gipsy Girl*, 1958; right: *Rocambole*, 1965. **A gauche: Gitane, 1958; à droite: Rocambole, 1965.**

RECORDS

DISQUES

During the 1950s and 1960s Peynet was approached by artists and record companies to design, or participate in the design of their record sleeves. Artists reflected the widespread popularity of Peynet's *Lovers*. The popular French singer, Marcel Amont, recorded two songs in homage to Peynet – *Les Poupées de Peynet*, written by White and Landy and *Les Amoureux de Papier* written by Charles Aznavour. Georges Brassens, a serious singer-poet renowned through France for the quality and punchiness of his lyrics, acknowledged that his song, *Bancs Publics*, was directly inspired by *The Lovers*.

Peynet generally produced original drawings for record covers and adapted some of his press drawings to suit the artist or the music. To illustrate the covers of Odette Laure and Cora Vaucaire's records, he even drew a caricature of the singers themselves.

It should also be mentioned that in the 1930s, Peynet drew the covers for several pieces of sheet music which are now extremely rare.

A list of record sleeves designed by Peynet is on p108.

C'est dans les années 50 et 60 que des maisons de disques demandèrent à Peynet de décorer des pochettes d'artistes connus.

Marcel Amont, chanteur populaire qu'on surnommait *L'Amoureux de Peynet* en bénéficia. Il enregistra deux morceaux en hommage à Peynet: *Les Poupées de Peynet* de D. White et *Les Amoureux de Papier* de Charles Aznavour. Il est évident que la popularité des *Amoureux* était telle que Georges Brassens, pour écrire la chanson *Bancs Publics* s'en était inspiré.

Peynet créa des dessins pour d'autres artistes, notamment Odette Laure et Cora Vaucaire, dont il dessina les caricatures pour illustrer leurs pochettes de disques. Comme il faisait parallèlement des décors de théâtre et d'opéra, Peynet fut invité à créer les pochettes des *Noces de Jeannette* de Victor Massé. A cette fin, il utilisa les décors qu'il avait conçus pour l'Opéra Comique.

Dans le registre musical, il ne faut pas oublier de mentionner que Peynet, dès 1930, fit de nombreuses couvertures de partitions musicales qui sont maintenant très difficiles à trouver. La liste des pochettes de disques dessinées par Peynet apparaît page 108.

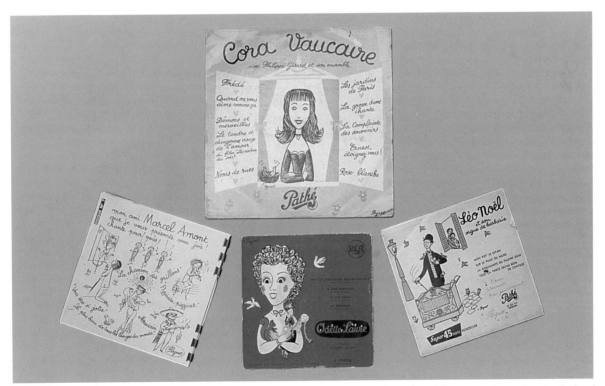

Top/en haut: *Cora Vaucaire*. LP Album /33 **Tours** (25cm), Pathé; with Peynet's drawing of the singer/avec **dessin de la chanteuse par Peynet.**
Left/ à gauche: *Sonorama no.39.* Peynet drawing inside the cover with his signed text for Marcel Amont/dessins de Peynet dans la **revue accompagné d'un texte pour Marcel Amont et signé.** April/**Avril** 1962.
Centre/**au centre:** *Odette Laure.* Single EP/**45 Tours,** R.C.A; with Peynet's drawing of the singer/avec dessin de la chanteuse par **Peynet.**
Right/ **à droite:** *Leo Noel and his Barrel Organ/**Léo Noël et Son Orgue de Barbarie.** Single EP/**45 Tours,** Pathé.

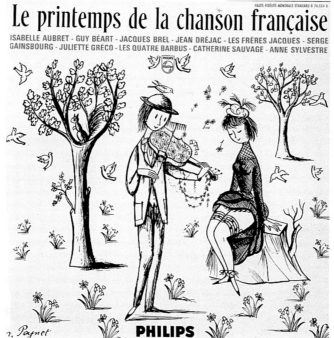

*Springtime of the French Song/**Le Printemps de la Chanson Française.** Album LP/**33 Tours,** Philips.

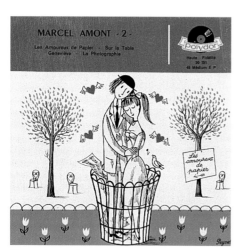

*Paper Lovers/**Les Amoureux de Papier,** Marcel Amont. Single EP/**45 Tours,** Polydor.

Air Love (Japanese record/**Disque Japonais). Single/**45 Tours,** Canyon.

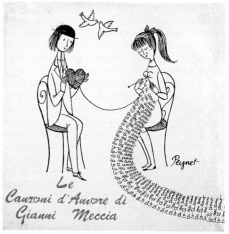

*Le Canzione d'Amore. (Love Songs/**Chansons d'Amour**), Gianni Meccia. Album LP/**33 Tours,** RCA Italiana.

*Songs from when we were Twenty/**Chansons de nos 20 ans** (Vol. 2), Lina Margy.* Album LP/**33 Tours,** CBS.

Beethoven Symphonie No.6 Pastorale, Vienna Philharmonic Orchestra/ **Orchestre Philharmonique de Vienne.** Album LP/**33 Tours,** HMV.

*Jeannette's Wedding/**Les Noces de Jeannette,** Orchestre National Opera Comique.* Album LP/**33 Tours,** (25cm) Pathé.

LIMITED EDITION PRINTS
LITHOGRAPHIES

In 1966 Peynet produced a series of four small prints for Arnaud de Vesgre, an art publisher in Neuilly near Paris. The prints were published in limited editions of 200 and represented a departure from Peynet's previous work. They were an extension, in colour, to his usual black and white drawings and Peynet enjoyed the lithographic process.

The success of this venture encouraged Peynet but the enormous demand for his other work did not allow him the time to continue producing limited edition prints at this time. However, he began to work again with Arnaud de Vesgre and in 1975 he produced *L'Oiseau Bleu*, The Blue Bird. This was the first large-size print in a series, which was to span nearly twenty years, include approximately 100 images, and would occupy Peynet until the end of his career. *L'Oiseau Bleu* combined pure romanticism and a touch of surrealism – *The Lovers* were placed on a highly decorated bird, flying with other birds over an 'Italianesque' empty city with hills in the background and lit by moonlight. The blue tones gave a ghostly feel to the painting.

This powerful image was followed by another gouache painting in 1976 which Peynet entitled *Le Fil de Lune*, The Thread of the Moon. It is, again, a moonlit scene showing the lovers sitting on a park bench. The little poet has one arm around his lady's shoulders, while she knits a thread which is coming directly from the moon. The charming composition of this beautiful painting, again in tones of blue and white, is very atmospheric and romantic. These two paintings represented a clear change of direction – Peynet had found another way in which to express his talent.

L'Oiseau Bleu and *Le Fil de Lune* were each printed in a limited edition of 250, and were numbered, titled and signed by Peynet. In the same year he produced a more conventional picture, *L'Arbre au Coeur*, The Heart Tree. Having bought a magnificent harp from an antique shop, Peynet painted the bride and groom with the harp on their wedding day. He used the same composition in another, later, painting, but this time with the *Lovers* and using a different colour scheme and background – creating two very distinct pictures.

Most of the prints Peynet produced with Arnaud de Vesgre in the 1970s were in editions of 250. As an experiment, some included 36 copies printed on rice paper while the others were printed on art paper. Peynet worked with the printer Deprest, in Paris, and was involved in every process of the printing which he understood from his early training at the Ecole des Arts Appliqués.

In 1979 Peynet produced *Le Chasseur d'Etoiles* and, in 1984, *Les Amoureux dans les Etoiles* using a Chagallesque

En 1966 Peynet produisit une série de quatre petites lithographies pour Arnaud de Vesgre, éditeur d'art à Neuilly, près de Paris. Elle furent publiées en édition de 200 et marquèrent un nouveau départ dans l'oeuvre de Peynet. Bien que ces quatre lithographies n'aient été que des dessins coloriés, Peynet aimait l'idée du processus lithographique qui lui permettrait de vendre ses images sous forme de tableaux.

Peynet fut encouragé à se lancer dans cette nouvelle entreprise mais il avait tellement d'autres travaux en cours qu'il dut remettre à plus tard son retour à la lithographie. Il recommença à travailler avec Arnaud de Vesgre et en 1975 sortit *L'Oiseau Bleu*, la première étape d'une oeuvre qui allait s'étendre sur près de vingt ans, consister d'environ cent images et occuper Peynet jusqu' à la fin de sa carrière. *L'Oiseau Bleu* associait le romantisme avec une touche de surréalisme: *Les Amoureux*, placés sur un oiseau très décoré, survolaient, accompagnés d'autres oiseaux, une cité de style italien vide sur fond de collines, le tout éclairé par la lune. Les tons bleus ajoutaient une sensation spectrale au tableau.

L'année suivante sortit *Le Fil de Lune* qui représentait *Les Amoureux* assis sur un banc, dans un jardin public encore une fois au clair de lune. Le petit poète, avait un bras autour des épaules de son amie qui tricotait, en utilisant un fil qui se déroulait depuis la lune. C'était une très belle peinture à la gouache. Peynet utilisa de nouveau des tons bleus et la composition en était très atmosphérique, romantique et charmante. Peynet avait encore une fois trouvé un nouveau moyen d'exprimer son talent.

Ces deux tableaux furent imprimés en édition de 250, chacun numéroté, titré et signé. Ces lithographies se vendirent très bien et elles sont maintenant rares et difficiles à trouver.

La même année Peynet produisit *L'Arbre au Coeur*, une image plus conventionnelle des *Amoureux*. Ayant acquis une magnifique harpe dans un magasin d'antiquité, Peynet décida de la peindre autour d'un couple de mariés. Plus tard il utilisa la même harpe, et en plaçant *Les Amoureux* au lieu des mariés, en les peignant sur un fond différent, il créa deux images bien distinctes.

La plupart des lithographies publiées par Arnaud de Vesgre étaient tirées en édition de 250. Quelques unes comprenaient un tirage sur papier Japon mais les autres étaient sur Velin d'Arches. Peynet travaillait avec l'imprimeur Deprest à Paris et il pouvait contrôler tous les stades de l'imprimerie et de la couleur, grâce à la

style of composition – again in single tones of blue and white – to create two charming pictures. These were produced in limited editions of 190 and 180 respectively, and twenty artist's proofs, all on art paper.

Peynet produced prints for Arnaud de Vesgre until 1984. These included a series of twelve lithographs entitled *Lettres de Mon Moulin*, illustrating the popular book by Alphonse Daudet which gave Peynet the opportunity to work without using *The Lovers*. He also produced *Les Coeurs, Les Amoureux, Les Fleurs* which seemed to indicate a change in style. This was painted with boldly coloured flowers and foliage reminiscent of the Fauvist movement and reflected Peynet's admiration for Henri Rousseau, Le Douanier, which was again shown in a similar style of painting on two later pictures. Another print *La Noce*, published in 1982, had a naive quality. It is obvious, with hindsight, that Peynet was having fun experimenting with different styles of painting and composition.

Peynet's major output in limited edition prints was with Les Editions des Maîtres Contemporains from Agay, near St. Raphael in the south of France with whom he worked from 1976 to 1987. There he produced about 35 limited edition prints, including a series of four prints representing the seasons, and a series of twelve etchings depicting the signs of the zodiac which he engraved himself at Rigal, the engraver in Fontenay-aux-Roses, near Paris. All the prints published by Les Editions des Maîtres Contemporains were in limited editions of 250 and 25 artist's proofs on art paper, numbered in the left-hand corner and signed in the right-hand corner.

In 1985, Les Editions des Maîtres Contemporains published 34 chromolithographs on glossy card using some of the images from the limited edition prints. These were sold with the 2F10 stamp that Peynet had designed for the French Post Office and the engraved markings of the St. Amour and St. Valentin post marks. The prints were produced in editions of 900 copies.

Between 1987 and 1991 Peynet produced seven prints especially designed to be sold in Japan. These were printed by Perrin in Paris and published in signed, limited editions of 250.

In the 1980s Peynet produced various prints for his private use, or for sponsored publications such as the Champagne Perrier-Jouët. These were used on special occasions or for Christmas and New Year greetings.

Finally, between 1986 and 1994 when he stopped working, Peynet, living in Provence, worked in collaboration with a local publisher, Agostini of Grasse. He produced twelve prints in limited editions of 250.

formation qu'il avait acquise à l'Ecole des Arts Appliqués.

En 1979 Peynet sortit *Le Chasseur d'Etoiles* et en 1984 *Les Amoureux dans les Etoiles*, utilisant une composition de style Chagall et encore une fois des tons bleus pour créer deux images charmantes. Elles furent tirées respectivement en édition de 190 et 180 ainsi que vingt épreuves d'artiste, toutes sur papier Arches.

Peynet produisit des lithographies pour Arnaud de Vesgre jusqu'en 1984. Parmi d'autres, il y avait une série de douze lithogravures intitulées: *Lettres de Mon Moulin* illustrant le livre célèbre d'Alphonse Daudet et donnant ainsi à Peynet l'occasion de travailler sans avoir à utiliser *Les Amoureux*. Il produisit également *Les Coeurs, Les Amoureux, Les Fleurs* qui marquaient un changement de style. Cette lithographie était peinte de grosses fleurs pleines de couleurs et de feuillages qui rappelait un peu le mouvement du Fauvisme. Il est vrai que Peynet admirait beaucoup le Douanier Rousseau et qu'un style similaire allait apparaître de temps à autre. Une autre lithographie, intitulée: *La Noce* publiée en 1982 avait un certain penchant vers la peinture naïve. Il est évident que lorsqu'on regarde ces lithographies maintenant, on s'aperçoit bien que Peynet s'amusait à expérimenter avec des styles de peinture et de composition différents.

C'est avec les Editions des Maîtres Contemporains d'Agay, près de St. Raphaël dans le Var, que Peynet produisit le plus grand nombre de lithographies. Il y travailla entre 1976 et 1987 et durant cette période environ 35 lithos furent produites, y compris une série représentant les quatre saisons. De plus, Peynet créa une série de douze lithogravures aux eaux-fortes représentant les signes du zodiaque en travaillant chez le graveur Rigal à Fontenay-aux-Roses. Toutes les lithographies et eaux-fortes publiées aux Editions des Maîtres Contemporains étaient limitées à des éditions de 250 et 25 épreuves d'artiste sur papier Arches, numérotées au bas à gauche et signées au bas à droite.

En 1985, les Editions des Maîtres Contemporains publièrent 34 chromomates sur papier carte glacé utilisant la plupart de leurs lithographies à édition limitée et en tirèrent 900 copies de chaque. Elles furent vendues avec le timbre de 2F10 que Peynet avait dessiné pour La Poste et le timbre incrusté des tampons de St. Amour et St. Valentin. Ces éditions chromomates sont encore trouvables en magasin de nos jours.

Entre 1987 et 1991 Peynet produisit sept lithographies spécialement pour le Japon. Elles étaient imprimées chez Perrin à Paris et toujours en édition de 250, signées par l'artiste.

Pendant les années 80 Peynet créa quelques lithographies pour son usage personnel et pour des particuliers, notamment le Champagne Perrier-Jouët. Elles étaient utilisées pour certaines occasions ou pour des cartes de voeux de Noël et du Jour de l'an.

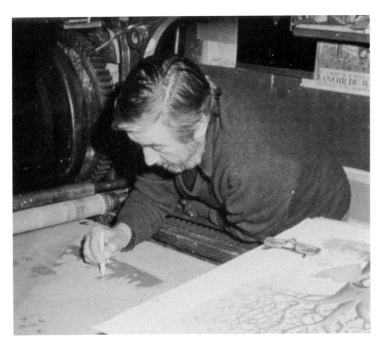

Finalement entre 1986 et 1994, l'année où il s'arrêta de travailler, Peynet collabora avec Agostini, un éditeur de Grasse, car il vivait maintenant en Provence. Il publia chez ce dernier, une douzaine de lithographies toujours en édition de 250.

Peynet working on the lithographic stone at Deprest, Paris, 1976.
Peynet travaillant sur une lithographie chez Deprest à Paris, 1976.

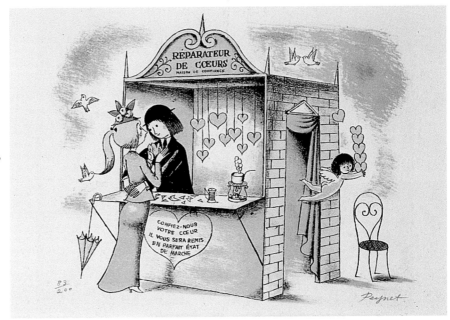

Le Réparateur de Coeurs/The Heart's Mender. Arnaud de Vesgre, 18cm x 24cm, 1966.

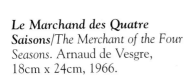

Le Marchand des Quatre Saisons/The Merchant of the Four Seasons. Arnaud de Vesgre, 18cm x 24cm, 1966.

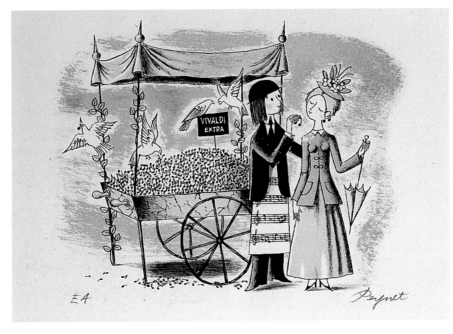

Le Bouquet d'Hirondelles/*The Bouquet of Swallows.*
Arnaud de Vesgre, 26cm x 18cm, 1966.

Lune/*Moon.* Arnaud de Vesgre, 26cm x 18cm, 1966.

Saules Pleureurs/*Weeping Willows.* Editions des Maîtres
Contemporains, 52cm x 38cm, 1976-1985.

Elle m'aime un Peu, Beaucoup, Passionnement.../
She loves me a Little, a Lot, Passionately. Editions des
Maîtres Contemporains, 52cm x 38cm, 1976-1985.

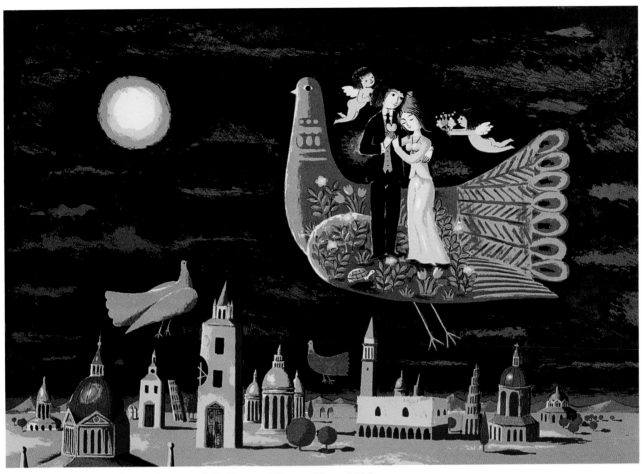

L'Oiseau Bleu/*The Blue Bird.* Arnaud de Vesgre, 38cm x 52cm, 1975.

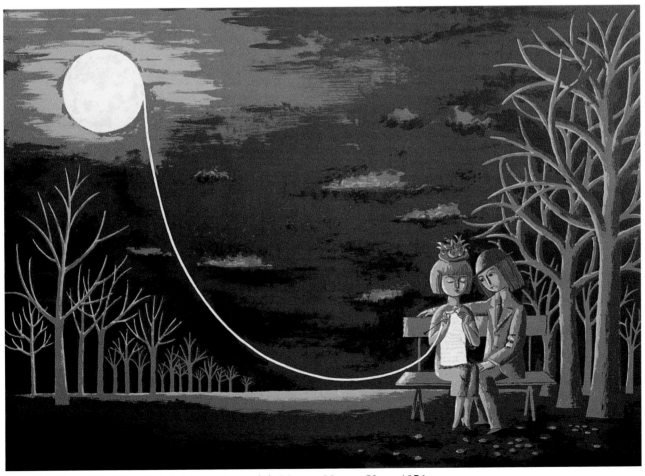

Le Fil de Lune/*The Thread of the Moon.* Arnaud de Vesgre, 38cm x 52cm, 1976.

LES QUATRE SAISONS / THE FOUR SEASONS
EDITIONS DES MAITRES CONTEMPORAINS, 1981

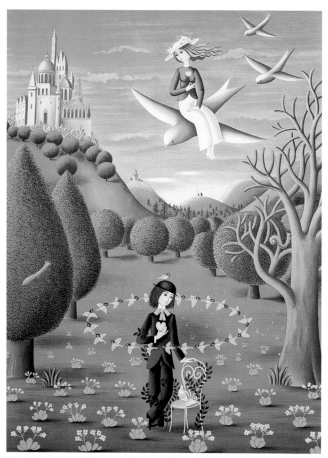

Le Printemps/Spring. 58cm x 43cm.

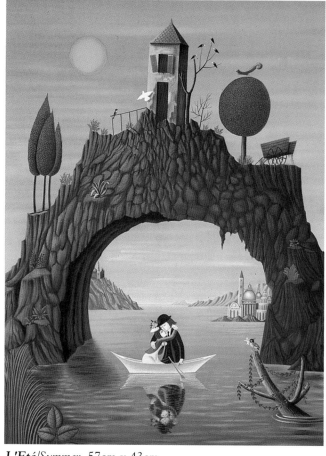

L'Eté/Summer. 57cm x 43cm.

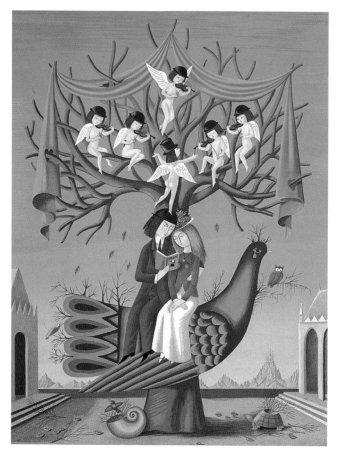

L'Automne/Autumn. 58cm x 43cm.

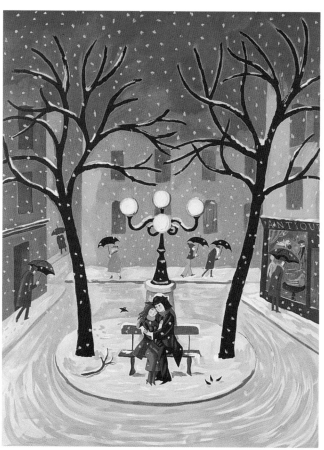

L'Hiver/Winter. 58cm x 44cm.

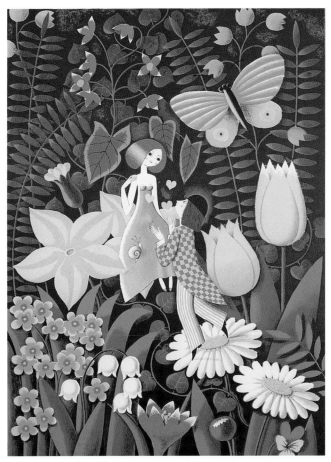

Les Coeurs, Les Amoureux, Les Fleurs/*Hearts, Lovers, Flowers*. Arnaud de Vesgre, 62cm x 44cm, 1977.

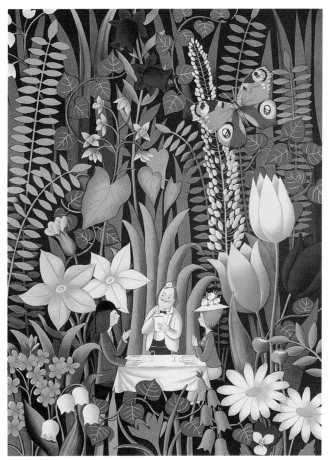

Dîner Chez Pic/*Dinner at the Pic Restaurant*. Editions des Maîtres Contemporains, 56cm x 48cm, 1976-1985.

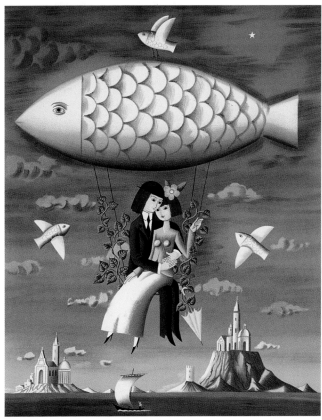

Le Poisson Volant/*The Flying Fish*. Editions des Maîtres des Contemporains, 56cm x 48cm, 1987.

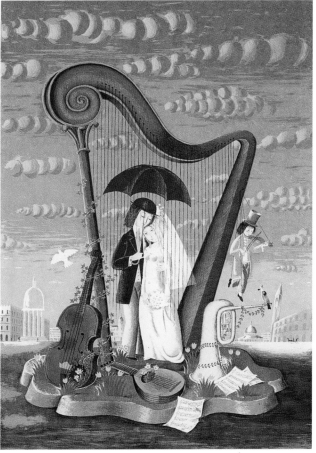

Les Mariés à la Harpe/*The Married Couple with the Harp*. Arnaud de Vesgre, 65cm x 45cm, 1976.

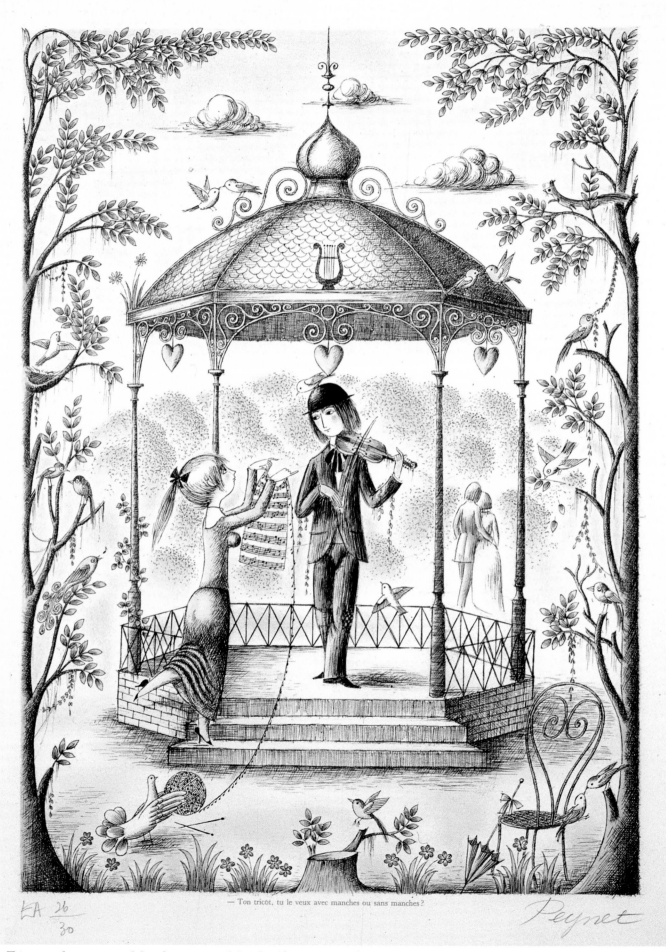

— Ton tricot, tu le veux avec manches ou sans manches?

Ton Tricot, tu le veux avec Manches ou sans Manches?/*Your Jumper, do you want it with Sleeves or without Sleeves? Editions des Maîtres des Contemporains, 52cm x 38cm, 1976-1985.*

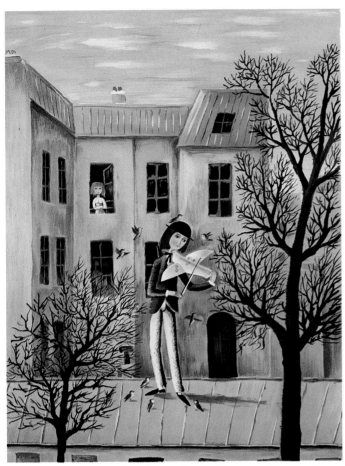

Le Violoniste/*The Violin Player*. Nippon Eurotec, 57cm x 43cm, 1990.

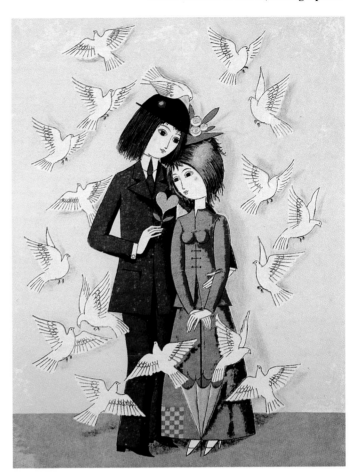

Les Amoureux aux Colombes/*Lovers with Doves*. Arnaud de Vesgre, 51cm x 37cm, 1980.

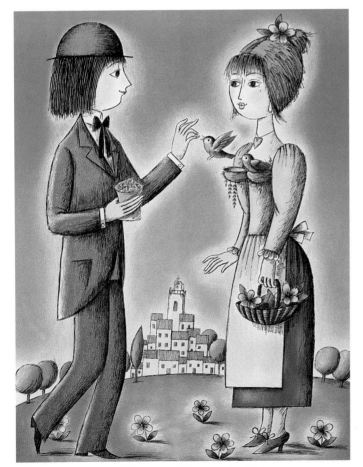

L'Heure du Goûter/*Tea Time*. Editions des Maîtres Contemporains, 52cm x 38cm, 1976-1985.

Il a passé la Nuit chez la Fleuriste…/*He has Spent the Night with the Florist…* Agostini, 46cm x 34cm, 1994.

LES LETTRES DE MON MOULIN / LETTERS FROM MY WINDMILL
ARNAUD DE VESGRE, 42CM X 32CM, 1983

L'Installation/The Arrival.

La Diligence de Beaucaire/The Stage Coach from Beaucaire.

Le Sous-Préfet aux Champs/The Councillor in the Country.

Le Secret de Maître Cornille/The Secret of Cornelius the Miller.

LES LETTRES DE MON MOULIN / LETTERS FROM MY WINDMILL
ARNAUD DE VESGRE, 42CM X 32CM, 1983

Les Trois Messes Basses/The Three Low Masses.

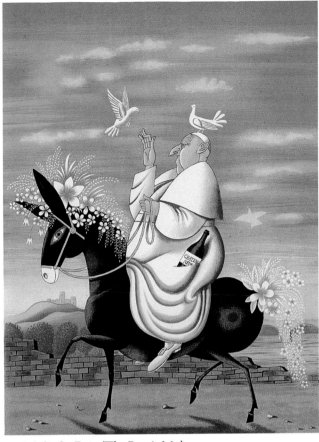

La Mule du Pape/The Pope's Mule.

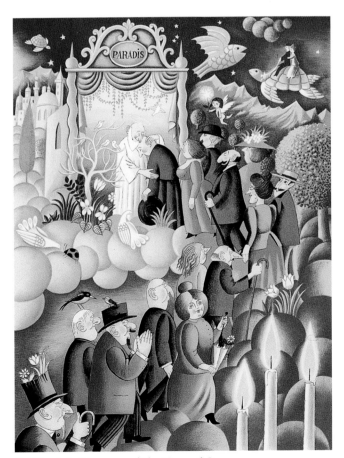

Le Curé de Cucugnan/The Vicar of Cucugnan.

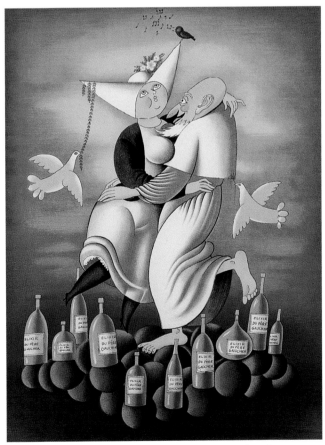

L'Elixir du Révérend Père Gaucher/Reverend Father Gaucher's Elixir.

LES LETTRES DE MON MOULIN / LETTERS FROM MY WINDMILL
ARNAUD DE VESGRE, 42CM X 32CM, 1983

La Chèvre de Monsieur Seguin/Mr. Seguin's Goat.

La Légende de l'Homme à la Cervelle d'Or/The Legend of the Man with the Golden Brain.

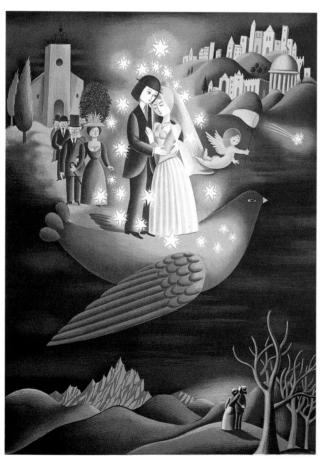

Le Mariage des Etoiles/The Wedding of the Stars.

Nostalgies de Caserne/Nostalgia for the Barracks.

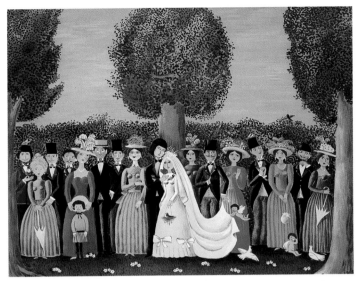

***La Noce**/The Wedding*. Nippon Eurotec, 43cm x 55cm, 1990.

***L'Amoureux**/The Suitor*. Editions des Maîtres Contemporains, 44cm x 59cm, 1987.

***Le Marché aux Oiseaux**/The Bird Market*. Editions des Maîtres Contemporains, 38cm x 52cm, 1976-1985.

***A quoi l'on joue…?**/What shall we play…?* Editions des Maîtres Contemporains, 38cm x 52cm, 1976-1985.

***La Ronde des Angelots**/The Circle of Little Angels*. Editions des Maîtres Contemporains, 44cm x 56cm, 1976-1985.

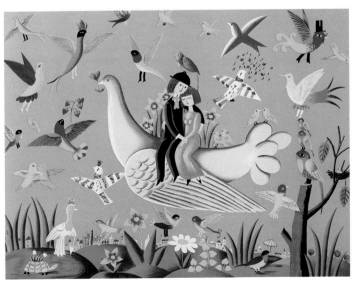

***Au Pays des Oiseaux**/In the Land of the Birds*. Nippon Eurotec, 44cm x 59cm, 1987.

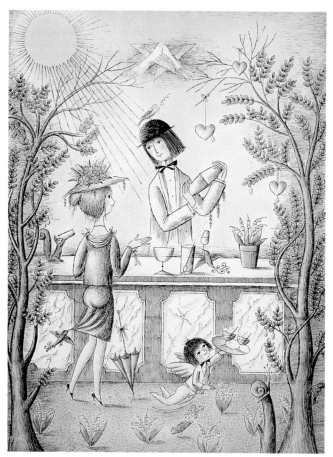

Coquetèle/*Cocktail*. Editions des Maîtres Contemporains, 52cm x 38cm, 1976-1985.

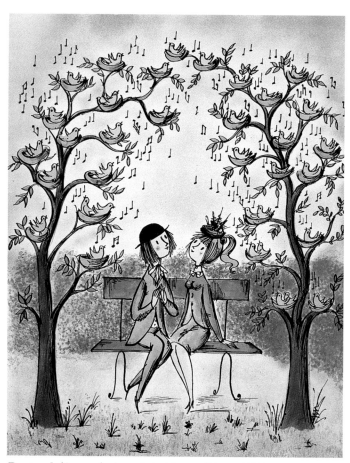

Pastorale/*Pastoral*. Agostini, 46cm x 34cm, 1994.

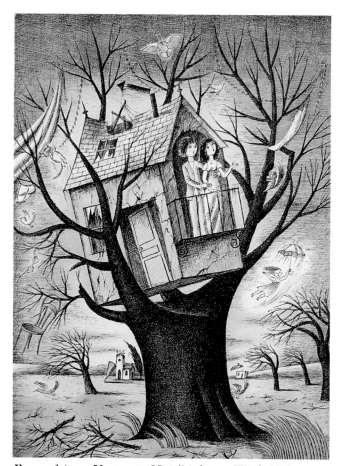

Il en a fait un Vent cette Nuit/*It's been a Windy Night*. Editions des Maîtres Contemporains, 52cm x 38cm, 1976-1985.

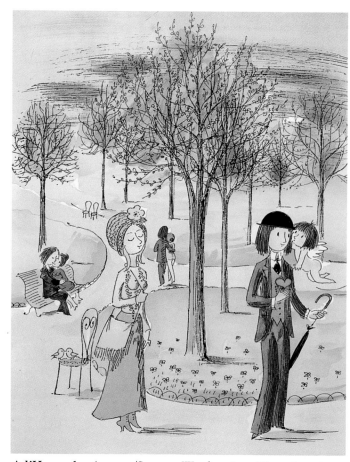

A l'Heure des Amours/*Set your Watch to Love Time*. Agostini, 51cm x 41cm, 1986.

Nos Coeurs sont fait l'un pour l'autre/Our Hearts are made for one another. Editions des Maîtres Contemporains, 52cm x 38cm, 1976-1985.

L'Amoureux Timide/The Shy Lover. Editions des Maîtres Contemporains, 52cm x 38cm, 1976-1985.

Pourquoi veux-tu sortir...?/Why do you want to go out...? Editions des Maîtres Contemporains, 52cm x 38cm, 1976-1985.

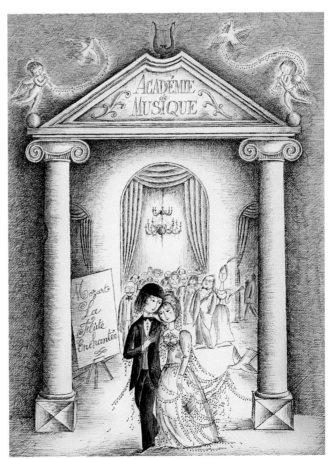

La Flûte Enchantée/The Magic Flute. Editions des Maîtres Contemporains, 52cm x 38cm, 1976-1985.

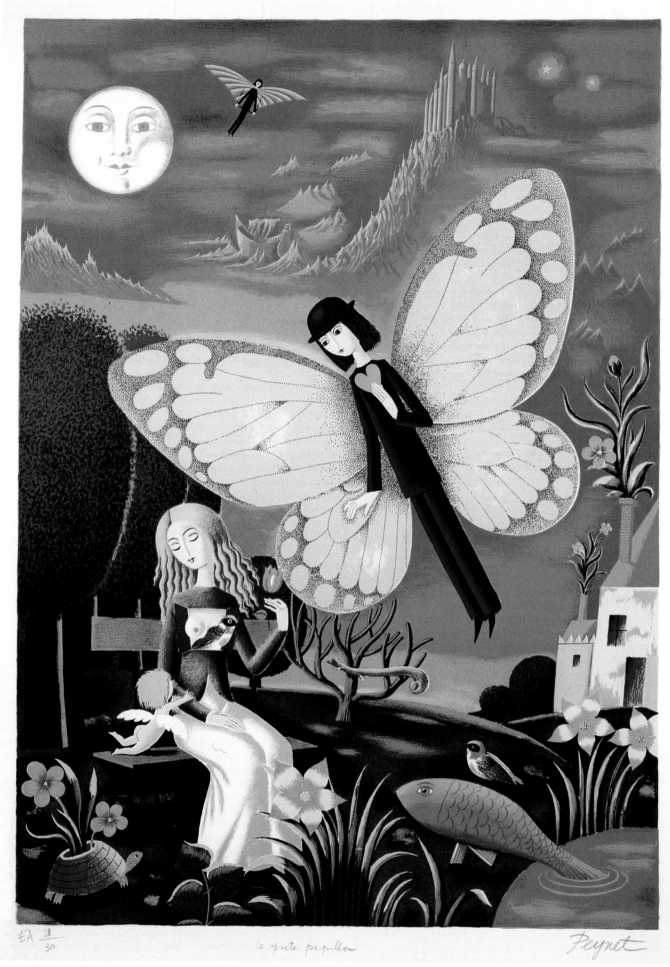

La Belle et le Papillon/*Beauty and the Butterfly*. Arnaud de Vesgre, 62cm x 44cm, 1980.

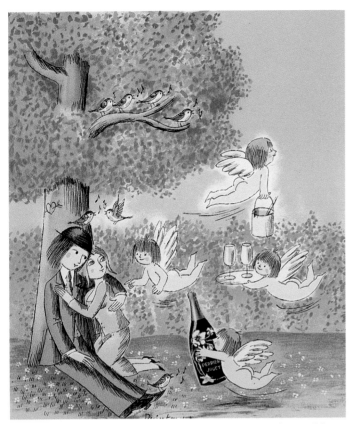

Printemps/*Springtime*. Champagne Perrier-Jouët, 40cm x 33cm, 1987.

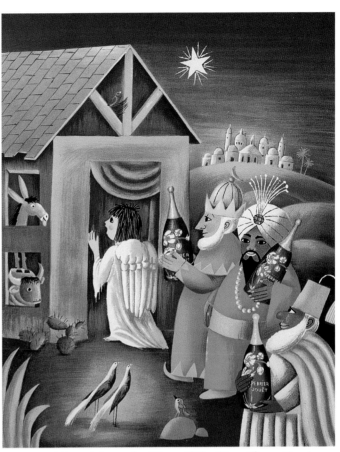

Les Rois Mages! Sortez les Verres!/*The Three Kings! Get the Glasses Out!* Champagne Perrier-Jouët, 42cm x 31cm, 1987.

La Fête au Village/*The Village Fête*. Rotary International, 50cm x 38cm, 1983.

La Maison Fleur/*The Flower House*. Arnaud de Vesgre, 48cm x 34cm, 1977.

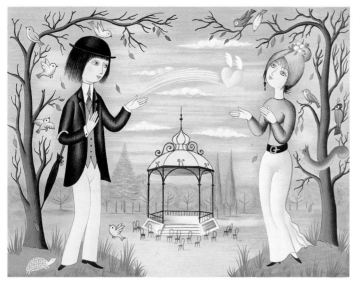

Le Kiosque Rose/*The Pink Bandstand.* Editions des Maîtres Contemporains, 48cm x 56cm, 1976-1985.

La Voie Lactée/*The Milky Way.* Editions des Maîtres Contemporains, 38cm x 52cm, 1976-1985.

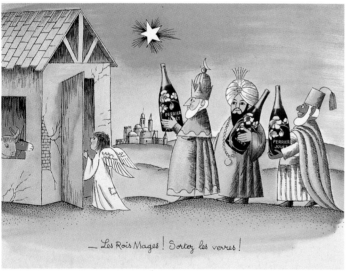

Les Rois Mages! Sortez les Verres!/*The Three Kings! Get the Glasses Out!* Champagne Perrier-Jouët, 31cm x 42cm, 1981.

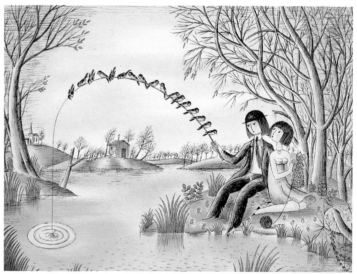

Je crains qu'aujourd'hui tu ne déçoives.../*I Fear that today you are going to disappoint...* Editions des Maîtres Contemporains, 38cm x 52cm, 1976-1985.

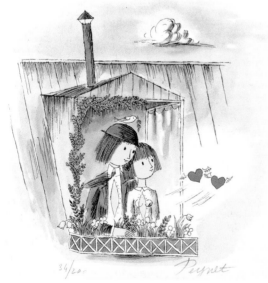

Bonne Année/*Happy New Year.* **Edition Personnelle Peynet**/*Private Edition Peynet,* 21cm x 21cm, 1988.

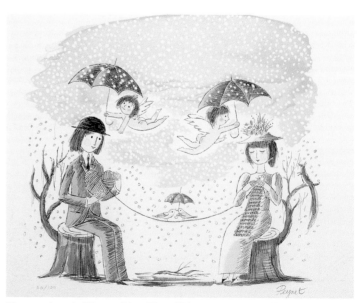

Bonne Année/*Happy New Year.* **Edition Personnelle Peynet**/*Private Edition Peynet,* 37cm x 34cm, 1984.

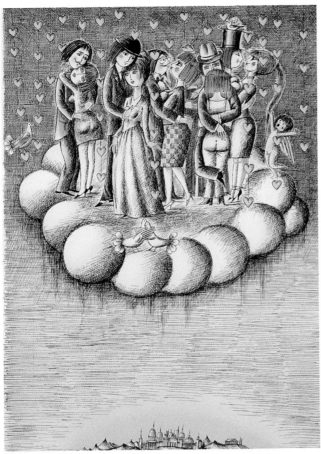

Septième Ciel…*/Seventh Heaven…* Editions des Maîtres Contemporains, 52cm x 38cm, 1976-1985.

L'Education Sexuelle*/Sex Education.* Editions des Maîtres Contemporains, 52cm x 38cm, 1976-1985.

Grand Hôtel du Ciel*/Grand Hotel in the Sky.* Editions des Maîtres Contemporains, 52cm x 38cm, 1976-1985.

Je me demande si la nuit sera assez longue…*/I wonder if the night is going to be long enough…* Editions des Maîtres Contemporains, 52cm x 38cm, 1976-1985.

La Noce/*The Wedding*. Arnaud de Vesgre, 60cm x 45cm, 1982.

L'Arbre au Coeur/*The Heart-Tree*. Arnaud de Vesgre, 54cm x 46cm, 1976.

Les Amoureux et les Oiseaux/*Lovers and Birds*. Nippon Eurotec, 51cm x 41cm, 1987.

C'est bien parce que vous m'inspirez confiance…/*It's because I trust you…* Editions des Maîtres Contemporains, 57cm x 43cm, 1976-1985.

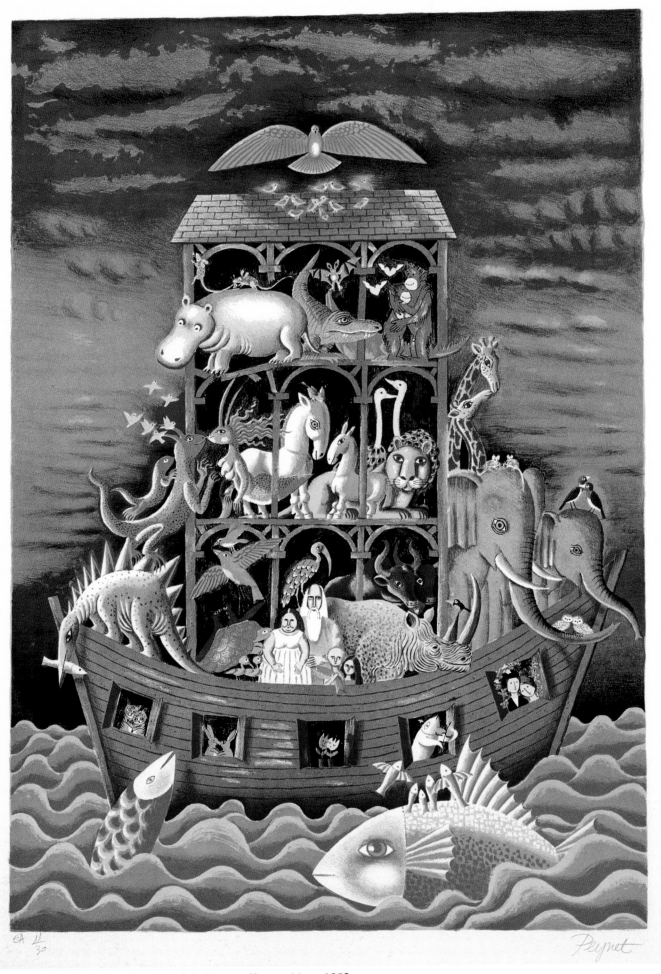

***L'Arche de Noë**/Noah's Ark*. Arnaud de Vesgre, 62cm x 44cm, 1982.

A Coeur Vole/*Flying Heart*. Agostini, 40cm x 40cm, 1994.

Les Amoureux au Kiosque de Valence/*Lovers in the Valence Bandstand*. Agostini, 40cm x 40cm, 1994.

La Cage Enchantée/*The Enchanted Cage*. Agostini, 40cm x 40cm, 1994.

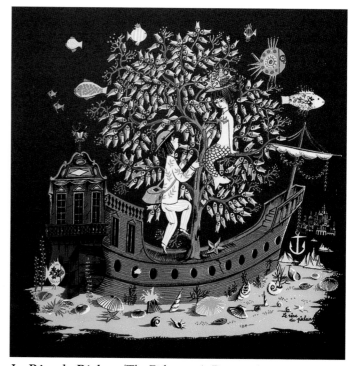

Le Rêve du Pêcheur/*The Fisherman's Dream*. Agostini, 40cm x 40cm, 1994.

Un petit chez soi…/*A little home of our own…* Editions des Maîtres Contemporains, 52cm x 38cm, 1976-1985.

Mais ne te promène donc pas toute nue devant la fenêtre/ *Don't walk about naked in front of the window.* Editions des Maîtres Contemporains, 52cm x 38cm. 1976-1985.

Une Gentillesse par çi, une Caresse par là…/*A Kindness here, a Caress there…* Editions des Maîtres Contemporains, 52cm x 38cm, 1976-1985.

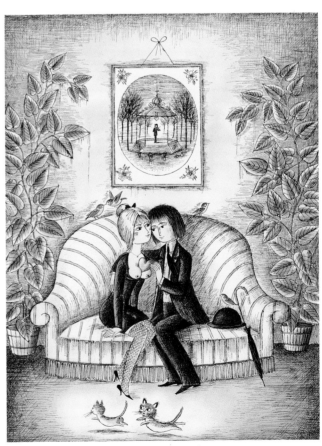

C'est merveilleux, vous les poètes…/*You poets are marvellous…* Editions des Maîtres Contemporains, 52cm x 38cm, 1976-1985.

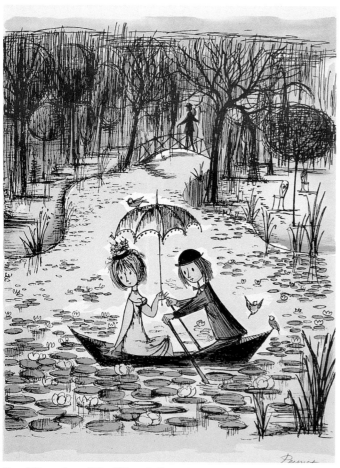

Les Nénuphars/*The Water Lillies*. Agostini, 51cm x 41cm, 1986.

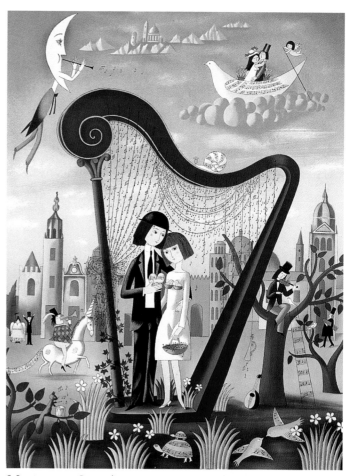

Musique au Coeur/*Music in your Heart*. Arnaud de Vesgre, 58cm x 44cm, 1984.

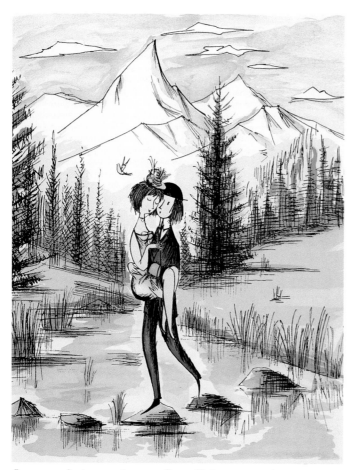

Je ne voudrais pas abuser…/*I wouldn't want to take advantage…* Agostini, 52cm x 42cm, 1986.

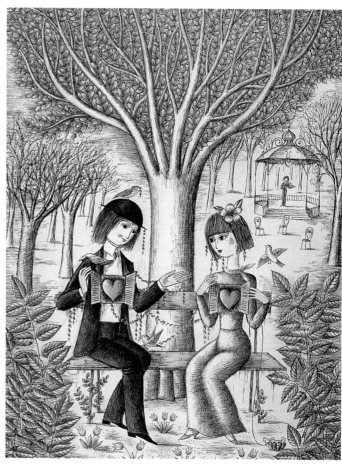

Opération à Coeur Ouvert/*Open Heart Surgery*. Editions des Maîtres Contemporains, 52cm x 38cm, 1976-1985.

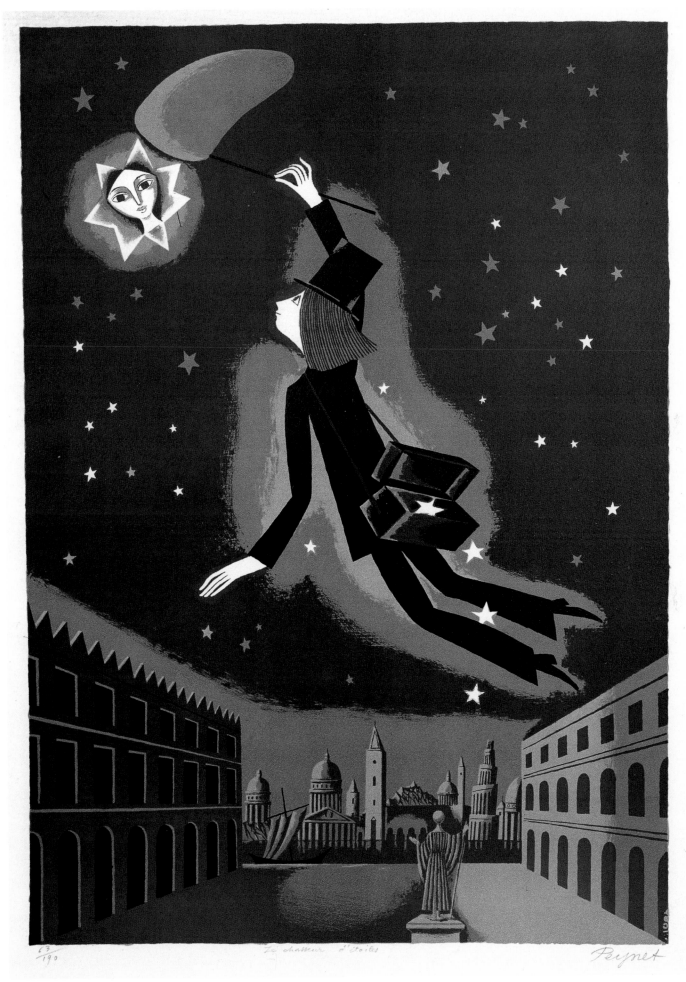

Le Chasseur d'Etoiles/*The Star Chaser*. Arnaud de Vesgre, 52cm x 38cm, 1979.

LES SIGNES DU ZODIAQUE / SIGNS OF THE ZODIAC
EDITIONS DES MAÎTRES CONTEMPORAINS, 52cm x 38cm 1979

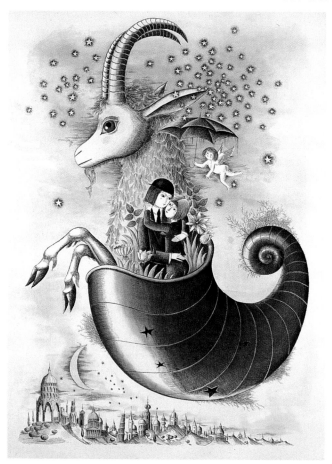

Capricorne/*Capricorn.*

Verseau/*Aquarius.*

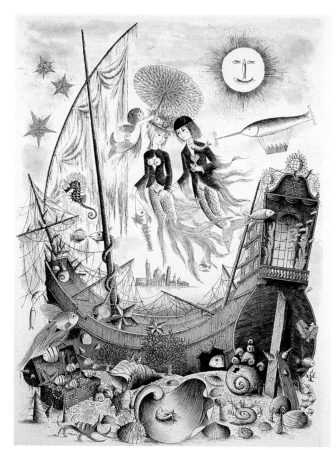

Poissons/*Pisces.*

Bélier/*Aries.*

Les Signes Du Zodiaque / *Signs Of The Zodiac*
Editions Des Maîtres Contemporains, 52cm x 38cm 1979

Taureau/*Taurus*.

Gémeaux/*Gemini*.

Cancer/*Cancer*.

Lion/*Leo*.

LES SIGNES DU ZODIAQUE / SIGNS OF THE ZODIAC
EDITIONS DES MAÎTRES CONTEMPORAINS, 52cm x 38cm 1979

Vierge/*Virgo*.

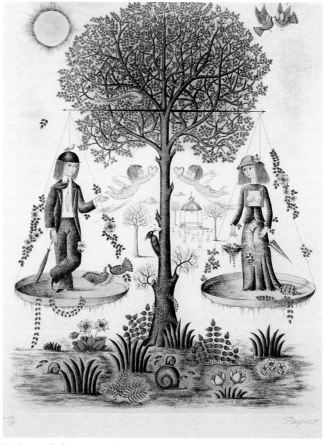

Balance/*Libra*.

Scorpion/*Scorpio*.

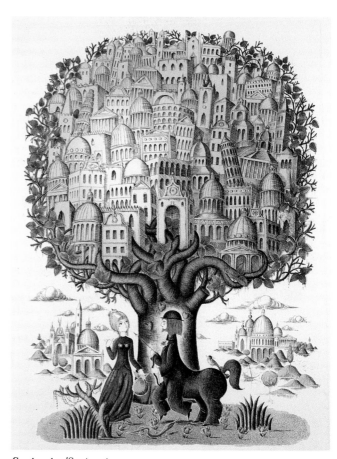

Sagittaire/*Sagittarius*.

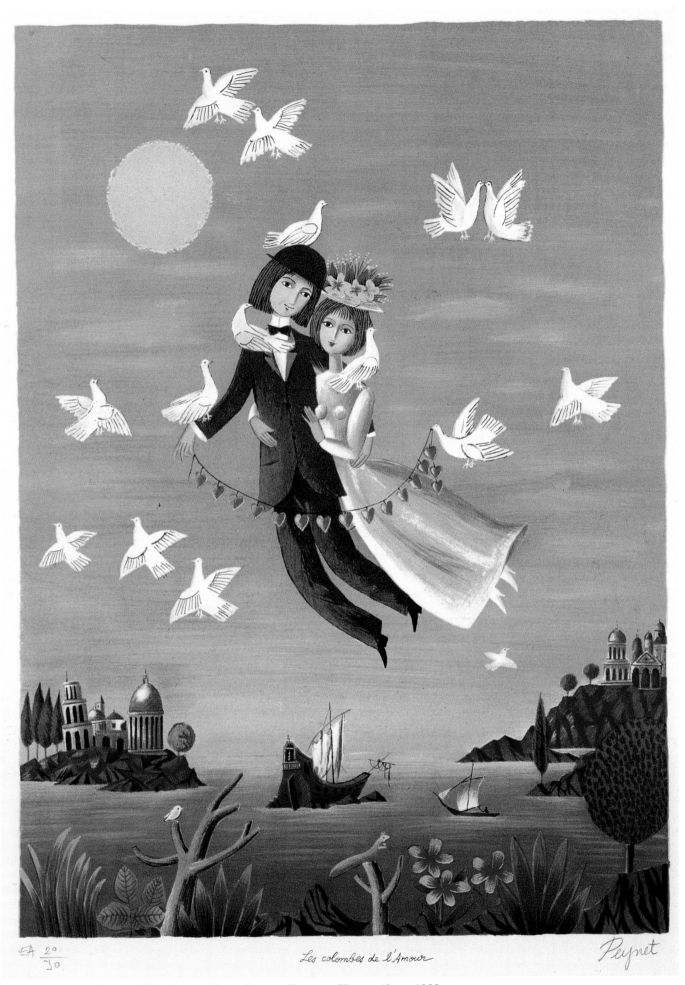

EA $\frac{2^o}{30}$ Les colombes de l'Amour Peynet

Les Colombes de l'Amour/*The Doves of Love*. Nippon Eurotec, 57cm x 42cm, 1988.

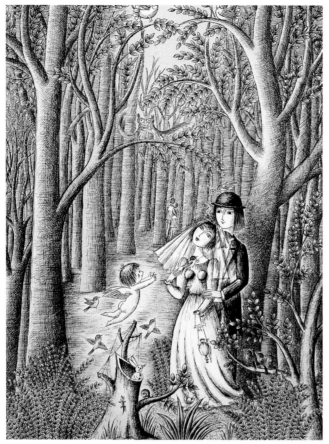

Prenez le sentier des désirs…/*Take the path of desire…*
Editions des Maîtres Contemporains, 52cm x 38cm,
1976-1985.

Vous n'avez pas froid Chérie?/*Aren't you cold Darling?*
Agostini, 52cm x 41cm, 1986.

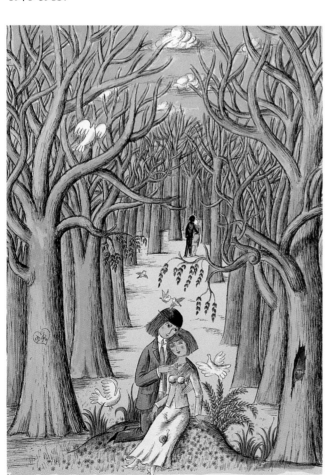

A quoi on Joue? (dans la forêt)/*What shall we Play? (in the
forest)*. Agostini, 46cm x 34cm, 1994.

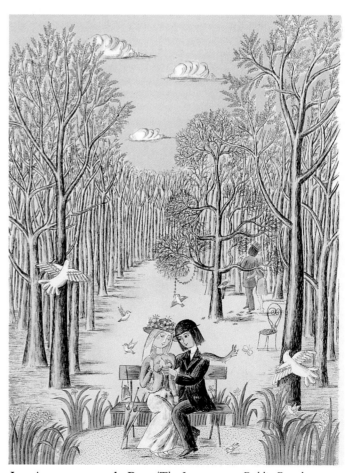

Les Amoureux sur le Banc/*The Lovers on a Public Bench.*
Agostini, 46cm x 34cm, 1994.

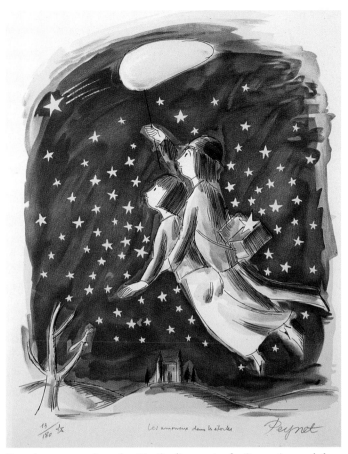

Les Amoureux dans les Etoiles/*Lovers in the Stars*. Arnaud de Vesgre, 48cm x 37cm, 1984.

Chérie, il ne faut pas avoir peur…/*Darling, you must not be afraid…* Editions des Maîtres Contemporains, 52cm x 38cm, 1976-1985.

La Fenêtre dans le Ciel/*The Window in the Sky*. Nippon Eurotec, 57cm x 42cm, 1991.

Départ Pour Cythère/*Departure for Cythera*. Nippon Eurotec, 56cm x 42cm, 1991.

MISCELLANEOUS
COLLECTIONS DIVERSES

Above all Peynet was a trained and talented graphic artist. In Paris during the 1930s he earned his living by designing advertisements and continued to do so throughout his career. His work was very varied and included illustrated advertisements for medical, pharmaceutical and beauty products. These designs are highly collectable today.

Peynet was a connoisseur of wine and good food and was approached by a number of wine growers to design their wine labels. He produced a Rosé d'Anjou label for the Cave Bonnamy in St. Cyr-en-Bourg; a Tavel label for Jean-Pierre Brotte in Châteauneuf-du-Pape; two Beaujolais Saint Amour labels for Pasquier-Desvignes in St. Lager and Chedeville in St. Georges de Reneins; plus several table wine labels including an Italian and Moroccan selection. He also designed a Japanese wine label – Hayashi Noen.

When dining at a restaurant, Peynet was often asked to design a menu and he drew about fifty particularly in France and Italy and, in 1955, even produced an English menu cover for the Dorchester Hotel in London.

From the end of the 1940s, when travelling to their property in the south of France, the Peynets would regularly visit Valence, a convenient stop-over between Paris and Biot, staying at the Hotel-Restaurant Pic. Over the years Peynet designed menus, a personalised champagne label for a Cuvée Spéciale and posters, including a limited edition print for the Hotel-Restaurant. His influence is still evident today.

Prompted by relatives, friends or acquaintances, Peynet often produced personalised, special-occasion cards for birthdays, wedding invitations and as thank-you's. He was also commissioned to design business cards and publicity material.

In 1968, Peynet used his famous characters as illustrations for a pack of playing cards. In 1974 a limited edition engraved silver plate with a design based on L'Arbre au Coeur – The Heart Tree – was produced by Peynet for the firm Le Médaillier in Paris. It was sold by mail order or through jewellers shops, in a presentation box that could also be used to hang on the wall. In 1985 he designed a St. Valentine stamp for the French Post Office – one sheet of stamps did not have the 2F10 printed on it and is consequently very valuable. There are Peynet clocks made by Odo and Capron from Vallauris and a series of stoneware tiles.

This section is left open-ended so that the enthusiast will be pleasantly surprised each time she or he finds a 'new' Peynet!

Peynet était avant tout un graphiste de grand talent. Au début des années 30 à Paris, il gagnait sa vie à dessiner des encarts publicitaires et il continua au long de toute sa carrière. Il faisait, parmi d'autres, des dessins pour la promotion de produits médicaux et pharmaceutiques ainsi que de produits de beauté. Les dessins de cette époque sont rares mais très collectionnés.

Etant fin gourmet et aimant le bon vin, tout naturellement Peynet fit des étiquettes pour différents crus. Un Rosé d'Anjou pour les Caves Bonnamy à St. Cyr-en-Bourg, un Châteauneuf-du-Pape pour Jean-Pierre Brotte, deux Beaujolais Saint-Amour pour Pasquier-Desvignes à St. Lager et pour Chedeville à St. Georges de Reneins. Il dessina aussi plusieurs étiquettes de vin de table, y compris une sélection pour des vins d'Italie et du Maroc. Il dessina même une étiquette pour un vin Japonais: Hayashi Noen.

Comme Peynet aimait aller régulièrement au restaurant, le patron lui demandait souvent de dessiner le menu. Il y a à l'heure actuelle une cinquantaine de menus qui existe en France, en Italie et en Angleterre où le directeur du Dorchester à Londres choisissait chaque année un dessin Peynet pour sa carte de voeux ou pour un menu exceptionnel.

Après 1947, ayant acheté une maison dans le sud de la France, une étape s'imposait; Valence dans la Drôme, où étaient nés Les Amoureux, sous le kiosque à musique de cette ville. Pic, le restaurateur bien connu, accueillait la famille Peynet. Au fil des années, Peynet créa des menus, des cartes de visite, une étiquette de bouteille de champagne et même une lithographie, spécialement pour le restaurateur. Encore aujourd'hui, l'empreinte Peynet y est toujours présente.

Souvent Peynet dessinait des cartes de voeux pour sa famille et ses amis ainsi que des faire-parts de naissance, de mariage et des cartes de visites commerciales.

En 1968 Peynet illustra un jeu de cartes. En 1974, une assiette en argent massif, gravée à l'eau-forte fut créée par Peynet pour l'entreprise Le Médailler à Paris et vendue par correspondance ou en magasins de bijouterie. La gravure était basée sur L'Arbre au Coeur et l'assiette, en édition limitée, était présentée dans un coffret qui pouvait servir soit de présentoir, soit de cadre à suspendre au mur. Il y a un timbre poste Peynet à 2F10, des pendules Peynet fabriquées par les sociétés Odo et Capron ainsi que des carrelages en grès.

Il faudra donc laisser cette rubrique ouverte afin que l'amateur soit agréablement surpris chaque fois qu'il découvrira un nouvel objet de collection Peynet.

A selection of menu cards designed by Peynet.
Sélection de menus dessinés par Peynet.

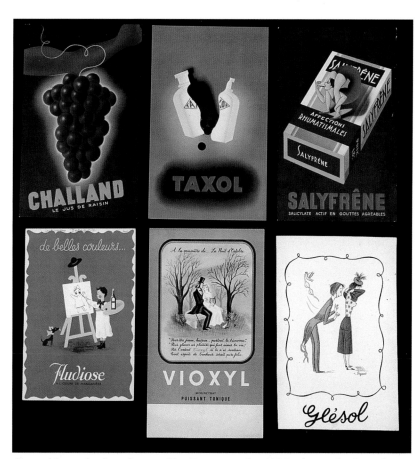

Six publicity leaflets designed by Peynet in the 1930s, for medical products.
Exemple de six encarts publicitaires de produits médicaux dessinés par Peynet dans les années 30.

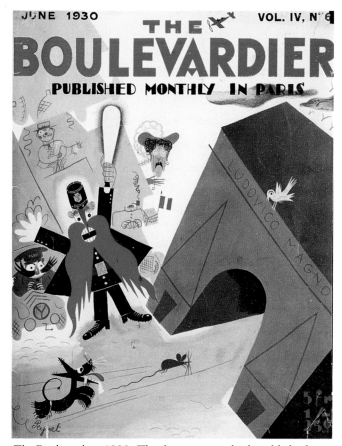

Postage stamp designed by Peynet, 1985. **Timbre poste par Peynet, 1985.**

Personalised wedding invitations designed by Peynet for family and friends.
Faire-parts de mariage personnalisés dessinés par Peynet pour sa famille et ses amis.

The Boulevardier, 1930. The first review which published Peynet's work. Interestingly, this was an English review, published in Paris for British ex-pats in the French capital.
La première revue qui publia un dessin de Peynet.

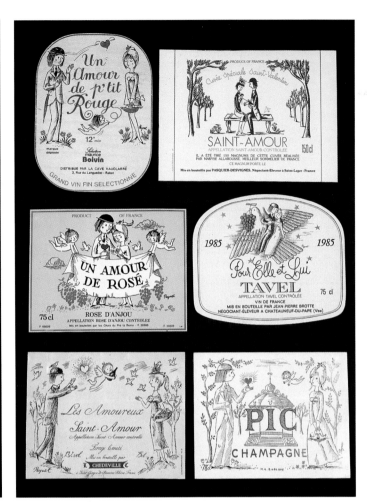

A selection of greeting and personalised cards designed by Peynet.
Sélection de cartes de voeux et de cartes personnalisées dessinées par Peynet.

Six wine labels designed by Peynet.
Six étiquettes de bouteilles de vin dessinées par Peynet.

Special occasion cards designed by Peynet for his family and friends.
Cartes pour occasions particulières dessinées par Peynet pour sa famille et ses amis.

Silver plate engraved with Peynet drawing signed in the engraving, 20$^{1}/_{2}$cm.
Assiette gravée en argent massif, signée dans la gravure, 20,5cm. 1974.

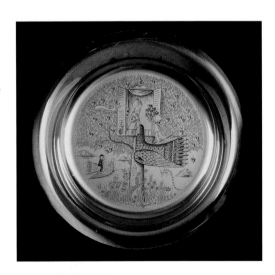

Playing cards by Peynet, 1968.
Cartes à jouer par Peynet, 1968.

JAPAN

JAPON

It would be difficult to produce a book on Peynet without mentioning Japan. The Japanese have an abiding interest in his work and *The Lovers* are particularly popular. Japan is the only country in the world, other than France, to have a Peynet Museum.

Towards the end of the 1950s an English book of Peynet's drawings, published by Perpetua, was the first to be translated into Japanese and published by Misuzu Shobo. In 1964, after the success of several books, Hakkuodo, an advertising agency, invited Peynet to make a promotional visit of Japan. Peynet merchandising was launched: sun glasses, paper bags, music boxes, ceramics and postcards became a commercial success – and were quickly followed by limited edition prints, produced in France exclusively for the Japanese market.

The simplicity of Peynet's drawings and the lightness of their composition strikes a chord with Japanese taste and design and explains, at least in part, the ongoing popularity of *The Lovers*. In 1996, 70% of Peynet's copyright revenue came from Japan.

Peynet's Museum in Karuizawa, owned by Mr Fuji Maki, welcomes many visitors each year. A bronze statue of *The Lovers* stands at the entrance to the museum. Hiroshima also has a bronze statue of Peynet's *Lovers* which is dedicated to peace and love. A third full-size marble statue is situated in a park in Sakuto-Sho.

Today one can find Peynet illustrations on telephone cards, postcards, playing cards, porcelain etc.

Il serait difficile d'écrire un livre sur Peynet sans mentionner le Japon.

Les Japonais semblent porter beaucoup d'intérêt à l'oeuvre de Peynet et tout particulièrement aux *Amoureux*. Après tout, le Japon est le seul pays avec la France à avoir un Musée Peynet.

Vers la fin des années 50 un recueil de dessins fut publié par Misuzu Shobo. En 1964, grâce au succès de ce livre, Peynet fut invité pendant un mois au Japon par Hakkuodo, grosse agence de publicité. A la suite de cette visite toute une serie de produits Peynet, furent lancés: sacs, lunettes, boîtes à musique, porcelaines, montres, etc., et des lithographies spécialement créées pour le Japon furent éditées.

Il semble que la simplicité du dessin, la légèreté de la composition touchent l'esprit japonais. Le Musée de Peynet à Karuizawa accueille chaque année de nombreux visiteurs, les écoliers japonais viennent régulièrement le visiter avec leurs maîtres. Une statue des *Amoureux* en bronze les accueille. La ville d'Hiroshima possède aussi une statue en bronze dédiée à la paix et à l'amour. Une troizième statue en marbre de Carrare se trouve dans un jardin public de Sakuto-Sho.

Aujourd'hui au Japon, l'on peut trouver des cartes téléphoniques, des cartes postales, des cartes à jouer, des porcelaines etc., toutes avec des dessins de Peynet.

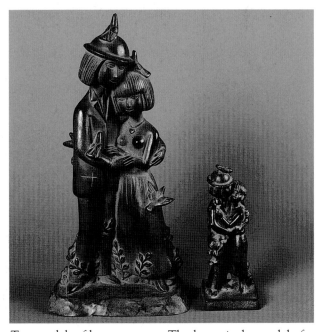

The marble statue of *Peynet's Lovers* in Sakuto-Sho. La Statue en marbre des *Amoureux de Peynet* à Sakuto-Sho.

Two models of bronze statues. The larger is the model of the statue in Hiroshima, made by the Parisian sculptress Geneviève Labrousse.
Deux miniatures de statues en bronze pour le Japon. La plus grande est le modèle de celle qui se trouve à Hiroshima, créée par Geneviève Labrousse, sculpteur à Paris.

Poster for the Peynet Museum in Karuizawa, 73cm x 52cm, c.1986.
Affiche du Musée de Peynet à Karuizawa, 73cm x 52cm, c.1986.

LISTS OF COLLECTIONS
LISTES DES COLLECTIONS

POSTERS / AFFICHES

1930s/1940s
Back to School/**Rentrée des Classes.** 68x84 (1930)
Humour 41. 65x50 (1941)
National Lottery/**Loterie Nationale.** 36x50 (1944)
Paris 1900 (film). 160x120 (1947)
Paris 1900 (different drawing). 160x120 (1947)
Véronique (film). 35x43 (1948)
*Play School /**La Maternelle**(film). 175x118 (1949)

1950s
*Petrified Forest /**La Forêt Pétrifiée** (theatre).
Penguin/**Pingouin.** 52x40
The Happy Pilgrims/**Les Joyeux Pélerins** (film). 175x118
The Little General/**Le Petit Général.** 70x41
The Little General/**Le Petit Général.** 39x21
Englebert Tyres/**Pneu Englebert.** 80x120
Englebert Tyres/**Pneu Englebert** (different drawing). 80x120
Englebert Tyres/**Pneu Englebert** (different drawing). 80x120
Tulips for a Mere Song/**Tulipes de Bagatelle.** 60x40 (1955)
Odette Laure. 58x80
Galeries Lafayette. 25x45
France Dimanche. 50x32
France Dimanche (different drawing). 50x32
France Dimanche (different drawing). 50x32
Foreign Press Party/**Gala de la Presse Etrangère.** 128x90
Bi-Millennium of Paris/**Bimillénaire de Paris.** 70x48
Garden Party. 60x40
New Year's Eve Party/**Réveillon de la St Sylvestre.** 48x37
Bal de l' X. 48x37 (1953)
Mad Success by Schiaparelli/**Succès Fou Schiaparelli.** 33x25
Mad Success by Schiaparelli/**Succès Fou Schiaparelli**
 (different drawing). 33x25
Grand Ball of the Norm Sup. School/**Grand Bal de Normale
 Supérieure.** 60x40
Chatelet. 76x118
Festival at the Polytechnic School/**Fête dans l'Enceinte
 de Polytechnique.** 54x39
Bal du Bac. 54x37
Milliners' Union/**Syndicat des Chapeliers.** 40x30
Paillard. 32x64
Semelflex. 40x30
Vote Bernard Brisac/**Votez Bernard Brisac.** 64x48
National Lottery/**Loterie Nationale.** 58x37
National Lottery/**Loterie Nationale** (different drawing). 58x37
Songs of Yesterday and Today/**Chansons d'Hier et
 d'Aujourd'hui.** 64x47
The Lovers/**Les Amoureux** (film). 160x120
Peynet's Dolls/**Les Poupées Peynet.** 40x30
Bal De l'X. 48x38 (1956)
Fête in Deauville/**Kermesse à Deauville.** 39x29
St Valentine/**St Valentin.** 60x40
College Advertisement/**Promotion Polytechnique.** 54x39
Christmas from the Police/**Noël de la Police.** 56x39 (1958)
Laurens Cigarettes with Peynet Dolls/**Cigarettes Laurens avec
 Poupée Peynet.** 47x37
Laurens Cigarettes with Peynet Dolls/**Cigarettes Laurens
 avec Poupée Peynet** (different drawing). 47x37
Laurens Cigarettes with Peynet Dolls/**Cigarettes Laurens
 avec Poupée Peynet** (different drawing). 47x37
The Merchant of Venice/**Le Marchand de Venise** (theatre). 50x32
Joy of Living/**Joie de Vivre.** 42x27
Bal HEC J.F. 50x34
The Midwives Ball/**Bal des Sages Femmes.** 70x50

College Fete/**Fête dans l'Enceinte de Polytechnique.** 60x40
Cake Makers Union/**Syndicat des Pâtissiers.** 40x30
Leo Noël and his Barrel Organ/**Léo Noël et son Orgue de Barbarie.**
 40x30
Mimi Pinson (film). 160x120

1960s
Dolls Exhibition in Galliera/**Exposition de Poupées à Galliera.** 60x40
Father's Day/**Fête des Pères.** 60x44 (1960)
Father's Day/**Fête des Pères.** 60x44 (1961)
Happy Christmas from the Police/**Noël de la Police.** 55x40 (1960)
Father's Day/**Fête des Pères.** 60x44 (1962)
Wilhem Busch Museum/**Musée Wilhem Busch.** 84x60
Happy Christmas from the Police/**Noël de la Police.** 64x46 (1963)
Happy Christmas from the Jouets-Fondation Lépine/**Noël 69 Jouets-
 Fondation Lépine.** 64x46
Happy Christmas from the Police/**Noël de la Police.** 64x46 (1964)
Polytechnic Ball/**Bal Polytechnique.** 48x37 (1965)
Craft Fair in Biot/**Fête Artisanale Biot.** 68x50
Biot. 65x46 (1966)
Happy Christmas from the Police/**Noël de la Police.** 64x46 (1966)
Happy Christmas from the Police/**Noël de la Police.** 64x46 (1967)
Humorous Show in Bordighera/**Salon de l'Humour à Bordighera.**
 98x68
Agora Gallery/**Galeries Agora Bruxelles.** 40x30
Happy Christmas from the Police/**Noël de la Police.** 64x46 (1968)
Red Cross Telegrams/**Télégrammes Croix Rouge.** 40x30
Red CrossTelegrams/**Télégrammes Croix Rouge**
 (different drawing). 40x30
Happy Christmas from the Police/**Noël de la Police.** 64x46 (1969).
Night of the Electronic/**Nuit de l'Electronique.** 40x30 (1969)
Peynet Dolls Game/**Jeu Poupées Peynet.** 40x30
Humorous Show in Brussels/**Salon de l'Humour à Bruxelles.** 60x40
Agora Gallery/**Galeries Agora Bruxelles.** 53x40

1970s
Blood Donor/**Don du Sang.** 42x27
Blood Donor/**Don du Sang** (different drawing). 42x27
Blood Donor/**Don du Sang** (different drawing). 42x27
Blood Donor/**Don du Sang** (different drawing). 60x44
Jeweller's Advertisement/**St Valentin Murat.** 34x25
Father's Day – Murat/**Fêtes des Pères Murat.** 34x25
Mother's Day – Murat/**Fête des Mères Murat.** 34x25
Happy Christmas from the Police/**Noël de la Police.** 70x47 (1970)
St Valentine's Day/**St Valentin.** 60x40 (1971)
Film Festival in Trento/**Festival du Film à Trento.** 70x48 (1971)
Record Festival in St Vincent/**Festival du Disque à St Vincent.** 70x47
Toys Exhibition/**Expo Jouets** (1971). 61x40
Fire Brigade, Japan/**Pompiers Japon.** 37x52
Cigarettes Kim. 74x50 (1970)
A Record for St Vincent/**Un Disco per l'Estate Saint Vincent** (Italie).
 70x47 1972
Cigarettes Kim. 74x50
Around the World with Peynet's Lovers/**Le Tour du Monde des
 Amoureux de Peynet,** (animated film, Italian version/**dessin
 animé, version italienne**). 70x50 (1972)
Around the World with Peynet's Lovers/**Le Tour du Monde des
 Amoureux de Peynet,** (animated film, Italian version/**dessin
 animé, version italienne**). 50x29 (1972)
Around the World with Peynet's Lovers/**Le Tour du Monde des
 Amoureux de Peynet,** (animated film, German version/**dessin
 animé, version allemande**). 120x84 (1972)
Around the World with Peynet's Lovers/**Le Tour du Monde des
 Amoureux de Peynet,** (animated film, Japanese version/**dessin
 animé, version japonaise**). 73x51 (1972)

Animated Film /Dessin Animé (canvas paper/**papier ciré**). 200x140
Club Cucinamica. 70x49
World Exhibition of Birds in Antibes/Mondiale des Oiseaux - Antibes.
 60x43
Happy Christmas from the Police/Noël de la Police. 65x50 1975
Fiat. 98x68
Peynet Exhibition in Metz/Expo Peynet à Metz. 40x30
Exhibition in Beaujolais/Expo dans le Beaujolais. 64x43
Machon in Paris/Machon à Paris. 49x37
Peynet Exhibition in Various Towns/Expo Peynet dans les Villes
 Diverses. 64x46
Peynet Exhibition in Various Towns/Expo Peynet dans les Villes
 Diverses (different drawing). 64x46
Happy Christmas from the Police/Noël de la Police. 65x50 (1976)
Happy Christmas from the Police/Noël de la Police. 65x50 (1977)
Music in Vence/Musique à Vence. 60x40 (1978)
Happy Christmas from the Police/Noël de la Police Jouets
 Fondation Lépine. 56x43 (1978)
Happy Christmas from the Police/Noël de la Police. 65x50 (1979)
Exhibition at the Denon Museum/Expo Musée Denon. 48x29
Rose Lovita. 46x36

Perrier-Jouët Champagne:
Lovingly Yours…/Amoureusement Vôtre… 69x50
Let's Live off Love…/On Vivra d'Amour… 76x56
I Can't See…/Je ne vois pas… 77x58
Life in the Pink/La Vie en Rose. 76x57
Life in the Pink/La Vie en Rose (white background/**fond blanc**).
 76x57
Golf. 77x56
Golf. 52x72
Noah/Noë. 72x52
I might be Tempted…/Je me laisserai Tenter… 72x52
If only you Knew…/Si vous Saviez… 77x55
Without Caption/Sans Légende. 64x41

1980s
Gala against Cancer/Gala contre le Cancer. 63x44
St.Valentine's National Lottery/St Valentin-Loterie Nationale. 40x30
Italian Riviera/Riviera dei Fiori. 49x34
Italian Riviera/Riviera dei Fiori. 98x68
Capron. 60x40
Signs of the Zodiac/Signes du Zodiaque. 76x55
St Valentine/St Valentin. 60x40
Monaco Exhibition/Expo Monaco. 76x55
4th Show of Humourists/IVᵉ Salon des Humoristes. 40x30
Antique Fair-Antibes/Salon des Antiquaires-Antibes. 60x40 (1982)
17th Musical Show/XVIIᵉ Salon Musical-Antibes Juan-Les-Pins.
 50x35
Antique Fair-Antibes/Salon des Antiquaires-Antibes. 59x39 (1984)
Rotary. 65x45
Air Show in Mandelieu/Salon de l'Aviation-Mandelieu. 64x49 (1984)
18th Musical Show/XVIIIᵉ Salon Musical (canvas paper/**papier ciré**).
 180x160
Glass Exhibition in Biot/Exposition Verres Biot. 60x40
Antique Fair-Antibes/Salon des Antiquaires-Antibes. 59x43 (1985)
Peynet Exhibition in Marseille/Exposition Peynet Marseille. 55x40
Corsican Days/Journées Corses. 62x45

Exhibition-Palm Beach Florida/Exposition-Palm Beach Florida.
 60x40
Stamp Exhibition/Exposition Philatélique. 64x36 (1985)
Homage to Victor Hugo/Hommage à Victor Hugo. 49x42
Corsica/Corse. 57x41
Opening of Japanese Museum/Inauguration Musée Japon. 88x61
Japanese Museum/Musée Japon. 103x73
Japanese Museum/Musée Japon (different drawing). 73x52
Japanese Museum/Musée Japon (different drawing). 73x52
Japanese Museum/Musée Japon. 52x37
Antique Fair-Antibes/Salon des Antiquaires-Antibes. 66x40 (1987)
Antique Fair-Antibes/Salon des Antiquaires-Antibes. 66x40 (1988)
St Valentine Red Cross/St Valentin Croix Rouge. 40x30 (1989)
Bridge-Playing Festival/Festival du Bridge. 63x44
Golden Snail/Escargot d'Or. 64x45
Peynet Museum-Antibes/Musée Peynet à Antibes. 72x52
Illustrated Telegrams-Red Cross/Télégrammes Illustrés Croix
 Rouge. 60x40 (1989)
Lions Club-Valence. 43x31
General State Free Communes/Etats Généraux des Communes
 Libres. 120x75
Medical Congress-Nice/Congrès Médical à Nice. 45x34
Peynet in St Vallier/Peynet à St Vallier. 42x30
Peynet. 60x42
Peynet (different drawing). 60x42

1990s
Inauguration of Mural in Le Cannet/Inauguration Mur Cannet.
 53x35
St Valentine Red Cross/St Valentin Croix Rouge. 60x40 (1990)
Flower Arrangement Show/Concours de Bouquets. 50x42
St Valentine/St Valentin. 62x40 (1990)
Peynet Exhibition in Le Cannet/Exposition Peynet au Cannet. 63x43
Exhibition in St. Just Le Martel/St. Just Le Martel Expo. 60x40
St Valentine/St Valentin. 60x40 (1991)
Exhibition in Toulouse/Exposition à Toulouse. 60x40
Antique Fair-Antibes/Salon des Antiquaires-Antibes. 60x40 (1991)
Tokyo Exhibition/Exposition Tokyo. 73x52
Tokyo Exhibition/Exposition Tokyo (different drawings-
 landscapes). 36x51
Exhibition-Valence/Exposition Valence. 70x50 (1992)
Wedding Exhibition/Mariage Expo. 60x40 (1992)
Antique Fair-Antibes/Salon des Antiquaires-Antibes. 60x40 (1992)
Commercial Ten Days in Antibes, Juan-les-Pins/Dizaine
 Commerciale Antibes, Juan-les Pins. 60x40
Antique Fair-Antibes/Salon des Antiquaires-Antibes. 46x44 (1993)
Antique Fair-Antibes/Salon des Antiquaires-Antibes. 46x44 (1994)
Antique Fair-Antibes/Salon des Antiquaires-Antibes. 46x44 (1995)
Antique Fair-Antibes/Salon des Antiquaires-Antibes. 46x44 (1996)
Antique Fair-Antibes/Salon des Antiquaires-Antibes. 46x44 (1997)
Exhibition Peynet's Museum-Antibes/Exposition Musée Peynet-
 Antibes 46x44 (1997).
Exhibition of Peynet's Dolls/Exposition de Poupées Peynet-
 Antibes. 46x44 (1996)
Exhibition-Monaco/Exposition-Monaco. 60x40 (1996)
Exhibition-Biot/Exposition-Biot. 60x40 (1996)
Peynet in St Ceré/Exposition Peynet à St Céré. 60x40 (1997)

BOOKS / LIVRES

The following list of Peynet's books has been divided into three categories: (1) Peynet books; (2) books by other authors and illustrated by Peynet; (3) books by other authors with covers only illustrated by Peynet. Because of the difficulty in reproducing Japanese characters, Japanese publications are listed in European languages.

Les listes ci-dessous sont divisées en trois catégories: (1) Ouvrages de Peynet; (2) auteurs divers illustrés par Peynet; (3) couvertures illustrées par Peynet. Notez que pour les publications japonaises, elles sont répertoriées en langues européennes – les caratères japonais ne sont pas sur nos imprimeuses.

(1) Peynet Books / Ouvrages de Peynet

France

1. *Peynet.* (Préface d'André Billy) Ed. du Livre 1943
2. *On Parle d'Amour à Peynet Ville.* Ed. Elmo del Duca Paris c.1950
3. *Les Amoureux de Peynet.* Ed. V. de Valence 1953
4. *Le Tour du Monde des Amoureux de Peynet.* Ed. V. de Valence 1954
5. *Les Amoureux de Peynet.* Ed. Jarres d'Or 1963
6. *Par les Rues par les Rêves.* Ed. Hachette 1964
7. *Si Tous les Amoureux du Monde.* Ed. Lutin 1966
8. *Avec les Yeux de l'Amour.* Ed. Denoël 1967
9. *Si l'on s'Aimait.* Ed. Denoël 1970
10. *Comme je t'Aime.* Ed. Denoël 1971
11. *Parler d'Amour avec Tendresse.* Ed. Fayard 1975
12. *Les Amoureux de Peynet.* Ed. Hoëbeke 1984
13. *De Tout Coeur.* Ed. Hoëbeke 1987
14. *Le Musée Peynet d'Antibes - Catalogue.* Ed. Hoëbeke 1987
15. *Les Amoureux de la Côte d'Azur.* Ed. Gismondi 1988
16. *Les Amoureux de Peynet.* Ed. Marabout 1990
17. *Le Livre de Mariage.* Ed. La Page et La Plume 1994
18. *Les Poupées de Peynet.* Michel Aveline 1994
19. *L'Agenda des Amoureux.* Ed. Hoëbeke 1995

Great Britain / Grande Bretagne

1. *The Lovers' Pocketbook.* Perpetua 1954
2. *The Lovers' Travelogue.* Perpetua 1955
3. *The Lovers' Bedside Book.* Perpetua 1956
4. *The Lovers' Keepsake.* Perpetua 1958
5. *The Lovers' Weekend Book.* Perpetua 1959
6. *The Lovers.* Penguin 1960
7. *L'Amour.* Penguin 1964
8. *She Loves Me, She Loves Me Not.* Michael Joseph Ltd., 1968
9. *Striking Without Tears.* Michael Joseph Ltd., 1973
10. *Love, Sweet Love.* Souvenir Press Ltd., 1986

Germany / Allemagne

1. *Verliebte Welt.* Rowohlt Verlag 1949
2. *Wunderland Der Liebe.* Rowohlt Verlag c.1950
3. *Liebes-Träume.* Rowohlt Verlag c.1950
4. *Zärtliche Liebes Poesie.* Rowohlt Verlag c.1950
5. *Liebes Gärtlein.* Rowohlt Verlag c.1950
6. *Aus Lauter Liebe.* Rowohlt Verlag 1953
7. *Amor Auf Weltreise.* Rowohlt Verlag 1955
8. *Das Rendez-Vous Der Liebe.* Rowohlt Verlag 1959
9. *Catalogue Porcelaines Rosenthal.* c.1960
10. *Verliebte Welt.* Rowohlt Verlag (new edition) 1963
11. *In Den Armen Der Liebe.* Rowohlt Verlag 1963
12. *Ein Bilder Buch Für Zärtliche Leute.* Buchausstattung, Ottmar Frick 1966
13. *Mit Den Augen Der Liebe.* Rowohlt Verlag 1966
14. *Mit Den Augen Der Liebe* (different cover). Ed. Deutscher Bücherbund 1966
15. *Den Ich Kann Ohne Dich Nicht Sein.* Scherz Verlag 1968
16. *Zärtliche Welt.* Rowohlt Verlag 1971
17. *Verliebt, Verlobt, Verheiratet.* Eulenspiegel Verlag Berlin 1972
18. *Liebe Ist...* Scherz Verlag 1975
19. *Sprache Des Herzens.* Rowohlt Verlag 1977
20. *Reise Ins Land Der Sehnsucht.* Fischer Verlag 1984

Italy / Italie

1. *Si Parla d'Amore a Peynetville.* Ed. Elmo c.1950. (Red velvet cover, red leather heart/**Couverture velour rouge et coeur en cuir rouge**).
2. *Si Parla d'Amore a Peynetville.* Ed. Elmo c.1950. (Cover with drawing/**Couverture avec dessin.**)
3. *Il Viaggio Degli Amanti.* Ed. Arnoldo Mondadori 1958
4. *Raymond Peynet.* Ed. Arnoldo Mondadori 1961
5. *Per le Strade Per le Nuvole.* Ed. Elmo 1963
6. *Noi Due.* Ed. Elmo 1963
7. *Come Parlare d'Amore Sorridendo.* Ed. Rizzoli 1968
8. *Come Parlare d'Amore Sorridendo.* Ed. Rizzoli 1968. (Different cover/**Couverture différente.**)
9. *Mettete Una Rosa Nel Vostre Cuore.* Club degli Editori 1974
10. *Diario – Agenda I Fidanzatini.* Publications 1980-1984
11. *Peynet – Salone La Stampa Torino.* Exhibition Catalogue/ **Catalogue Expo.** 1984
12. *I Fidanzatini.* Ed. Biblioteca Universale Rizzoli 1985
13. *Il Codice dei Fidanzatini.* Ed. Biblioteca Universale Rizzoli 1985
14. *Il Codice dei Fidanzatini.* Ed. Biblioteca Universale Rizzoli 1986 (Different cover, smaller book/**Couverture différente, mini livre.**)
15. *Di Tutto Cuore.* Ed. Arnoldo Mondadori 1987
16. *Come Ti Amo.* Ed. Biblioteca Universale Rizzoli 1990

Slovenia / Slovenie

1. *Peynet.* Ed. Co-Libri (Ljubljana) 1995

Japan / Japon

1. *The Lovers' Pocketbook.* Ed. Misuzu Shobo 1960
2. *The Lovers' Weekend Book.* Ed. Misuzu Shobo 1960
3. *The Lovers' Bedside Book.* Ed. Misuzu Shobo 1961
4. *The Lovers' Keepsake.* Ed. Misuzu Shobo 1961
5. *Les Amoureux de Peynet.* Ed. Misuzu Shobo 1974
6. *L'Anthologie de l'Amour.* Ed. Misuzu Shobo 1974
7. *Le Tour du Monde des Amoureux de Peynet.* 1975 (Book of the film/**Livre du film.**)
8. *Lob Des Bettes.* Orion Services for Rowohlt Verlag c.1980
9. *With All My Heart.* Ed. Herald 1987
10. *Peynet.* Exhibition Catalogue/**Catalogue Expo.** Japan 1992
11. *Peynet Premier.* Koike Shoin Pub. Co. Ltd. 1993
12. *Peynet Deuxième.* Studio Ship Pub. Co. Ltd. 1993
13. *Peynet Troisième.* Studio Ship Pub. Co. Ltd. 1993

U.S.A. / Etats-Unis

1. *The Lovers' Weekend Book.* Ed. Grosset & Dunlap, New York 1964
2. *The Lovers' Keepsake.* Ed. Grosset & Dunlap, New York 1964
3. *The Lovers' Bedside Book.* Ed. Grosset & Dunlap, New York 1964

Netherlands / Pays-Bas

1. *De Verliefden Van.* Ed. De Bezige, Amsterdam c.1960
2. *Ik Kan Niet Leven Zonder Jou.* Ed. De Boekerij 1969
3. *Ik Hou Van Jou.* Ed. De Boekerij 1969
4. *Met De Wapens Der Liefde.* Ed. De Boekerij 1970
5. *Een Tuiltje Bloemen Voor Verliefden.* Ed. De Boekerij 1970
6. *Madeliefjes En Meizoentjes.* Ed. De Boekerij 1973
7. *Hier Is Mijn Hart.* Ed. Elmar B.V. 1977
8. *Liefdesglimlach.* Ed. De Boekerij
9. *Peynet.* Ed. Carlo Silva

Denmark / Danemark

Nos.7-12 are new editions with different covers
No. 7 à 12 nouvelles éditions, couvertures différentes.

1. *Den Lille Poet.* Ed. Rasmus Navers Forlag 1953
2. *Lutter Koerlighed.* Ed. Rasmus Navers Forlag 1954
3. *Hjertets Arstider.* Ed. Rasmus Navers Forlag 1955
4. *Pä Kaerlighedens Vinger.* Ed. Rasmus Navers Forlag 1956
5. *Forelskede Verden.* Ed. Rasmus Navers Forlag 1957
6. *De Sma Havfruer.* Ed. Rasmus Navers Forlag 1960
7. *Den Lille Poet.* Ed. Samlerens Forlag 1966

8. *Lutter Koerlighed*. Ed. Samlerens Forlag 1967.
9. *Hjertets Arstider*. Ed. Samlerens Forlag 1967.
10. *Pä Kaerlighedens Vinger*. Ed. Samlerens Forlag 1967
11. *De Sma Havfruer*. Ed. Samlerens Forlag 1967
12. *Forelskede Verden*. Ed. Samlerens Forlag 1968.

SWEDEN / SUEDE
1. *Förälskade*. Ed. Stockholm 1957
2. *Hjärtans Kär*. Ed. Stockholm 1959

SWITZERLAND / SUISSE
1. *Reise Ins Land Der Sehnsucht*. Verner Classen Verlag (Zurich) 1965

POLAND / POLOGNE
1. *Zakochani*. Ed. Wydawnigtwo Warszawa 1958

NORWAY / NORVEGE
1. *Til Deg!* Ed. Cappelen 1987

(2) BOOKS BY OTHER AUTHORS ILLUSTRATED BY PEYNET / AUTEURS DIVERS, ILLUSTRÉS PAR PEYNET

FRANCE
1. *Le Voyage de Monsieur Perrichon*. Labiche et Martin. Ed. Calman-Levy c.1940
2. *Un Chapeau de Paille d'Italie*. Labiche et Marc Michel. Ed. du Bélier 1943
3. *Le Marché Noir*. Maurice Constantin-Weyer. Ed. A.G. Badert 1943
4. *On ne badine pas avec l'Amour*. Alfred de Musset. Ed. du Bélier 1944
5. *La Princesse Boule de Neige et le Prince Frizotine*. Thérèse Foussard. Ed. Françaises Nouvelles 1947
6. *Dessins Animés*. Elsa Triolet. Ed. Bordas 1947
7. *Lettres de mon Moulin*. Alphonse Daudet. Ed. du Livre, Monte-Carlo 1948
8. *Contes du Lundi*. Alphonse Daudet. Ed. du Livre, Monte-Carlo 1948
9. *Il ne faut jurer de rien*. Alfred de Musset. Ed. du Bélier 1949
10. *L'A.B.C. de l'Amour*. Paul Reboux. Ed. Raoul Solar 1949
11. *Humulus le Muet*. J. Anouilh and J. Aurenche. Ed. Bordas c.1950
12. *Ah! Jeunesse*. Georges Courteline. Ed. Librairie Gründ c.1950
13. *Elle et Lui*. Jean Duché. Ed. Flammarion 1951
14. *Trois sans Toit*. Jean Duché. Ed. Flammarion 1952
15. *C'est la Nature qui a Raison*. M. Messegué. Ed. Librairie Secretan 1952
16. *Le Bal des Voleurs*. Jean Anouilh. Ed. du Bélier 1952
17. *L'Histoire de France Racontée à Juliette*. Jean Duché. Ed. Amiot Drumont 1954
18. *Le Livre des Indiens*. B. Flornoy. Ed. de Paris 1954
19. *Les Nouvelles Récréations*. B. des Périers. Ed. Club Français du Livre 1955
20. *On s'aimera toute la Vie*. Jean Duché. Ed. Le Livre Contemporain A.D. 1956
21. *Chantons la France*. Paul Arma. Ed. Les Presses d'Ile de France 1922.
22. *La Mieux-Aimée*. Michel Beau. Cherrier Editeur 1972
23. *La Mieux-Aimée*. Michel Beau. Ed. Denoël 1977. (Different cover/Couverture différente.)
24. Pour Tant d'Amour. Yvonne Decouard 1981

SWITZERLAND / SUISSE
1. *Zärtliche Weise*. Henri de Graff. Ed. Sanssouci Zurich 1959

GERMANY / ALLEMAGNE
1. *Die Reise Nach Amazonien*. B. Flornay. Ed. George Lentz, Munchen 1955
2. *Prinzessin Schneeball Und Prinz Schmuddelfritz*. Thérèse Foussard. Ed. Büchergilde-Gutenberg 1956
3. *Liebe Für Ein Ganzes Leben*. Jean Duché. Ed. Rowohlt 1959
4. *Lob Des Bettes*. Kurt Kusenberg. Ed. Rowohlt 1966 (Also translated in Japanese as a Peynet book, Orion c.1980.)

ITALY / ITALIE
1. *Codice dei Fidanzati*. Campanile & Peynet. Ed. Elmo 1958
2. *Come Fare la Guerra con Amore*. Carlo Silva & R. Peynet. Ed. Rizzoli 1970
3. *Come Fare lo Sciopero con Amore*. Carlo Silva & R. Peynet. Ed. Rizzoli 1971
4. *Come Fare lo Sciopero con Amore*. Carlo Silva & R. Peynet. Ed. Rizzoli 1974
5. *La Mia Prima S. Comuniuone*. Cesare Perfetto. Ed. Intercart Carusco
6. *Detto Franci*. Domina. Ed. Elmo

(3) BOOKS BY OTHER AUTHORS WITH THE COVER ONLY ILLUSTRATED BY PEYNET / AUTEURS DIVERS, AVEC COUVERTURES SEULEMENT ILLUSTRÉES PAR PEYNET

FRANCE
1. *Petite Géographie et Histoire du Département de la Drôme*. Paul Méjean. Ed. de la France Nouvelle 1941
2. *Variations sur l'Article 12*. St Granier/Claude Marcel Laurent. Ed. Musy 1946
3. *La Flânerie à Paris*. Ed. Commissariat Général au Tourisme 1946
4. *Vingt Ans chez les Femmes Nues*. Maurice Hermite. Ed. Lugdunum 1948
5. *Si tous les Enfants de la Terre mêlaient leurs Voix*. Paul Arma. Ed. Librarie Larousse 1948
6. *Occupe toi d'Amélie*. Georges Feydeau. Ed. du Bélier 1949
7. *Ecclesia Lectures Chrétiennes*. Société Internationale d'Editions 1950
8. *Le Petit Don Juan*. Jean Dutourd. Ed. Robert Laffont 1950
9. *Panorama du Monde (Avril)*. Galiban 1951
10. *Ordre Alphabétique*. Jamblan. Ed. du Scorpion 1952
11. *Le Père ce Méconnu*. Jean Monteaux. Ed. Denoël 1952
12. *Coeur S.O.S.* Claude Maresca. Ed. Librarie Secrétan, Paris 1952
13. *Voulez vous...Réussir dans la Vie?* J. Lemarchant. Ed. Ferenczi 1952
14. *Voulez vous...Apprendre l'Amour?* G. Lemerle. Ed. Ferenczi 1952
15. *Voulez vous...Vous marier?* Florence Picard. Ed. Ferenczi 1952
16. *Au Pays des Hommes Nus*. L.R. Royer. Ed. de Paris 1954
17. *Des Honnestes Voluptés de Bouche et d'Amour*. Edouard de Pomiane. Ed. SEGEP Bernard Grasset 1954
18. *Physiologie de Paris*. Armand Lanoux. Ed. Librairie Arthème Fayard.
19. *Le Naïf sous les Drapeaux*. Paul Guth. Ed. Albin Michel 1954
20. *Le Naïf Locataire*. Paul Guth. Ed. Albin Michel 1956
21. *Poèmes de Poche*. Jean Berthet. Ed. Le Mouton Bleu 1956
22. *Marron des Dimanches*. André Deslandes. Nouvelles Editions Debresse 1956
23. *Aux quatres Coins du Monde*. Album published by Air France/Publié par Air France 1957
24. *Magie du Voyage*. Ed. Air France 1958
25. *Je n'ai rien que l'Amour*. Claudine Lichize. Ed. Collection Nouvelle Pléiade 1965
26. *De Bric et de Broc (poèmes)*. Nine Castaing. Ed. Les Paragraphes Litteraires de Paris 1965
27. *Histoire d'Amour de la Télévision Française*. Henri Spade. Ed. France Empire 1968
28. *Avec toi, mon Aimée*. Marcel Farges. Ed. Les Paragraphes Litteraires de Paris 1970
29. *Arielle, tout ça n'est pas Normal*. Gérard Caillet. Ed. Hachette 1970
30. *Douce était la Nuit...(poèmes)*. Marcel Farges. Ed. Les Paragraphes Litteraires de Paris 1975
31. *A quoi sert le Couple?* Willy Pasini. Ed. Odile Jacob 1996
32. *Le Temps d'Aimer*. Willy Pasini. Ed. Odile Jacob 1997

GREAT BRITAIN / GRANDE BRETAGNE

1. *Grand Prix.* Stephen Black & James Boothby.
 Ed. Lilliiput (June-July) 1953
2. *The Return of René Darridan.* Roderick Milton.
 Ed. Lilliput (Oct-Nov) 1953
3. *The Bushrangers.* Dal Stivens. Ed. Lilliput (Nov-Dec) 1953
4. *The Dollar Bottom.* James Kennaway. Ed. Lilliput (Jan-Feb) 1954

ITALY / ITALIE

1. *Humor Nel Mondo.* Anno 1 N.7 1949
2. *Una Burocrazia Per Sorridere.* Ed. Bordighera
3. *Notebook I Fidanzatini (Linea D'Oro).* 1980

SWITZERLAND / SUISSE

1. *Si tous les Amoureux du Monde.* Micheline & Grégoire Brainin.
 Ed. Franck Luthi, Lausanne 1965

SWEDEN / SUEDE

1. *Den Fortryllede Have.* C.J. Elmquist. Ed. Gyldendal 1950

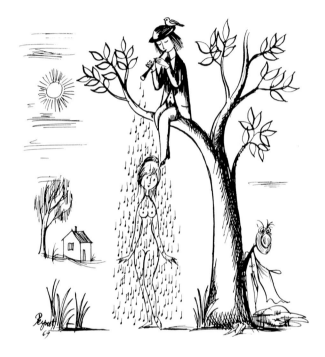

POSTCARDS / **CARTES POSTALES**

PEYNET'S DOLLS SERIES / SERIE LES POUPEES DE PEYNET

Editions Yvon

1. *The working girl/***La midinette.**
2. *The flower girl/***La bouquetière.**
3. *The student/***L'étudiante.**
4. *Good night/***Bonne nuit.**
5. *The painter and the ballet dancer/***Le peintre et la danseuse étoile,** & large size/**grand format.** Reprinted in Italy in smaller size/**Retirage petit format-Italie.**
6. *Serenade to a beauty/***Sérénade à la belle.**Reprinted in Italy in smaller size/**Retirage petit format-Italie.**
7. *The gardener and Miss Jonquil/***Le jardinier et Mlle Jonquille.** Reprinted in Italy in smaller size/**Retirage petit format-Italie.**
8. *And then here is my heart/***Et puis voici mon coeur.**
9. *We shall love each other all our life/***Nous nous aimerons toute la vie.**
9N.*Jeannette goes shopping/***Jeannette achète.**
10. *Would you like to dance with me?/***Voulez-vous danser avec moi?**
11. *My heart is faithful/***Mon coeur est fidèle.**
12 & 12a.*Would you like to dream with me by the silvery moon?/* **Voulez-vous rêver avec moi au clair de lune?**
13. *Would you be my muse?/***Voulez-vous être ma muse?**

14. *I live off love and fresh water/***Je vis d'amour et d'eau fraîche.** *Same card but without inscription /***Même carte mais sans inscription.**
15. *Do not refuse the heart of a poet/***Ne refusez pas le coeur d'un poète.**
16. *I shall look after you/***Je veillerai sur vous.**
17. *Hello! I love you/***Allo! Je vous aime.**
18. *Brittany/***Bretagne.**
19. *Normandy/***Normandie.**
20. *Alsace/***Alsace.**
21. *Auvergne/***Auvergne.**
22. *I shall take care of you/***Je prendrai soin de vous.**
23. *My heart sings like a violin/***Mon coeur chante comme un violon.**
24. *I do not dare admit my love for you/***Je n'ose pas vous avouer mon amour.**
25. *I love you/***Je vous aime.**
26. *I only dream of you/***Je ne rêve qu'à vous.**
27. *How beautiful you are in a swimsuit/***Comme vous êtes belle en maillot de bain!**
28. *I shall keep your photograph on my heart/***Je garderai votre photo sur mon coeur.**
29. *You have broken my heart/***Vous m'avez fait beaucoup de peine.**
30. *Hold me tight in your arms/***Serrz-moi dans vos bras.**
31. *Basque Country/***Pays Bas.**
32. *Camargue/***Camargue,** & large size/**grand format.**
33. *Napoleon and Josephine/***Napoléon et Joséphine,** & large size/**grand format.**
34. *Provence/***Provence.**
35. *Peach flower: nothing will separate us/***Fleur de pêcher: rien ne pourra plus nous séparer.**
36. *Tulip: I declare my love to you/***Tulipe: je vous déclare mon amour.**
37. *Myosotis: forget-me-not/* **Myosotis: ne m'oubliez pas.**
38. *Geranium: I am happy by your side/***Géranium: je suis heureux près de vous.**
39. *Lilac: my heart belongs to you/***Lilas: mon coeur est à vous.**
40. *Periwinkle: I dream only of you/***Pervenche: je ne rêve qu'à vous.**
41. *Camelia: you are the most beautiful/***Camélia: vous êtes la plus belle.**
42. *Marguerite: you are the most loved/***Marguerite: vous êtes la plus aimée.**
43. *Cornflower: I dare not admit my love to you/***Bleuet: je n'ose vous avouer mon amour.**
44. *Orange Blossom: pure love/***Fleur d'Oranger: amour pur.**
45. *Art College/***Beaux-Arts.**
46. *Opera/***Opéra.**
47. *Tennis player/***Joueuse de tennis.**
48. *First rendezvous/***Premier rendez-vous.**
49. *Hitch-hiker/***Auto-stop.**
50. *Champs-Elysées/***Champs-Elysées.**
51. *Promise of happiness/***Promesses de Bonheur.**
52. *Winter sport/***Sports d'hiver.**
53. *Good cook/***Petit Cordon Bleu,** & large size/**grand format.**
54. *Basking in the sun/***Bain de soleil,** & large size/**grand format.**
55. *Hurry up! There's one heart left/***Dépêchez-vous! Il reste encore un coeur,** & large size/**grand format.**
56. *You are about to find a flat/***C'est que vous êtes sur le point de trouver un appartement,** & large size/**grand format.**
57. *Your heart needs warmth/***C'est que votre coeur à besoin de chaleur.**
58. *Consult your doctor immediately/***Consultez votre médecin de toute urgence,** & large size/**grand format.**
59. *You haven't got a clear conscience/***C'est que vous n'avez pas la conscience tranquille,** & large size/**grand format.**
60. *The number 5 will be your lucky number/***Le 5 sera votre chiffre porte-bonheur,** & large size/**grand format.**
61. *You will have a happy awakening/***Vous aurez un heureux réveil,** & large size/**grand format.**
62. *He will whisper words of love to you/***Il vous chuchotera des mots d'amour,** & large size/**grand format.**
63. *You can't wait to see him again/***C'est que vous êtes impatiente de le retrouver,** & large size/**grand format.**

64. *You will have the most beautiful cruise of your life*/**Vous ferez la plus belle croisière de votre vie**, & large size/**grand format**.
65. *Pretty, let's see the rose*/**Mignonne, allons voir si la rose** (Pierre de Ronsard).
66. *I often have this strange dream…*/**Je fais souvent ce rêve étrange…** (Paul Verlaine).
67. *To see each other as much as possible and to love each other*/**Se voir le plus possible et s'aimer** (Alfred de Musset).
68. *Here are fruits, flowers, leaves*/**Voici des fruits, des fleurs, des feuilles** (Paul Verlaine).
69. *Poet, take your lute and give me…*/**Poète, prends ton luth et me donne…** (Alfred de Musset).
70. *Happy, who is wise*/**Heureux, qui de la sagesse** (Jean Racine).
71. *The New Nightingale Singer Poet*/**Le Chantre Rossignolet Nouvelet** (Pierre de Ronsard).
72. *If you think that I am going to say…*/**Si vous croyez que je vais dire…** (Alfred de Musset).
73. *Let's all sing together*/**Nous allons chanter à la ronde** (Alfred de Musset).
74. *When your pink coloured collar…*/**Quand ton col de couleur rosé…** (Joachim du Bellay).
75. *Souvenir from Champagne country*/**Souvenir de Champagne**.
76. **Alfred de Musset et/and George Sand**.
77. **Tristan et/and Yseult**.
78. *Anthony and Cleopatra*/**Antoine et Cléopâtre**.
79. **Adam et/and Eve**.
80. **Henry IV et/and Gabriella**.
81. **Des Grieux et/and Manon Lescaut**.
82. *Romeo and Juliet*/**Roméo et Juliette**.
83. **Cyrano et/and Roxanne**.
84. **Rodolphe et/and Mimi Pinson**.
85. **Carmen et/and Don José**.
86. **Western**.
87. *Student*/**Etudiante**.
88. *Little muse*/**Petite muse**.
89. *Air hostess*/**Hôtesse de l'air**.
90. *Horse woman*/**Ecuyère**.
91. *Aquarius*/**Verseau**.
92. *Pisces*/**Poissons**.
93. *Aries*/**Bélier**.
94. *Taurus*/**Taureau**.
95. *Gemini*/**Gémeaux**.
96. *Cancer*/**Cancer**.
97. *Leo*/**Lion**.
98. *Virgo*/**Vierge**.
99. *Libra*/**Balance**.
100. *Scorpio*/**Scorpion**.
101. *Sagittarius*/**Sagittaire**.
102. *Capricorn*/**Capricorne**.
103. *The white elephant*/**L'eléphant blanc**.
104. *Ladybird*/**La coccinelle**, & large size/**grand format**.
105. *The number 13*/**Le chiffre 13**.
106. *Four-leaf clover*/**Le trèfle à quatre feuilles**.
107. *The horseshoe*/**Le fer à cheval**.
108. *The little pink pig*/**Le petit cochon rose**.
109. *The sailor's pompom hat*/**Le pompon du béret de marin**.
110. *Fatma's hand*/**La main de Fatma**.
111. *The lover's medal*/**La médaille des amoureux**.
112. *The swallow's nest*/**Le nid d'hirondelle**, & large size/**grand format**.
113. *The Landes country*/**Pays Landais**.
114. *Arcachon Basin*/**Bassin d'Arcachon**.
115. *Brittany*/**Bretagne**.
116. *Corsica*/**Corse**, & large size/**grand format**.
117. *The North*/**Le Nord**.
118. *When you park in the blue zone*/**Lorsque vous stationnez en zone bleue**. 2 cards: one with heart, one without/**2 cartes: une avec coeur, une sans coeur**.
119. *The car driver must never…*/**Le conducteur d'une automobile ne doit jamais…** 2 cards: one with heart, one without/**2 cartes: une avec coeur, une sans coeur**.
120. *When a girl hitch-hiker…*/**Lorsqu'une auto-stoppeuse…** 2 cards:

one with heart, one without/**2 cartes: une avec coeur, une sans coeur**.
121. *Be courteous at the wheel*/**Soyez courtois au volant**. 2 cards: one with heart, one without/**2 cartes: une avec coeur, une sans coeur**.
122. *In the Spring, in order to avoid slowing down…*/**Au Printemps, afin d'éviter les ralentissements…** 2 cards: one with heart, one without/**2 cartes: une avec coeur, une sans coeur**.
123. *Respect all the signals*/**Respectez toutes les signalisations**. 2 cards: one with heart, one without/**2 cartes: une avec coeur, une sans coeur**.
124. *Even if you have a large family*/**Même si vous avez une famille nombreuse**. 2 cards: one with heart, one without/**2 cartes: une avec coeur, une sans coeur**.
125. *At slow or at great speed*/**A petite ou à grande vitesse**. 2 cards: one with heart, one without/**2 cartes: une avec coeur, une sans coeur**.
126. *If you make driving errors*/**Si vous commettez des erreurs de conduite**. 2 cards: one with heart, one without/**2 cartes: une avec coeur, une sans coeur**.
127. *If you drive across a cornfield*/**Si vous circulez au milieu d'un champ de blé**. 2 cards: one with heart, one without/**2 cartes: une avec coeur, une sans coeur**.

The following cards have a white frame/**Les cartes suivantes ont un encadrement blanc:**

128. *Take everything to heart*/**Prendre tout à coeur**.
129. *Have a heart of gold*/**Avoir un coeur d'or**.
130. *Wear your heart on your sleeve*/**Le coeur sur la main**.
131. *Whole-heartedly*/**De tout coeur**.
132. *With an open heart*/**A coeur ouvert**.
133. *Straight to the heart*/**Allez droit au coeur**.
134. *Fanciful*/**Faire le joli coeur**.
135. *Unwillingly*/**A contre-coeur**.
136. *Sad at heart*/**Avoir le coeur gros**, & large size/**grand format**.
137. *Get to the bottom of it*/**Avoir le coeur net**.

REPRODUCTIONS FROM POSTERS
REPRODUCTIONS D'AFFICHES

Back to school/**Rentrée des classes**. 1930
Englebert. It holds…I hold on to it/**Englebert. Il tient…J'y tiens…** 1950
Songs of Yesterday and Today/**Chansons d'Hier et d'Aujourd'hui**. 1953
What must I do to please you?/**Que dois-je faire pour vous plaire?** 1956
Christmas 1958-Foundation Louis Lépine/**Noël 1958-Fondation Louis Lépine**. 1958
With Illustrated Telegrams/**Avec les Télégrammes Illustrés**. 1960
Father's Day/**Fête des Pères**. 1962
Party night at the Polytechnic College/**Nuit de l'Ecole Polytechnique**. 1965
Biot. 1966
St Valentine's Day – Festival of Lovers/**St Valentin – Fête de ceux qui s'aiment**. 1970
Blood Donor/**Don du Sang** (felt tip/au feutre). 1970
Toys/**Jouets**. 1972
Music in Vence/**Musique à Vence**. 1978
Perrier-Jouët Champagne: Lovingly Yours/**Perrier-Jouët Champagne: Amoureusement Vôtre**. 1978
Pick Happiness on the Riviera/**Cueillez le Bonheur en Riviéra**. 1980
Bridge lovers/**Les amoureux du Bridge**. 1987
16th Antique Fair-Antibes/**XVI^e Salon d'Antiquité Brocante-Antibes**. 1988
1st General States of the Communities/**1^er Etats Généraux des Communes**. 1989

ST VALENTINE'S DAY / SAINT VALENTIN

St Valentine – Heart of France – Lovers' Festival/**St Valentin – Coeur de la France – Fête des Fiancés**.
Peynet – St Valentine's Day/**Peynet – La St Valentin** (drawing of the stamp/**dessin du timbre**) 1985.
St Valentine's Day in Nevers/**La St Valentin à Nevers**. 1986
'The Village of the Lovers' Series/**Série "Le Village des Amoureux"** (blue drawing/**dessin bleu**).
Lovers at a Tower's Window/**Amoureux à la Fenêtre d'une Tour**. 1987

*Loving Couple under a Weeping Willow/***Couple d'Amoureux sous un Saule Pleureur** (brown drawing/*dessin marron*). 1987
*Three Loving Couples and Swallows/***Trois Couples d'Amoureux et Hirondelles.** 1990
*Lovers on a Bench/***Amoureux sur un Banc.** 1986
*Loving Couple – Hitch-hiker/***Couple Amoureux – Auto Stopeuse** (red drawing/*dessin rouge*). 1986
*Lovers under a Tree with Suitcase/***Amoureux sous un Arbre avec Valise.** 1989

POST OFFICE – PHILATELY / LA POSTE – PHILATÉLIE
*The Lovers of Stamp Collecting/***Les Amoureux de la Philatélie.** 1985
*Peynet – St Valentine's Day/***Peynet – La Saint Valentin.** 2 different cards from stamp drawing/*2 cartes différentes des dessins du timbre.* 1985
*At the Post Office Counter/***Au Guichet des P.T.T.** 1985
*Peynet – The Lovers – St Amour Stamp/***Peynet – Les Amoureux – Timbre St Amour.**
*Lovers with an Umbrella – Rain of Hearts/***Amoureux assis avec un Parapluie – Pluie de Coeur.** 1985
*Happily Married Lovers/***Bonne Fête – Amoureux Mariés** (folded card/*carte pliée*).
*Peynet's Public Bench/***Banc Public de Peynet.** 1993
*Post Office in St Valentine – Lovers Bust/***Point Poste à St Valentin – Buste Amoureux.** 1994
*The Village of the Lovers/***Le Village des Amoureux.** 1995

FRENCH RED CROSS / CROIX ROUGE FRANÇAISE
*Music Notes Merchant/***Marchand de Notes de Musique.** 1986
*In a Park in Autumn/***Dans un Parc en Automne.** 1987
*The Lovers and the Red Cross of Nevers/***Les Amoureux et la Croix Rouge de Nevers.** 1987
*The Musician Lovers and the Red Cross of Nevers/***Les Amoureux Musiciens et la Croix Rouge de Nevers.** 1988
*Parking Allowed Zone/***Zone à Stationnement Autorisé.** 1989
*Taking a photo in the Park/***Prise d'une photo dans un Parc.** 1990
*Lovers offering a necklace (with the Red Cross)/***Amoureux offrant un collier (avec la Croix Rouge).** 1991

BLOOD DONOR / DON DU SANG
*Your blood can save my life, mine can save yours/***Ton sang peut sauver ma vie, le mien peut sauver la tienne.**
*Blood Donation – Angel/***Collecte de Sang – Ange.**
*Blood Donation – Angel and Text (Laval)/***Collecte de Sang – Ange et Texte (Laval).**
*Blood Donation – Lovers on a Bench/***Collecte de Sang – Amoureux sur un Banc.**
*Offering flowers is great – Offering blood is better/***Offrez des fleurs c'est bien – Offrez du sang c'est mieux.**
*Blood Donation (La Rochelle)/***Collecte de Sang (La Rochelle).**

VALENCE
Hotel Restaurant Pic.
*Sites and Buildings No.2610 – The Bandstand/***Sites et Monuments No.2610 – Le Kiosque.**
*Valence: The Bandstand and the Lovers/***Valence: Le Kiosque et les Amoureux.**
*Valence: Peynet's Bandstand/***Valence: Kiosque de Peynet.**
*The Lovers Seated in Bandstand (50th Anniversary, 2 cards)/***Les Amoureux assis sous le Kiosque (50ème Anniversaire, 2 cartes).**
*The Lovers in a Heart with Bandstand (50th Anniversary)/***Les Amoureux dans un Coeur avec Kiosque (50ème Anniversaire).**

MISCELLANEOUS / DIVERS
*Clacquesin Radio/***Radio Clacquesin.** 1938
Saint-Amour (Jura).
*Hello, Saint-Amour Speaking/***Allô ici Saint Amour.**
*Saint-Amour Coat of Arms sticker/***Blason Adhésif de Saint-Amour.**
*Saint Genevieve in the Woods/***Sainte Geneviève des Bois.** 1987
*Perce Neige Committee – St Cloud/***Comité Perce Neige – St Cloud.** 1992
C.I.C.P.C. Albi-Tarn. 1991

Biot – Alpes Maritimes.
*Saintes – Exhibition at Villa Musso/***Saintes – Villa Musso Exposition.** 1992
*Paris – Passebon Gallery/***Paris– Galeries Passebon.** 1994
*Paris – Sèvres Leisure Space/***Paris – Sèvres Espace Loisirs.** 1995
*St Pierre-du-Chemin – Exhibition of Peynet's Lovers/***St Pierre-du-Chemin – Exposition Les Amoureux de Peynet.** 1996
*Corsican Lovers in their Island/***Les Amoureux Corses dans leur Ile.** 1982
*Corsican Lovers in Antibes/***Les Amoureux Corses à Antibes.** 1983
*Membership Card of the Peynet Club in Reims/***Carte de Membre Club Peynet Reims.** 1996
*They love each other so…Artificial Hearts/***Ils ne se sont jamais tant aimés que…Coeur Artificiel.**
*Fresh Music/***La Musique Fraîche.**
*Smiling Face – Brussels/***La Mine Souriante – Bruxelles.**
*Champagne Perrier-Jouët – Golf/***Champagne Perrier-Jouët – Golf.**
*Champagne Perrier-Jouët – Enchanted Island/***Champagne Perrier-Jouët – l'Ile Enchantée.**
*Champagne Perrier-Jouët – The Three Kings/***Champagne Perrier-Jouët – Les Rois Mages.**
*Champagne Perrier-Jouët – Spring/***Champagne Perrier-Jouët – Le Printemps.**
*Champagne Perrier-Jouët – Autumn/***Champagne Perrier-Jouët – Automne.**
*Champagne Perrier-Jouët – We shall live off love and…/***Champagne Perrier-Jouët – On vivra d'amour et de…**
*Champagne Perrier-Jouët – A Golf Player/***Champagne Perrier-Jouët – Un Joueur de Golf.**
*Best Wishes Card, Mono-Service/***Carte de Voeux de Mono-Service.** 1956
*Best Wishes Card, 'Doremifasol'/***Carte de Voeux "Dorémifasol'.** 1987
*Best Wishes Card, Post Office Social Work/***Carte de Voeux, Oeuvres Sociales des P.T.T.** 1987
*33rd International Fair of Humorists/***33ème Salon International des Humoristes, Bruxelles.** 1968
*20th International Fair of Humorists/***XXº Salone Internazionale dell Umorismo, Bordighera** (Italie).
*Community of Diano Marina/***Comune di Diano Marina** (Italie).

Series of 10 Colour Cards/**Série Cartes d'Art:**
1. *A Love Song/***Une Chanson d'Amour.**
2. *Concerto/***Concerto.**
3. *Happy Marriage/***Heureux Mariage.**
4. *A Message for you/***Un Message pour toi.**
5. *A Little Message for you/***Une Petite Note pour toi.**
6. *Under the Roofs/***Sous les Toits.**
7. *A Heart for you/***Un Coeur pour toi.**
8. *With All my Heart/***De Tout Coeur.**
9. *Birds of Happiness/***Les Oiseaux du Bonheur.**
10. *The Lovers of the Eiffel Tower/***Les Amoureux de la Tour Eiffel.**

Series of 9 black and white postcards of Peynet's Stand: Pavillion de l'Urbanisme. Brussels World Fair, 1958
Serie de 9 cartes postales (photographies en noir et blanc) représentant le Pavillon de l'Urbanisme de Peynet. Expo Bruxelles, 1958.

Signs of the Zodiac/**Les Signes du Zodiaque.** Editions Maîtres Contemporains.
*Capricorn/***Capricorne.**
*Aquarius/***Verseau.**
*Pisces/***Poissons.**
*Aries/***Bélier.**
*Taurus/***Taureau.**
*Gemini/***Gémeaux.**
*Cancer/***Cancer.**
*Leo/***Lion.**
*Virgo/***Vierge.**
*Libra/***Balance.**
*Scorpio/***Scorpion.**
*Sagittarius/***Sagittaire.**

Also with another editor, Arts of Europe, same cards with coloured frames/aussi avec un autre éditeur, Arts d'Europe, mêmes cartes avec cadres de couleurs différentes.

T.V. Programme Series / **Série Canal et Fleurs-Bleues**:
St Valentine's Lovers' Festival/*St Valentin – Fête de ceux qui s'aiment*.
The Lovers/**Les Amoureux**:
 Throwing his heart to his Lady/*Lançant son coeur à sa Belle*.
The Lovers/**Les Amoureux**:
 Don't leave Darling…/*Ne partez pas Chérie…*
The Lovers/**Les Amoureux**:
 On a bench, flowers on his chest/*Sur un banc, lui avec fleurs sur sa poitrine*.
Peynet's Dolls/**Les Poupées de Peynet**:
 I don't dare telling you how much I love you/*Je n'ose pas vous avouer mon amour*.
Peynet's Dolls/**Les Poupées de Peynet**:
 Heartache…/*Vous m'avez fait beaucoup de peine…*

Exclusive to the Peynet Museum– Antibes/**Exclusivité Musée Peynet – Antibes**
Colour Postcards/**Cartes Postales en Couleurs**:
The Ramparts (Old town with the Lovers)/*Les Remparts (La vieille ville aux Amoureux)*.
The Four Seasons' Salesman/*Le Marchand des Quatre Saisons*. 1960
The Lovers with Doves/*Les Amoureux aux Colombes*.
The March/*La Manif*.
The Newly Weds/*Les Mariés*.
Money-City/*Fric-Ville*. 1965
The Bird Man/*L'Homme Oiseau*.
Morning Glory/*Les Volubilis*. 1960
The Bunch of Swallows/*Le Bouquet d'Hirondelles*. 1960
Happy New Year/*Bonne Année*. 1985
Exchanging Views/*Un Echange de Vues*.

Black and White Postcards/**Cartes Postales Noir et Blanc**:
Notification of Birth/*Faire-part de Naissance*. 1963
Notification of Birth/*Faire-part de Naissance*. 1966
Good Wishes Card/*Carte de Voeux*.
Alone at Last!/*Enfins Seuls!*
The Hitch-Hikers/*Les Auto-Stoppeurs*.
Raining Musical Notes, Avenue Mozart/*Pluie de Notes, Avenue Mozart*.
The Wedding and the Sleeping Painter/*La Noce et le Peintre Endormi*.
National Assembly/*Assemblée Nationale*.

PEYNET MUSEUM, KARUIZAWA – JAPAN
MUSEE DE PEYNET, KARUIZAWA – JAPON

A Packet of 6 Coloured Postcards, 1986/**Pochette Dessin Couleur avec 6 Cartes, 1986**:
Lovers in Black and White/*Amoureux Noir et Blanc*.
In a Park, in the Snow/*Dans un Parc, dans la Neige*.
Lovers/*Amoureux*.
In the Stars, Black and White/*Volant dans les Etoiles, Noir et Blanc*.
Lovers with Angels/*Amoureux avec deux Anges Dessin Bleuté*.
Astride a Bird (same drawing as on the packet)/*Sur un Oiseau (carte même dessin que la pochette)*.

A Packet of 6 Coloured Postcards/**Pochette Dessin Couleur avec 6 Cartes**:
Lovers lying down under a tree (as on the packet)/*Amoureux allongés sous un arbre (même dessin que pochette)*.
One Rose: Hurry Up!/*Une Rose: Dépêchez-vous!*
Two Roses: Mummy, may I go to play…/*Deux Roses: Maman est ce que je peux aller jouer…*
One Rose: It looks like she is crying/*Une Rose: On dirait qu'elle pleure*.
One Rose: Don't disturb/*Une Rose: Ne pas déranger*.
One Rose: What an aroma…/*Une Rose: Quel parfum!*

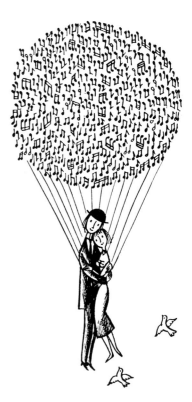

DOLLS / POUPEES

Agatha/**Agathe**.
Alfred de Musset et/and *George Sand*.1960
Alsace/**Alsace**. 1954
Altitude. 1860
Friend Pierrot (green hat)/**Ami Pierrot (chapeau vert)**. 1953
Friend Pierrot (beige hat)/**Ami Pierrot (chapeau beige)**. 1953
The Lovers - Andalouse/**Les Amoureux - Andalouse**.
The 1950s/**Années 50**.
Girl from the Antilles/**Antillaise**.
Anthony and Cleopatra/**Antoine et Cléopâtre**.
The Painter/**Artiste-Peintre**. 1953
Hitch-Hiker/**Auto-Stop**.
Auvergne/**L'Auvergne**. 1954
The Lady Lawyer/**Avocate**.
Baby.
Swimmers 1900, couple/**Baigneurs 1900, couple**.
Swimmers 1900, man/**Baigneurs 1900, homme**.
Swimmers 1900, woman/**Baigneurs 1900, femme**.
Night Ball/**Bal de Nuit**.
Masked Ball/**Bal Masqué**. 1957/8
Bank of France/**Banque de France**.
Art School, woman/**Beaux-Arts, femme**.
Art School, couple/**Beaux-Arts, couple**.
Shepherdess/**Bergère**. 1953
Good Night/**Bonne Nuit**.
Fish Soup/**Bouillabaisse**.
The Book Lover/**La Bouquinière**.
The Flower Girl/**La Bouquetière**.
Brittany/**Bretagne**. 1954
Powder Your Nose/**Brin de Toilette**. 1953
Romantic Setting/**Le Cadre Romantique**.
Camargue, couple/**La Camargue, couple**. 1960
Cat Ballou.
Capri.
Carmen.
Country Doctor/**Cécilia, Médecin de Campagne**. 1964/5
Champs Elysées.
Butterfly Chase/**Chasse aux Papillons**.
Hunting is Forbidden/**Chasse Gardée**.

Cleopatra/**Cléopâtre.**
Happy Heart/**Coeur en Fête.**
The Lady's Hairdresser/**Coiffeuse.**
Little Friend/**Copinette.**
Poppy/**Coquelicot.**
Cocktail/**Coquetèle.**
French Riviera/**Côte d'Azur.**
Couple of Gardeners/**Couple de Jardiniers.**
Married Couple of the 1950s (open dress with a bow)/**Couple de Mariés Années 50 (robe ouverte avec noeud).**
Married Couple of the 1960s (dress closed, with flowers)/**Couple de mariés Années 60 (robe fermée avec fleurs).**
Cover Girl.
Cuban Girl/**Cubaine.**
Fashionable/**Dans le Vent.**
Ballet Dancer/**Danseuse Etoile.** 1953
Black Dancer/**Danseuse Noire.**
The Designer/**Dessinatrice.**
Supper by Candlelight/**Dîner aux Chandelles.**
Dorothy.
Pleasure of Living/**Douceur de Vivre.**
Cosy/**Douillette.**
Schoolgirl/**Ecolière.**
Horsewoman/**Ecuyère.**
Absent Minded Girl/**Etourdie.**
Student/**Etudiante.** 1957
Festival.
The Engagement/**Les Fiancés.**
Strong Man/**Fort des Halles.**
Frederic the Guardian/**Frédéric le Gardian.**
Chilly Girl/**Frileuse.**
Police Constable/**Gardien de la Paix.**
Gavroche.
George Sand. 1960
Gypsy Woman (shift dress)/**Gitane (robe droite).** 1957/8
Gypsy Woman (shift dress)/**Gitane (robe plissée).** 1957/8
The Grand-Parents/**Les Grands-Parents.**
Grandma/**Grand-Maman.**
Grandpa/**Grand-Papa.**
Grenoble.
Big Sorrow/**Gros Chagrin.** 1957/8
The Guitarist/**Le Guitariste.** 1958
Gipsy.
Happy Birthday/**Heureux Anniversaire.**
Air Hostess/**Hôtesse de L'Air.**
Hula-Hoop.
The Idols/**Les Idoles.** 1960
Qualified Illusionist/**Illusionniste Diplômé.**
Nurse/**Infirmière.**
Artless Girl/**Ingénue.**
Intimacy/**Intimité.**
Isabelle.
Isabella and Rocambole/**Isabella et Rocambole.** 1964/5
I love/**J'aime.**
Gardener/**Jardinier.**
Daffodils – Gardener's Couple/**Jonquille – Couple de Jardiniers.**
Jeannette Buys/**Jeannette Achète.**
The Young Parents/**Les Jeunes Parents.**
Newly-Wed Man/**Jeune Marié.**
Newly-Wed Woman/**Jeune Mariée.**
The Newly-Weds/**Les Jeunes Mariés.**
Daffodil/**Jonquille.**
Jockey and Horse-Betting/**Jockey et le Tiercé.**
Lady Tennis Player/**Joueuse de Tennis.**
Juan-les-Pins, red-headed girl, big dots/**Juan-les-Pins, rousse, gros pois.**
Juan-les-Pins, red-headed girl, small dots/**Juan-les-Pins, rousse, petits pois.**
The Romantics/**Les Romantiques.**
Lido.

Girl Friend/**Ma Copine.**
My Milliner/**Ma Modiste.**
Miss Periwinkle/**Mademoiselle Pervenche.**
Madras.
School Mistress/**Maîtresse d'Ecole.**
Four Seasons Saleslady/**Marchande des Quatre Saisons.**
Fruit and Vegetable/**Les Fruits et les Légumes.**
Antique Market/**Marché aux Puces.**
The Mayor/**Monsieur le Maire.**
Marianne (ribbon at the bottom)/**Marianne (ruban en bas).**
Marianne with Veil/**Marianne avec Voile.** 1957
Sailor/**Marin.**
Girl from Martinique/**Martiniquaise.**
Household Lady/**Ménagère.**
Cabinet Maker/**Menuisier.**
My Idols/**Mes Idoles.**
Midinette.
Mimi Pinson.
Mini-Heart/**Mini Coeur.**
Mini-Skirt Pop Art/**Mini Jupe Pop'Art.**
Mini Bride/**Mini Mariée.**
Mimouna.
Miss Twist. 1960
My Idol/**Mon Idole.**
Montmartre. 1957
Montparnasse, couple.
Napoléon et/and **Joséphine.** 1960
Normandy, couple/**Normandie, couple.**
New Orleans.
Normandy/**Normandie.**
New Ware/**Nouvelle Vague.**
Opera/**Opéra.** 1957
Op Art.
Palm Beach.
Paris Lady/**Parisienne.**
The Ice Skater/**Patineuse.**
The Basque Country, couple/**Le Pays Basque, couple.** 1960
Paintress/**Peinturlurette.**
Perette. 1953
Fisherman/**Pescadou.**
Little Clown/**Petit Clown.**
Little Lady/**Petite Lady.**
The Little Poet/**Le Petit Poète.** 1953
Little Party/**Petite Soirée.**
First Ball/**Premier Bal.**
First Rendevous/**Premier Rendez-vous.**
The President/**Le Président.**
Next Wave/**Prochaine Vague.**
Provence, couple/**La Provence, couple.** 1960
Chimney Sweep/**Ramoneur.**
Photo-Journalist/**Reporter-Photographe.** 1957/8
Trapeze Dress/**Robe Trapèze.**
Tea Rose, 1950s/**Rose Thé, Années 50.**
Tea Rose, 1960s/**Rose Thé, Années 60.**
Rocambole.
St Tropez (black)/**Saint-Trop (noir).**
St Tropez/**Saint-Trop.** 1953
Secretary/**Secrétaire.**
Shopping.
Scoubinette.
Maid/**Soubrette.**
Squaw Valley.
Starlet/**Starlette.**
Strip Tease.
White Party Dress/**Surboum, Robe Blanche.**
Pink Party Dress/**Surboum, Robe Rose.**
Surprise Party/**Surprise-Party.**
Tahitian Girl/**Tahitienne.**
Aunt Agatha/**Tante Agathe.**
Tchao.

Telephone Operator (brown hair)/***Téléphoniste*** **(brune)**. 1953
Telephone Operator (blonde hair)/***Téléphoniste*** **(blonde)**. 1953
Horse Bet/***Tiercé.***
Violinist/***Violoniste.***
Long Live Rain/***Vive la Pluie.***
Weekend. 1953
Whisky à Gogo.

Dolls created for postcards only/**Poupées créées pour cartes postales uniquement:**

Arachon Bassin, couple/***Bassin d'Arachon*, couple.**
***Champagne*, couple.**
Rule of the Road/***Code de la Route.***
Corsica, couple/***Corse*, couple.**
The New Key to Dreams/***La Nouvelle Clé des Songes.***
North, couple/***Nord*, couple.**
Landes Country/***Pays Landais.***
Good Luck Charm/***Les Porte-Bonheur.***
The Signs of the Zodiac/***Les Signes du Zodiaque.***

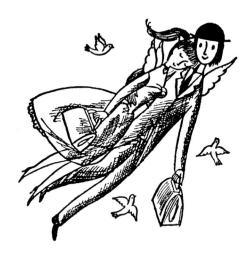

RECORD COVERS
POCHETTES DE DISQUES

Albums LPs/33 tours (30cm):

Songs from when we were Twenty/***Chansons de nos 20 ans,*** Lina Margy. Volumes: 1, 2, 3, 4, 5, 6. CBS 52061, 52314, 52314, 52315, 52316, 52462. A different drawing on each cover/**Un dessin différent sur chaque pochette.**
Jeannette's Wedding/***Les Noces de Jeannette,*** Orchestre National Opera Comique. Pathé ASTX 121. Colour drawing on the whole cover/**Dessin couleurs sur toute la pochette.**
Jeannette's Wedding/***Les Noces de Jeannette,*** Orchestre et Choeurs Richard Blareau. RCA
Le Canzoni d'Amore di Gianni Meccia (Love Songs/***Chansons d'Amour***), Gianni Meccia con Morricone. RCA Italiana PML 10353.
Beethoven's Symphony No.6 Pastoral /***Beethoven Symphonie No.6 Pastorale,*** Orchestre Philharmonique de Vienne. HMV (Voix de son Maître) FALP 288

Olympia 64, Marcel Amont. Polydor 46152. A little Peynet drawing on each side of the cover/**Un petit dessin de Peynet sur chacun des côtés de la pochette.**
Delibes – Coppelia Sylvia Ballets, Orchestre National de Paris. Disques Odeon. Peynet's doll on the cover/**Poupée de Peynet sur la pochette.**
Sweet France/***Douce France,*** Ensemble Vocal Ile de France. Guilde Internationale du Disque.
Concert Waltzes, Henry Krips. EMI SREG 2020. Two Peynet dolls in colour on white cover/**Deux poupées Peynet en couleurs sur la pochette blanche.**

Albums LPs/33 tours (25cm):

10 Songs/***10 Chansons,*** Cora Vaucaire. Pathé 33 AT 1042. Signed Peynet drawing representing the singer/**Dessin signé de Peynet représentant la chanteuse.**
The Notebook of Odette Laure/***Le Petit Carnet d'Odette Laure,*** Odette Laure. RCA F230 002. Peynet drawing representing the singer. The same as the EP but larger/**Dessin de Peynet représentant la chanteuse. Le même en grand que celui du 45 tours.**
Springtime of the French Song/***Le Printemps de la Chanson Française.*** Compilation, Philips B 76. 524 R. Signed, large drawing in black and white/**Grand dessin en noir et blanc, signé.**
Christine of my Heart/***Christine de mon Coeur,*** Michel Legrand. Philips B 07. 838 R. Peynet drawing on the back in the shape of a record/**Dessin de Peynet au dos de la pochette en forme de disque.**
I Love Paris, Michel Legrand. Philips.

Singles EP/45 tours:

The Paper Lovers/***Les Amoureux de Papier,*** & 3 other titles/**3 autres titres** Marcel Amont. Polydor 20721 EPH. Same record – cover with same drawing, different colours, signed/**Même disque – pochette avec même dessin, autres couleurs, signé.**
Peynet's Dolls/***Les Poupées de Peynet,*** & 3 other titles/**3 autres titres,** Marcel Amont. Polydor 20918. Colourful drawing/**Dessin en couleurs.**
Love, Dance and Violins/***Amour, Danse et Violons,*** Frank Pourcel. HMV (Voix de son Maître) 7MH 1072.
Odette Laure, 4 titles/**4 titres.** RCA F 75004. Peynet's drawing representing the singer as on the LP/ **Caricature de la chanteuse sur la pochette. Même dessin que sur le 33 tours.**
The Bird on my Head/***L'Oiseau sur ma Tête*** & 3 other titles/**3 autres titres,** Ginette Garcin. VEGA V45P 1992
If All the Lovers in the World/***Si tous les Amoureux du Monde*** (Original soundtrack of the film/**Bande originale du film**), Robert Brummel. Germinal GEP 17.
Leo Noel and his Barrel Organ/***Léo Noël et son Orgue de Barbarie,*** 4 titles/**4 titres.** Pathé 45 EG 115. Dedication by Peynet/**Dédicace de Peynet.**
The History of France/***L'Histoire de France.*** Set of 7 records/**Boîte de 7 disques.** Polydor.
Air Love. Japanese Record/**Disque Japonais.** Canyon A 217 V500.
The Eiffel Tower is having fun/***La Tour Eiffel s'amuse,*** Audrey Arno. Disques Tour Eiffel (promotion).
Pierre Thibaud and his Trumpet/***Pierre Thibaud et sa Trompette.*** Pronuptia (promotion). At the back of the record cover there is a Peynet drawing on a green background/**Au verso de la pochette il y a un dessin sur fond vert.**
Sonorama No. 18. Peynet drawing inside the cover with his signed text for Marcel Amont/**Dessin de Peynet dans la Revue (disque no.7) accompagné d'un texte pour Marcel Amont et signé,** April/**Avril** 1962.

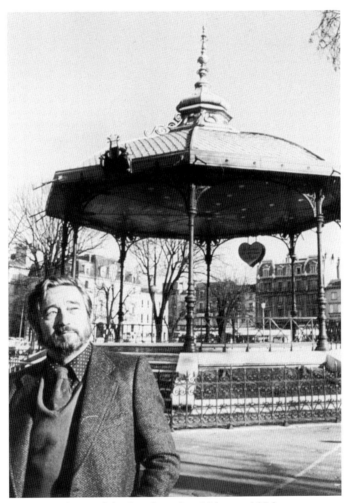

Peynet in front of the bandstand in Valence, 1976.
Peynet devant le kiosque à musique de Valence, 1976.